ROMANTIC LANDSCAPE

THE NORWICH SCHOOL OF PAINTERS

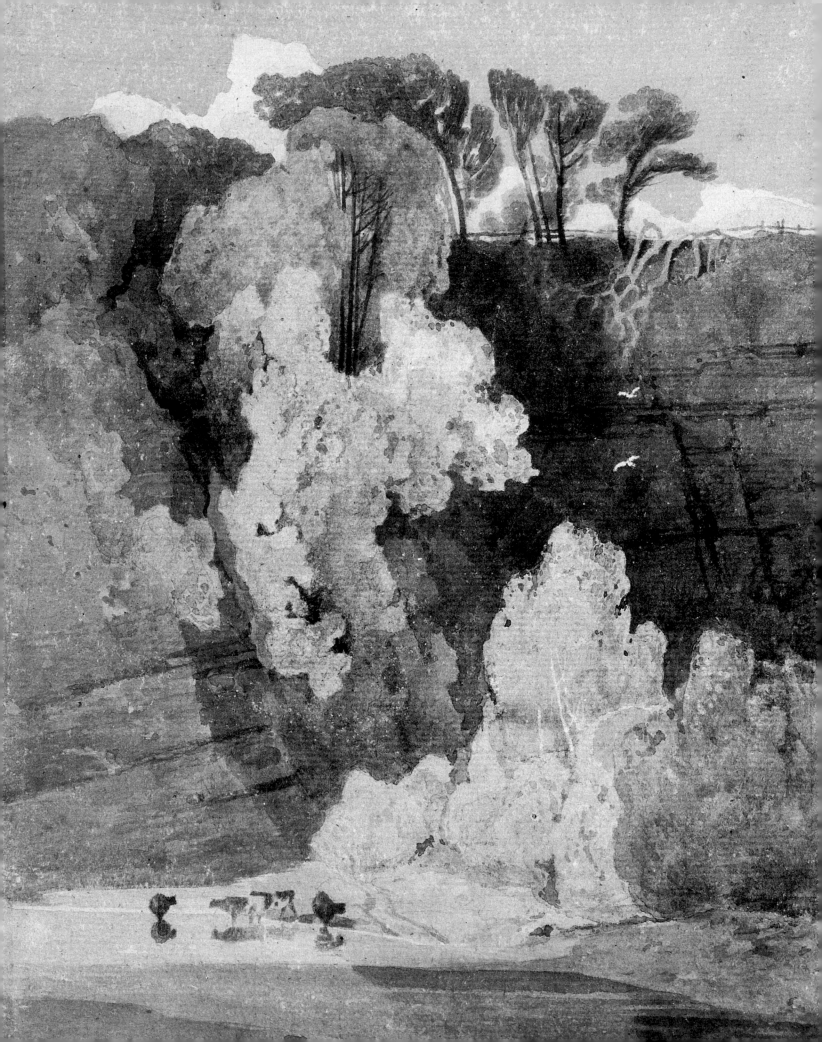

ROMANTIC LANDSCAPE
THE NORWICH SCHOOL OF PAINTERS

DAVID BLAYNEY BROWN

ANDREW HEMINGWAY

ANNE LYLES

TATE GALLERY PUBLISHING

Published by order of the Trustees of the Tate Gallery 2000
on the occasion of the exhibition at Tate Britain
24 March – 17 September 2000

ISBN 1 85437 315 3

A catalogue record for this publication is available from the British Library

Published by Tate Gallery Publishing Limited,
Millbank, London SW1P 4RG
© The Trustees of the Tate Gallery 2000. All rights reserved
Designed and typeset by Caroline Johnston
Printed and bound in Belgium by
Snoeck-Ducaju & Zoon nv, Ghent

CONTENTS

FOREWORD

The term 'Norwich School' is usually applied to several generations of artists, mainly landscape painters, working in Norfolk during the first two-thirds of the nineteenth century. Tate Britain's exhibition focuses on the early phase of their output, the period of the Norwich Society of Artists and its exhibitions from 1803 to 1833 in which the School had the greatest claim to integrity and its leading personalities John Crome and John Sell Cotman were active. Crome and Cotman were distinguished in their own right and very different in essence and ambition – the one best known as an oil painter, the other for his spectacularly original watercolours. Both helped to form the character of the School, but were also linked at a national level and with the mainstream of contemporary art and taste through their engagement with old master paintings, the 'picturesque', rustic naturalism and antiquarianism. These local and national contexts are investigated in two catalogue essays by Andrew Hemingway of University College London, and David Blayney Brown of Tate Collections, who is the exhibition's lead curator.

The exhibition is drawn very largely from the extraordinary holdings of the Norwich Castle Museum, which, in the year of its closure for a major refurbishment project supported by the Heritage Lottery Fund, most generously offered us an unrestricted choice of Norwich School works for display in London. These include important holdings from the Russell J. Colman and Jeremiah J. Colman Bequests, which have been permitted by Sir Timothy Colman and the Colman family to leave Norwich for this exceptional occasion. We owe many thanks to Andrew Moore, Keeper of Art at the Castle Museum, for initiating the project and supporting it throughout, to Norma Watt, Assistant Keeper, for her constant help and patience, and to the Head of the Norfolk Museums Service, Vanessa Trevelyan, for approving the Norwich loans and also agreeing to part with George Vincent's *Dutch Fair at Yarmouth* from the Elizabethan House Museum, Great Yarmouth. It is also appropriate to acknowledge the distinguished work that has been undertaken by past curators at Norwich since the magnificent Colman Bequests transformed the Castle Museum. In particular the work of the late Miklos Rajnai and his team laid important foundations for much subsequent research in the field of regional studies.

This collaboration between Tate and the Norwich Castle Museum stems from a long-standing partnership. Supported by the Tate in East Anglia Foundation, originally chaired by Merlin Waterson, ten displays and exhibitions of Tate works were organised in Norwich during the 1990s. Now reconstituted as the East Anglia Art Foundation, chaired by Richard Jewson, a wider programme is under development to bring great works to the region from many sources and to support the Castle's visual arts programme more widely. The Tate's direct work with Norwich continues through its Partnership Scheme (supported by the HLF Access Fund) and we are committed over the three years ahead to assist their making and development of an annual display. The Castle Museum's major loan of works to *Romantic Landscape* is a further sign of this creative relationship between our two institutions.

For the present exhibition we have added a number of Tate works to the Castle Museum core as well as a small number of significant loans from other places. We are most grateful to Duncan Robinson, Director of the Fitzwilliam Museum, and the Syndics of the Fitzwilliam Museum, Cambridge, for agreeing to lend Joseph Stannard's *River Yare at Bramerton*; to Godfrey Worsdale and Tim Craven of Southampton City Art Gallery for lending George Vincent's *View on the River Yare near Norwich*; and to Julia Findlater of English Heritage and Judith Rutherford, Director of the Iveagh Bequest, Kenwood, for lending John Berney Crome's *Yarmouth Water Frolic*. The process of selection was led by David Blayney Brown, with advice from Andrew Hemingway and much additional input from Anne Lyles, who has also contributed many catalogue entries. Cathy Proudlove of the Norwich Castle Museum, and Rica Jones and Brian McKenzie of Tate Conservation were the project conservators. Martin Myrone and Tim Batchelor of Tate Britain, with exhibitions registrar Sionaigh Durrant, were responsible for the practical organisation and co-ordination of the project. For other help and advice our thanks are also due to Emma Hathaway, Ralph Hyde, Andrew Loukes, Alexander Norcross-Robinson, Sheila O'Connell, Peter Kennedy Scott, Greg Smith, Sue Smith, Clare Storey, Sarah Taft, Alison Tallontire and Rosalind Tennent.

Through all these contributions Tate Britain is able, in its inaugural year, to offer a broad survey of an important movement in British landscape and marine painting. With this year's special display of Constables from the Victoria & Albert Museum alongside the main Turner displays and close to the present exhibition too, the Clore Gallery in 2000 is presenting an exceptionally rich picture of Romantic landscape from the first half of the nineteenth century. By such juxtapositions, relationships between the artists and wider artistic movements are explored in new ways. This is part of Tate Britain's commitment to reappraising and reanimating the history of British art and our engagement with it today.

Stephen Deuchar
Director, Tate Britain

'NORWICH SCHOOL': MYTH AND REALITY

Andrew Hemingway

Formation of a Myth

'Norwich School' is customarily taken to refer to three generations of artists who lived and worked in Norwich for all or part of their careers *c*.1800–80. Leading figures among them were John Crome, John Berney Crome, James Stark, George Vincent, Robert Ladbrooke, Joseph Stannard, Alfred Stannard, Robert Dixon, John Thirtle, John Sell Cotman and his sons Miles Edmund Cotman and John Joseph Cotman. But, in addition, more than twenty other artists, both professional and amateur, have been included in the category. While the best-known Norwich artists were landscape painters, the term has sometimes been extended to the still-life painters Emily Stannard and James Sillett, and the portrait painter Joseph Clover. Conventionally, these artists are assumed to be linked by their common geographical base, by the fact that they often exhibited together, by a shared concern with local subject-matter, and by various kinds of professional, institutional, personal and family relationships. Even leaving aside the works of specialists in other genres, the landscape paintings produced by Norwich-based artists are extremely diverse in character.[1]

To begin with, it needs to be stressed that the 'Norwich School' did not exist in its modern form in the minds of early nineteenth-century observers. Although the term appeared as early as 1806 in a review in the *Norwich Mercury* (16 August), and the paper used it occasionally in later notices, it was applied mainly in the sense given under 'school' in the 1814 edition of Johnson's dictionary as: 'a state of instruction', and not in the alternative sense of a 'system of doctrine as delivered by particular teachers'. Significantly, the *Mercury*'s art reviews were written by its proprietor Richard Mackenzie Bacon, an amateur artist and a friend of the Crome family. The other Norwich paper, the *Norfolk Chronicle*, whose proprietor had no such personal investment in Norwich art, rarely referred to it as a school.

There were reasons for talking about Norwich as a centre of art instruction. The key institution of Norwich art was the Norwich Society of Artists, which held meetings from 1803 until the mid-1830s, and ran exhibitions from 1805 to 1833, excepting a two-year break in 1826–7. According to its articles of foundation, the Society was established 'for the purpose of an enquiry into the Rise, Progress, and Present State of Painting, Architecture, and Sculpture, with a view to discover and point out the best methods of study, to attain to greater perfection in these arts.'[2]

The articles describe the Society as an academy at several points, and although in retrospect its exhibitions have seemed its most important function – partly because they are the only aspect of its activity of which there is a substantial record – to its members the fortnightly discussion meetings held in its rooms may have been as central. In fact there

was no real academy in Norwich (in the sense of a drawing school) until the 1830s, but there were a number of master–apprentice relations, such as those between Crome and Stark and Vincent, and between Robert Ladbrooke and Joseph Stannard. Further, Crome, Cotman and others worked as drawing masters and had an extensive influence on a wide circle of amateurs, some of whom achieved a high standard.

In so far as 'Norwich School' was used in the press in the early years to imply the dissemination of a doctrine or approach, it referred always to the relationship between Crome and his pupils. Both locally and nationally, some commentators began to describe Crome as the 'founder' or 'father' of a school around the time of his death in 1821. Yet this did not imply some close family resemblance between his work and that of his pupils, and an obituary notice in the *Magazine of Fine Arts* observed of the latter: 'His mind was too acute to exact from them a servile imitation of their master's style. On the contrary, he contented himself with instilling the most solid and useful principles of art and giving freedom and spirit to their pencils ...'[3] Evidence of this was provided by the works of J.B. Crome, Stark and Vincent. That this group should seem the main basis for Norwich's reputation in art was inevitable. Stark and Vincent had both lived in London in the second decade, and received a number of laudatory reviews in the London press. They had also sold works to major patrons of British art such as Sir George Beaumont, Sir John Leicester and the Marquess of Stafford. No other Norwich artists had made anything like the same impact on the national scene. Although Cotman had achieved some success in London prior to his return to Norwich in 1806, he was not associated with the Crome group.

Stark and Vincent's heyday in the London press was the period between 1818 and 1825, but thereafter both their work and their standing declined. Until the 1860s Crome's reputation seems to have been sustained mainly through the efforts of local collectors, and particularly those of his patron, the Yarmouth banker Dawson Turner, who owned eleven paintings by him. It was Turner who supplied Allan Cunningham with the information for the account of Crome in his *Cabinet Gallery of British Pictures* (1836), and Turner produced his own memoir to accompany the first edition of Crome's etchings in 1838, the publication of which he organised. It was also through Turner's offices that Crome received a favourable notice in Dr Waagen's *Treasures of Art in Great Britain* (1854). Yet even in the late 1850s Crome's pictures were still fetching modest prices, and the turning point in his reputation seems to have been the showing of seven of them at the London International Exhibition of 1862. Several reviews of this exhibition remarked that his work, hitherto little known, had made a considerable impact, and the French critic Théophile Thoré found him a more even talent than either Constable or Turner, describing his works in the jargon of naturalism as 'perfect expressions of the sites' he represented.[4] Crome's new-found status was confirmed by the National Gallery's purchase of *Mousehold Heath* (cat.26) for £400 in the same year.

As late as the 1870s, the term Norwich School, in so far as it had general currency, seems to have referred only to Crome and his pupils and to Cotman.[5] Indeed, in 1878 a sceptical critic in *The Builder* magazine observed that the whole idea was 'somewhat of an illusion'.[6] It seems quite clear that the concept was perpetuated and developed primarily by groups among the Norfolk bourgeoisie, and that it was institutionalised mainly

through a series of exhibitions organised in Norwich by a variety of bodies over the years 1860–1902. Some of these bodies were philanthropic in orientation, others were directly concerned to promote the 'Norwich School'. Another key agency was an immensely powerful and wealthy Norwich family that was an institution in its own right, namely the Colman family.

The first of these exhibitions of 'deceased local artists' was organised in 1860 by the Norfolk and Norwich Fine Arts Association, a body comprised of prominent Norwich bourgeois, and headed by the mayor, the liberal MP J.H. Tillett. Other loan exhibitions with important collections of works by 'deceased Norwich artists' or 'the Norwich School' were put on in 1874, 1878, 1885 and 1902, and contemporaneously several exhibitions of individual local artists were organised by the Norwich Art Circle. The beginnings of a permanent collection of Norwich art lie in the East Anglian Art Society (EAAS), established in 1876 to buy works of both deceased and contemporary local artists. However, the society had very limited funds, and displayed its unimpressive collection on screens in the Norfolk and Norwich Museum. In 1894 when the museum was taken over by the city and moved to its present home in the Castle, the EAAS donated its collection to the new institution and was dissolved. The catalogues of the city's pictures that the museum began to publish in 1897 further defined Norwich's cultural claims, but far more important was W.F. Dickes' monumental study *The Norwich School of Painting*, published by the local firm of Jarrolds in 1905, and based mainly on the research of James Reeve, curator of the Norwich Museum from 1851 to 1910. Dickes defined the whole gamut of artists associated with Norwich as a unique provincial formation, on whose works the Norfolk scenery had impressed a quite distinctive character.

It was at this point the Colman family began to play a crucial role. At the opening of the Castle Museum Gallery, Jeremiah James Colman (a central figure in the EAAS) made a donation of Joseph Stannard's *Thorpe Water Frolic* (cat.109), and at his death in 1898 a bequest of twenty pictures passed to the city. His son, Russell Colman, followed his example, and in 1951 his massive collection was added to the museum's holdings. A total of 228 oils and 985 watercolours, selectively displayed in purpose-built galleries emblazoned with the donor's name, it is the largest collection of Norwich art anywhere, and a monument to a particular conception of the Norwich School, forever cemented with the Colman name.

In the second half of the nineteenth century, the Colman family was Norwich's largest employer. By 1905 its mustard and laundry blue works at Carrow covered thirty-two acres, and its products carried the name of Colman throughout the world. J.J. Colman lived in Carrow House, next to the plant, and contemporary accounts stress his 'patriarchal attitude' to the workforce. Although work in 'Colmanopolis' was mechanical and highly intensive for the most part, wages were relatively high, and there was an extensive educational and welfare programme. Indeed, J.J. Colman was a model nineteenth-century bourgeois: a committed non-conformist, an active MP and a Gladstonian liberal with a prominent role in city government and the magistracy. The family stressed its longstanding Norfolk connections and identified closely with both city and county. Although the firm modernised rapidly in the first half of the twentieth century and Russell Colman

moved outside the city, he played an equally prominent role in the public life of Norfolk as his father had.

For the Colmans, the donation of their Norwich art collections was a symbol of their local roots and status, and of their responsible stewardship of the wealth their labour force produced for them. For the Norfolk bourgeoisie generally, the Norwich School came to function, I believe, as part of a larger effort to establish a distinctive regional identity – to give this relatively marginal economic region a status that hinged precisely on its rural quality and essential Englishness. In other words, it needs to be seen in relation to that complex redefinition of national identity in the late nineteenth century, which partly focused on the alleged richness of areas supposedly remote from modernisation and change. By the late 1850s, Norwich School pictures were already being interpreted as representations of Old Norfolk and their modern features forgotten. Increasingly Norfolk artists were given a special identity because they were both of Norfolk and represented it. But this imagined organic relation between artist and region obscured the actual character of the works it was invoked to explain and the social relations that had underpinned their production.

A Sketch of Realities

The grouping of artists that formed in Norwich in the early nineteenth century should be understood in relation to the larger expansion of artistic production in this period in both London and the provinces. Beginning with the first Norwich exhibition of 1805, by 1830 more than twenty provincial towns and cities from Plymouth to Aberdeen had seen art exhibitions.[7] This efflorescence of exhibitions is related to the growth of a leisured bourgeoisie and the increasing vitality of provincial life that accompanied Britain's dramatic economic growth in the period of the first Industrial Revolution. Many of those in the swelling ranks of this class were eager to establish their status through culture, which also became for the more progressive-minded among them a symbol of their political virtue – of their superiority over an enervated and corrupt landed plutocracy.

By 1800 Norwich had long been a regional capital of considerable importance. The urban focus of a flourishing agricultural hinterland, it was also a major centre of the textiles industry. In the eighteenth century it experienced the same kinds of economic, social, and demographic change as many other British cities. Its population rose from an estimated 28,881 in 1693 to an estimated 41,764 in 1801. Between 1750 and 1800 the textiles industry grew enormously, but although this brought considerable wealth, the industry also developed an increasingly capitalistic structure, with the erosion of apprenticeship restrictions, the ending of customary pricing, and the formation of larger business units. The self-confidence of its bourgeoisie, and particularly those among the dissenting communities, was reflected in the city's reputation for radical politics in the 1790s. But the harsher forms of competition of the late eighteenth century were also to cause considerable sufferings among the hand-loom weavers and others, who were increasingly proletarianised in these years. This was reflected in the rising cost of poor relief and a

corresponding decline in the number of voters. Not surprisingly there was considerable and sometimes violent social unrest in and around Norwich in the early nineteenth century.[8]

The eighteenth century also saw Norwich turning into a modern city, with its corporate government taking on a much wider range of functions, and affecting considerable improvements in streets, bridges, lighting and drainage – and also in the river system, which was its most important trade route. The historian J.K. Edwards has commented that 'by the end of the century the face of much of the city probably bore only a superficial resemblance to that of a hundred years earlier'.[9] For instance, between 1793 and 1795 eight of the city's twelve medieval gates were demolished, as was much of the medieval wall, and over the years many smaller houses were pulled down to make way for improvements. In the second and third decades of the new century, there was a building boom as the population began to spread into hamlets and suburbs outside the walls. Numerous topographical images by Norwich artists directly or indirectly address this process of modernisation in the urban fabric.

The developments I have been talking about are not background to the artistic output of the Norwich artists, they are fundamental to understanding how it came to be produced at several levels. John Crome was the child of a journeyman weaver, who also kept an alehouse.[10] His first employer, Dr Edward Rigby, became mayor of the city in 1805, and was prominent in its intellectual life. (Rigby was also a member of the Norwich Society of Artists, and a sometime patron of that body.) Among Crome's most important patrons were Thomas Harvey of Catton, the Gurney family, and Dawson Turner of Great Yarmouth. Harvey was a rich master weaver, while the Gurneys, whose vast wealth came in the first place from the textiles trade, are typical of the new type of country banker that emerged during the Industrial Revolution. Dawson Turner was another banker with close business links with the Gurneys.

It was because of people like these that Norwich had two newspapers, a number of circulating libraries, philosophical and literary societies, a thriving theatre and regular musical festivals.[11] The Norwich Society of Artists was only one small aspect of this gamut of cultural activity. Provincial cities with a large and prosperous bourgeoisie could provide a new kind of living for landscape artists. Indeed the lifestyle of provincial artists was intimately connected with this class, for they survived often by teaching drawing to its female part, although there were also other expedients such as picture dealing, restoring, scene painting and so on.[12] What the reliance on these various enterprises means, of course, is that provincial society could not generally support landscape painters through the sale of their works alone. John Crome was basically a Sunday painter, and Cotman was never able to find a market that would permit him to develop his talents as a painter in oils. At the end of his life, Crome is said to have got between 15 and 50 guineas for a picture, while in 1825 Cotman received 10 guineas, plus the cost of materials, for his *Dutch Boats off Yarmouth* (cat.70). Two of Cotman's finest oils, *The Baggage Wagon* and *The Mishap* (cats.83 and 84), were disposed of in a sale for derisory sums when he left Norwich in 1834. Although artists did sell works locally, there was simply never enough patronage to go round. When the Norwich Society re-formed in 1827 as the Norfolk and Suffolk Institution for the

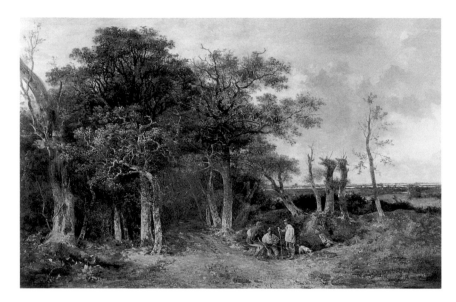

fig.1 John Crome, *The Beaters* (National Galleries of Scotland)

Promotion of the Fine Arts, it issued a circular letter soliciting support for the new body, which observed that 'scarcely a single picture' had been bought from the exhibitions during the course of its existence, and that receipts at the door had never covered expenses. Perhaps this exaggerated the lack of sales, but it was a view that Norwich artists expressed privately and which also had currency in the local press.[13] It is worth noting that the Norwich Society was unusual among provincial art institutions in being run by the artists themselves, rather than by patrons. Yet as well as being a social and intellectual club, it was also a business venture – and, in the long run, an unprofitable one.

The image in the early nineteenth-century metropolitan press was correct in its fundamental perception that Crome was both Norwich art's central personality and its leading talent. (Rivalry between Crome and Robert Ladbrooke seems to have been one cause of the schism in the Norwich Society that led to the setting up of a secession body which held exhibitions from 1816 to 1818.) To define that which is original to Crome's art, we might emulate Meyer Schapiro's famous comment on Early Impressionism and ask what was its specific mode of vision, what its 'moral aspect'. There can be no single answer to this question since despite the small number of authentic works connected with his name, Crome's art is very various. Indeed, contrary to the relentless stress on the artist's provincialism in the Norwich School tale, what is striking about his output is how very much it was engaged with the latest developments in the metropolitan exhibitions. His early works such as *The Blacksmith's Shop* (*c.*1806, Philadelphia Museum of Art), *Carrow Abbey* and *Road with Pollards* (cats.1 and 24) are precisely in tune with the efforts by innovative landscape painters – and most notably, of course, Girtin and Turner – to assimilate the painterly qualities of Wilson and Gainsborough's works, and apply them to a more naturalistic and topographical conception of what constituted a motif.

One thing that has often been said to give some kind of unity to Norwich painting is a common interest in the example of seventeenth-century Dutch painting. On his death bed,

Crome is supposed to have suddenly awoken and exclaimed: 'Oh, Hobbima, my dear Hobbima, how I have loved you!', and an 1842 Sale catalogue even referred to him as 'the Norfolk Hobbema'. But Crome's admiration for Hobbema in biographical legend was no more extreme than Constable's for Ruisdael – after all the latter's friend, John Fisher, referred to Constable's house in Keppel Street as 'Ruysdael House'. And neither was the influence of Dutch art on Crome's work any more predominant than it was on that of many contemporary painters. Crome's most obviously Dutch-inspired paintings date from around 1810, and include *The Beaters* (National Gallery of Scotland; fig.1). While this picture is clearly based on the Hobbema glade scene format, it is no closer to that model than say Callcott's *Market Day* (Tabley House, University of Manchester; fig.2) of 1807. Similarly, Crome's so-called *St Martin's Gate* (cat.6) of *c*.1812–13 recalls the cottage scenes of Adriaen van Ostade, but no more so than some near contemporary works by William Mulready, such as *Near the Mall, Kensington Gravel Pits* (1812–13, Victoria & Albert Museum).

The crucial point being that Crome was not a pasticheur, and his interest in Dutch models was partly driven by the contemporary aesthetic of naturalism, which underlay much of the most innovative landscape and genre painting of the period.[14] Although, crudely put, that aesthetic was premissed on the idea of producing an original and modern art through a revision of representational codes and an imagery of contemporary British life, precedents for such an art lay primarily in Dutch painting. However, given the commitment to empirical observation intrinsic to the aesthetic, the paradigms of Dutch naturalism were inevitably subjected to revision through outdoor sketching procedures.[15] The decade 1810–20 saw the production of some of the most original naturalistic canvases in John Linnell's *Kensington Gravel Pits* (1813, Tate Gallery), George Robert Lewis's two Hereford views of 1815 (Tate Gallery), and Constable's *View of Dedham* (Boston Museum of Fine Arts, 1815) and *Flatford Mill* (1817, Tate Gallery), all of which are partly the fruit of 'plein air' painting.

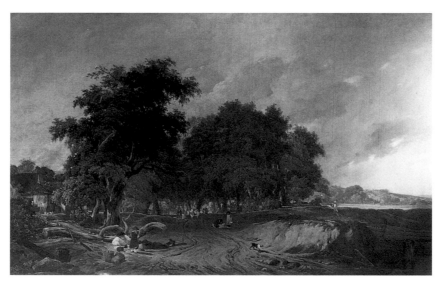

fig.2 Augustus Wall Callcott, *Market Day*
(Tabley House, Knutsford, Victoria University of Manchester)

Norwich artists were certainly affected by the new vogue for sketching in watercolour outdoors, which was particularly associated with the example of Girtin – although the practice had also been developed since the early years of the century by John and Cornelius Varley, Joshua Cristall and others in their circle. One of the latter was Cotman. Whether or not Cotman's return to Norwich in 1806 helped to stimulate Crome, Thirtle and Dixon to experiment with the watercolour sketch can only be subject for speculation, but at any rate, by around 1810 they were all doing so. In 1808, Cotman also exhibited at the Norwich Society an oil sketch made on the spot – perhaps that now in the Tate Gallery's collection. Although Crome exhibited sketches in oil and watercolour painted on the spot from 1805 onwards, he probably never painted a finished work outside, or at least it seems improbable that he did so from those that survive.[16] None the less, the colour of his work brightened considerably in the second decade, and he began to produce limpid and luminous light effects unlike anything in his paintings hitherto. *Back of the New Mills* and *Norwich River – Afternoon* (cats.8, 27) exemplify this development.

Given that the aesthetic of naturalism valorised a more topographical approach to motif, it is entirely consonant that Crome and other Norwich painters developed a common iconography of Norfolk scenery – although other factors contributed to this including the market for topographical illustration and the aesthetic valorisation of native landscapes in English nature poetry. In his 1858 essay on Crome, the local journalist John Wodderspoon noted how much Norfolk had changed since the artist's death, particularly in its rural features: the high-gabled thatched cottage had been superseded by 'the spruce model cottage', the wide rutted meandering lanes with high banks and hedgerows by straight narrow paths.[17] But this response rested partly on an illusion produced by the way some of Crome's motifs – such as *Bury Road Scene* (c.1812–14, Birmingham Museums and Art Gallery) and *Marlingford Grove* (c.1812–14, Lady Lever Art Gallery, Port Sunlight; fig.3) – were conceived within the Picturesque aesthetic. In fact, early nineteenth-century Norfolk had about the most progressive agriculture in Britain, and its farming practices were widely publicised by Arthur Young and others. (Crome's early employer, Dr Rigby, published a panegyric to Coke of Norfolk in 1817.)[18] Occasionally, indications of this improved agriculture appear in the enclosure hedges pictured in works such as Cotman's famous *Ploughed Field* (c.1808–10, Leeds City Art Gallery) or *Kett's Castle* (cat.55), but the oil paintings of the school tend to suggest more traditional modes of representing rural life.

In fact, Wodderspoon's comment reformulates a nostalgia that was already there among Norvicensians in the early nineteenth century. Thus, one of the reasons Mousehold Heath on the edge of the city seems to have been so significant to Crome, Cotman and others, was that between 1799 and 1814 this hitherto common land was largely enclosed and thus closed off as an area for recreation for the city's populace. The resentments this process produced are suggested by a letter to a local newspaper, *The Iris*, in 1803 (16 April), which recalled that the heath had formerly been 'a favourite spot', on which 'many hundreds' could be 'seen on a summer's evening engaged in their different sports and games': 'In short, it was the only place in the vicinity of the City where it was possible to retire "from the busy hum of men", without being choked with the dust of roads, and deafened with the succession of carriages.' Behind images of the expanse of apparently unenclosed

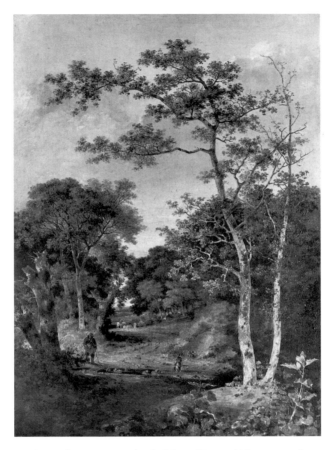

fig.3 John Crome, *Marlingford Grove* (National Museums and
Galleries on Merseyside, Lady Lever Art Gallery, Port Sunlight)

heath (cats.12, 62) lies the implied counter-image of a congested and noisy commercial
Norwich.[19]

What this indicates is that Norwich landscape painting – like landscape painting more
generally – offered an essentially urban vision.[20] But I think we can be yet more specific
about the social perspective to which it corresponded at its most distinctive. As I men-
tioned earlier, Crome came out of Norwich's artisan culture (he served an apprenticeship
to a coach and sign painter), and for all Dawson Turner's attempt to fashion a biograph-
ical legend for him as a model of middle-class propriety, he was a freemason,[21] a dissenter
and a political liberal, who probably never lost the outlook of the class from which he
came. Indeed his impressive course of self-education is typical of its aspirations. This out-
look, I believe, gave a particular inflection to his images of leisure, to figures enjoying what
appears to be *free time*. Such images appeared particularly in connection with two main
motifs: the Norwich River and Yarmouth beach.

The Norfolk river system was essential to Norwich's prosperity[22] – a fact not lost on
Norwich artists, as James Stark's important series of engravings, *The Rivers of Norfolk*
(1834) which was intended to mark the effects of the 1827 Norwich and Lowestoft Navi-
gation Bill, vividly illustrates. Crome helped to establish the iconography on which Stark

drew with views of the river below Norwich such as *Wherries on the Yare* (*c*.1810, Leeds City Art Gallery; fig.4), and his watercolours of Norwich's commercial waterfront, *Houses and Wherries on the Wensum*.[23] However, it was not these so much as his views of the river where it enters the city in the north-west in the parish of St Martin's at Oak that Wodderspoon singled out as among his 'best productions':

> Along the lazy stream which finds a devious course through that part, are many patches of picturesque gardens kept by poor men, who, to the enjoyment of their small though successful experiments in horticulture, add that of keeping boats. A boat was always a great attraction for Crome, and he has painted many such morsels of river life as these localities disclose, with rude staithes and ruder boathouses, and morsels of garden ground skirting the stream ...

Whatever misconceptions Wodderspoon may have had about the functions of the Norwich river, his observations evoke quite vividly the social realm depicted in paintings such as *Back of the New Mills* (cat.8) and *Norwich River – Afternoon* (cat.27), and suggest a continuum between the simple pleasures Crome depicts and the artist's own social perspective.[24]

These riverbank activities find a counterpart in the iconography of Crome's several views of Yarmouth beach. At a basic level, these need to be seen in relation to the numerous views of seaside resorts painted by British artists in this period, of which Constable's *The Beach at Brighton, the Chain Pier in the Distance* (1826–7, Tate Gallery) and Turner's *Brighton from the Sea* (*c*.1829, Petworth House) are only the best-known. There is an obvious connection between such images and the leisure habits of the middle class and of artists themselves, since seaside resorts were the fastest growing type of British town in the first half of the nineteenth century. Yarmouth was representative of this phenomenon, but also quite specific in that, unlike most such towns, it was not a decaying fishing village but a major port, with a flourishing fishery, shipyards, breweries and a silk mill. It thus did not have the exclusive tone of resorts like Hastings or Weymouth, and was characterised pejoratively in an 1819 guidebook as 'the Margate of Norfolk'. It is significant that Crome and the other Norwich artists should paint mainly there rather than in the far more select and distant Cromer. In one of the most important and best-preserved of Crome's Yarmouth Jetty pictures (cat.10), we are presented with images both of the fishing industry and the vista of ships which made the jetty and beach such an attractive promenade for visitors, and also with images of promenaders themselves intermingled with the busy figures of fisherfolk.

What distinguishes Crome's *Yarmouth Jetty* from the major pictures of seaside resorts exhibited in the period is its small size, the immediacy of its composition, and the sense it gives of direct involvement with ordinary social intercourse. Although other pictures also present figures in the foreground plane, they are usually just the first stage in a receding view. By keeping most of the incident in the foreground and treating distance more as background, Crome's composition highlights the quotidienne activities of the jetty and beach. It was this small scale and engagement with the ordinary that perhaps made Crome's paintings appeal to the relatively modest clientele of professionals and trades-

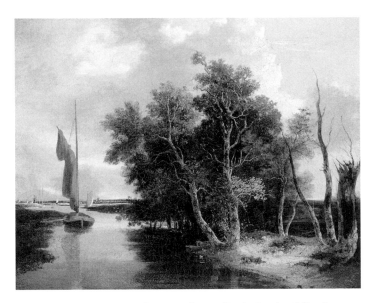

fig.4 John Crome, *Wherries on the Yare* (Leeds City Art Gallery)

people who lent the majority of works to a posthumous exhibition of his works in 1821, and for whom his intimate viewpoint may have had a special charm. It is this that distinguishes its 'moral aspect', and which marks it out not just from the more ambitious works of Constable and Turner, but also from that of his pupils.

From what we can identify of the major pictures Stark and Vincent showed in London, it is striking how much they differ from their master's, both in compositional diffuseness and their degree of engagement with the naturalist aesthetic. Thus we may compare Vincent's expansive views of the Norfolk rivers, such as the Southampton *View on the River Yare, near Norwich* (cat.106), with the tight enclosed composition of Crome's *Wherries on the Yare* in Leeds; or the former's *Fish Auction, Yarmouth Beach* and *Dutch Fair on Yarmouth Beach* (cats.103 and 102) with the latter's *Yarmouth Jetty* (cat.10) The ambience of the large exhibition room and the anonymous metropolitan audience that peopled its spaces tended to drive the ambitious landscape painter towards the production of synoptic views of general scenery, a tendency vividly represented by Vincent's *Distant View of Pevensey Bay, the Landing Place of King William the Conqueror* (cat.105), which was undoubtedly intended to present a paradigmatic image of the national landscape and the social hierarchy on which its order depended. (We can see the same logic in Constable's move from the highly particularised local landscapes he exhibited in the second decade, to the larger and more generalised views that begin with the showing of *A Scene on the River Stour*[25] in 1819.) Yet although they are evidently studio machines, there is a freshness of colour and variety of light effect about Vincent's work of the early 1820s that links it with naturalism. Some roughly contemporary pictures by Stark, such as the *Lambeth from the River, Looking Towards Westminster Bridge* (1818; Yale Center for British Art, fig.5) and *Wroxham Regatta* (1819?, Private Collection), suggest that his work had a comparable quality before he began to produce the repetitive grove scenes that were a staple of his output in the mid-1820s. Although the pictures he painted for engraving as *The Rivers of Norfolk* marked a

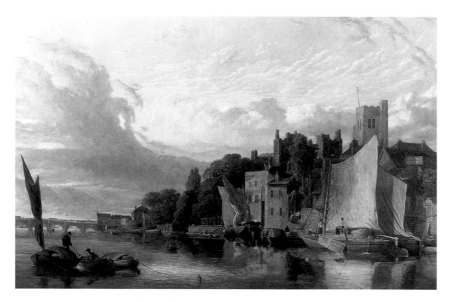

fig.5 James Stark, *Lambeth from the River, Looking Towards Westminster Bridge*
(Yale Center for British Art, Paul Mellon Collection)

return to a specific Norfolk iconography, they were in fact directed as much at the national market as the local one, and in 1830 Stark left Norwich for good, despairing at the state of patronage in the city.[26]

I am not suggesting a simple necessary connection between small-scale architectonic compositions, restricted views and an artisanal outlook, but rather that there is a concatenation of factors bearing on the output of Crome that make it appropriate to see such a social perspective embodied in some of his works. The somewhat comparable qualities which distinguish the rest of what is best and most distinctive in Norwich art – notably the watercolours of Cotman's first Norwich period and some of Thirtle's drawings – have to be explained rather differently. Cotman's output was so large and diverse that any generalisation about it is difficult, and much of it seems clearly a response to developments outside Norwich. None the less, over the years 1807–10 Cotman produced a body of outstanding watercolours that matched with the larger tendency of Norwich artists to 'perpetuate local scenes, and fix attention to their pictures by all the force of local attachment' – as the *Norwich Mercury* put it.[27] *Trowse Hythe* and *St Luke's Chapel, Norwich Cathedral, East* (cats.51 and 48) both exemplify this moment. Much of the antiquarian work Cotman did in the following decade would seek to capitalise on a more specialist strand within the same structure of feeling. Thereafter most of his output was oriented to a metropolitan market. The sequence of tightly structured views of the Norwich River that Thirtle produced *c*.1809–17 tellingly juxtaposed the city's modern commercial activities with fragments of its medieval remains. The modern is represented most unequivocally in *A View of Thorpe, with Steam Barge working up – Evening* but it is just as present in the workaday foreground of *Boat-Builder's Yard, near the Cow's Tower, Norwich* or the modern villas of *View of the River near Cow's Tower* (cats.93, 90, 89). Although the naturalist aesthetic and concern with the *associations* of familiar locality inform the work of both Cotman and Thirtle, there

is not the same intense engagement with sites of humble pleasure that we seem to find in Crome's. In the former the urban picturesque tends to be more antiquarian and the river more a working river. Such works breathe that sense of immanent change characteristic of modernity which activated so much of the most ambitious British landscape painting of the period, but which Crome's work largely evades despite the modern mill buildings that are the background to his Wensum.

The only artist of the second generation to maintain the intense engagement with local subject-matter of the first and approach it with a truly rigorous technique was Ladbrooke's pupil Joseph Stannard. The hard bright colour and finished surfaces of Stannard's work suggest that in addition to the examples of Dutch painting, he was also responsive to the work of contemporaries such as William Collins.[28] Corresponding with these developments, the genre element is stronger in his treatment of Yarmouth beach, the Yare at Thorpe, and most notably in *Thorpe Water Frolic* (cat.109) than it had been in Crome's. It seems appropriate to conclude with the last of these, not only because it is one of the most ambitious paintings that has a specifically Norfolk iconography, but also because it may stand as something of an epitaph on the moment in the city's history that saw its artistic flowering.

Water frolics and regattas were a major feature of Norfolk leisure life in the summer months, and provided the themes for a trio of major pictures by J.B. Crome (cat.30), Stannard and Stark.[29] A number of Norwich artists were keen sailors, including Crome, Cotman and Stannard, but beyond any such personal involvements, what made the theme so attractive was its capacity to function as an image of harmonious relations between different social classes. This is particularly the case with Stannard's picture, which was probably painted for Lieutenant Colonel John Harvey, a Norwich cloth merchant and manufacturer, who initiated the Thorpe Frolic in 1821 on a stretch of the river that ran through this fashionable suburb to the east of the city. Harvey opened the occasion as an entertainment to the labouring population, and by 1824 it had become a public holiday for much of the urban workforce. Stannard's painting mirrors the social character of the event by keeping fashionable society to the left of the composition, adjacent to the grounds of Harvey's home, Thorpe Lodge, while the plebeian element is restricted to a narrower space on the right, in actuality next to the meadows of the south bank. Harvey himself – the figure with white hair standing under the trees – is made the hub of the scenario he had orchestrated. A major player in the Norwich corporation and the police of the county, he liked to pose as 'the weaver's friend'. But such an image of genial paternalism must very quickly have appeared incongruous. In December 1827 Harvey himself wrote to the Home Secretary protesting plans to disband the East Norfolk Yeomanry Cavalry which he commanded, and insisting on its crucial role in the protection of property in a manufacturing district dependent on the textiles trade.

In the year after *Thorpe Water Frolic* was exhibited in Norwich, the Norwich Society of Artists ceased exhibitions for two years when its rooms were demolished to make way for a new corn exchange. Although the reconstituted society managed to resume them from 1828 to 1833, in 1834 it announced that the dirth of patronage in the city made it impossible for it to meet the obligations on its exhibition rooms.[30] Later Norwich art exhibitions

were not run by the artists themselves. Not coincidentally, in 1826 the Norwich textiles industry plunged into a deep recession from which it never fully recovered, and the increasing immiseration of the weavers led to personal attacks on manufacturers and to major disturbances in 1830. The industry's relatively poor competitiveness by comparison with its northern rivals made it increasingly vulnerable in periods of national recession, and the fortunes of other Norwich industries were interlocked with it in some degree. The condition of the city's workforce in the 1830s can be gauged from the appeal Chartism had there at the end of the decade.[31] Perceptions of the city's decline (although in the long term unfounded) were widespread to judge from the local papers, and one symptom of this was discovered in a falling-off in the amusements of Assize Week, of which the Norwich Society exhibitions had been a feature.

Norwich's economy did not in itself bring forth the efflorescene of art there in the early nineteenth century, but the artistic community that focused on the Norwich Society was interlocked with a particular phase in the history of the city's manufactures. Always a fragile plant, this artistic culture could not survive the economic and social changes of the 1830s in any significant form. Which is not to say that some artists of talent did not work in the city thereafter, but they were relatively few and there was no institutional formation to keep them together. When a real School of Design was established in Norwich by the corporation in 1845, it was intended to generate skills among the workforce that would increase the competitiveness of Norwich manufacturers.[32] In the early part of the century, artists had looked to the manufacturers to support a culture of the Fine Arts.

1 The arguments of this section are developed in greater detail in my article: 'Cultural Philanthropy and the Invention of the Norwich School', *Oxford Art Journal*, vol.11, no.2 (1988), pp.17–39. For a modern account, see: Andrew W. Moore, *The Norwich School of Artists* (Norwich: 1985).

2 See Miklos Rajnai, with Mary Stevens, *The Norwich Society of Artists, 1805–33: A Dictionary of Contributors and their Work* (Norwich: 1976).

3 'Memoir of the late Mr. John Crome of Norwich', *Magazine of Fine Arts*, vol.1, no.5, pp.381–2.

4 T. Thoré, *Salons de W. Bürger, 1861 à 1868* (Paris: 1870), p.357.

5 For example, see Richard & Samuel Redgrave's authoritative *A Century of British Painters* (1866; London 1957) chapter 25.

6 'The Old Masters Exhibition', *The Builder*, 12 January 1878.

7 See Trevor Fawcett, *The Rise of English Provincial Art: Artists, Patrons, and Institutions Outside London, 1800–1830* (Oxford: 1974).

8 J.K. Edwards, 'The Economic Development of Norwich, 1780–1950, with Special Reference to the Worsted Industry', PhD thesis, University of Leeds, 1963; P.J. Corfield, 'The Social and Economic History of Norwich, 1650–1850: A Study in Urban Growth', PhD thesis, University of London, 1976.

9 J.K. Edwards, 'Norwich in the Eighteenth Century: A Study in Social and Economic Organization' (Manuscript in Local Studies Library, Norwich, 1972), p.165.

10 His pupils Stark and Vincent were the sons of a dyer and a weaver and shawl manufacturer, respectively,

11 For contrasting overviews of Norwich culture in the period, see: Trevor Fawcett, 'The Culture of Late Georgian Norwich: A Conflict of Evidence', *UEA Bulletin*, vol.4, no.4, March 1972, pp.1–10; Philip Mosley, 'Much Ado About Norwich?', *UEA Bulletin*, vol.5, no.5, June 1973, pp.38–46.

12 For another source of income, see Trevor Fawcett, 'Patriotic Transparencies in Norwich, 1798–1814', *Norfolk Archaeology*, vol.34, 1969.

13 David Hodgson, Secretary, Circular Letter for the Norfolk and Suffolk Institution for the Promotion of the Fine Arts, 1827. Cf. James Stark's extended plea for patronage in a contemporary address on behalf of the institution: 'Of the Moral & Political Influence of the Fine Arts' (Bolingbroke Manuscript, Norwich Castle Museum). Complaints about lack of patronage go back to the *Norwich Mercury's* exhibition review of 20 August 1808.

14 On which, see Andrew Hemingway, *Landscape Imagery and Urban Culture in Early Nineteenth-Century Britain* (Cambridge: 1992), pp.15–28.

15 The key statement calling for this is Henry Richter's *Daylight: A Recent Discovery in the Art of Painting* (London: 1817).

16 Having said this, when *Boulevard des Italiens* was exhibited in Norwich in 1860 a correspondent to the *Norwich Mercury* reported: 'I remember seeing him [i.e. Crome] at work on it, and I believe that the greater part was painted on the spot in the early summer of 1814.' ('The Exhibition', 15 September 1860).

17 John Wodderspoon, *John Crome and his Works* (1858; 2nd edn Norwich 1876), p.16.

18 Edward Rigby, *Holkham, Its Agriculture &c.* (Norwich: 1817).

19 On this issue, see Andrew Hemingway, 'Meaning in Cotman's Norfolk Subjects', *Art History*, vol.7, no.1, March 1984, pp.64–6. Trevor Fawcett describes the enclosure of Mousehold and argues that it is correspondingly significant Crome should represent it unenclosed in the Tate's picture (cat.26) in his important article 'John Crome and the Idea of Mousehold', *Norfolk Archaeology*, vol.37, part 2, 1982, pp.168–81.

20 The most incisive discussion of this dynamic is Nicholas Green's *The Spectacle of Nature: Landscape and Urban Culture in Nineteenth-Century France* (Manchester: 1990).

21 As were J.B. Crome and Cotman.

22 J.K. Edwards, 'Communications and the Economic Development of Norwich 1750–1850', *Journal of Transport History*, no.7, 1965, pp.96–108. Maintenance of the rivers was a continuing concern of city government – see Edwards, 'Norwich in the Eighteenth Century'.

23 Of which there are two versions, in the Manchester City Art Gallery and Whitworth Art Gallery, University of Manchester, respectively. On the distinctive Norfolk wherry, see R. Clark, *Black-Sailed Traders* (London: 1961).

24 A similar realm is the subject of *The Wensum, Norwich* and *Scene on the River at Norwich*, both in the Yale Center for British Art, New Haven, Conn. *Norwich River – Afternoon* was very probably the picture singled out in the *Norfolk Chronicle's* exhibition review of 14 August 1819 as exemplary of the artist's abilities.

25 Now known as *The White Horse* (Frick Collection, New York).

26 James Stark to Richard Mackenzie Bacon, 13 February 1830 and 19 December 1831, in 'Autograph Letters from the Collection of R.M. Bacon', Cambridge University Library, MS 6246.61. By contrast with what we may surmize from Crome's attitude from his Norwich river pictures, Stark was of the view that :[t]here is but little in the city, or its immediate vicinity, to interest the painter' – see William Wilkie Collins, *Memoirs of the Life of William Collins* (London: 1848), p.75.

27 'The Amusements of the Assize Week', *Norwich Mercury*, 17 August 1816.

28 Collins visited Norwich in 1815 and stayed with Stark's family, and in the following year showed *Shrimp Boys – Cromer* at the Royal Academy.

29 See Hemingway, *Landscape Imagery and Urban Culture*, pp.277–90.; Trevor Fawcett, 'Thorpe Water Frolic', *Norfolk Archaeology*, vol.36, part 4, 1977, pp.393–8.

30 'Norwich Exhibition', *Norwich Mercury*, 26 July 1834.

31 J.K. Edwards, 'Chartism in Norwich', *Yorkshire Bulletin of Economic and Social Research*, 19, 1967, pp.85–100.

32 Marjorie Allthorpe-Guyton & John Stevens, *A Happy Eye: A School of Art in Norwich, 1845–1982* (Norwich: 1982).

NATIONALISING NORWICH:
THE 'SCHOOL' IN A WIDER CONTEXT

David Blayney Brown

'There is but little in the city, or its immediate vicinity, to interest the painter.'

James Stark on a visit home to his family in Norwich, 1815

'... intelligent men are of more service to each other in a provincial place than in London. The sharpness of the air or some other quality of this place, certainly tends to give a stimulus to the people, surpassing the inhabitants of any locality I ever was in before.'

William Collins in a letter to his family from Norwich, 1815

'If you wish to be an artist you *must* leave Norwich, for nothing can be done for you there. Give up Norwich and all its little associations ...'

John Sell Cotman to his son John Joseph

Such were the mixed impressions that Norwich could make on native and visiting artists at the height of its so-called 'School'. They have been chosen for their bias, but should be kept in mind as we examine the 'Norwich School' in the larger national perspective. Both Stark and Cotman were at various times among the leaders of the 'School', but had at best an ambivalent relationship with Norwich and lived away from it for long periods. Though Norwich-born, Stark prospered in London, and in 1827 could be heard complaining that in Norwich 'patronage is and ever has been *unknown*'.[1] While the intellectual vigour noticed by Collins had produced an exhibiting society of artists in the first place and eased Cotman's return from London in 1806, he never ceased to feel the pull of the capital; and when he finally moved back, it was to experience a wholly new sense of professional pride and self-worth: 'Much as I have ever loved London', he told his wife, ' I have never trod its gold paved streets feeling so much a man of business, and so much to belong to it as now.'[2]

The upsurge of art in Norwich at the end of the eighteenth century owed much to the presence of London artists, notably the portraitists William Beechey and John Opie, in the city in the 1780s and 1790s, but young aspirants like Cotman, Stark, Vincent, Clover or Thirtle and even, one suspects, briefly, Crome, were as likely to follow them to the capital as to commit themselves to Norwich. And when the Norwich Society was formed in 1803, its proud provincialism soon stood in contrast to the outward-looking sophistication of its leading members – Cotman above all. While, unlike exhibiting societies elsewhere, the Society never tried to attract support from London or other provincial centres, and mainly showed London residents only if they were natives of Norwich, its members sent pictures to other cities, and when they sought to compete with their metropolitan peers, it was in

the Royal Academy or the British Institution. London also provided access to a new generation of patrons more sympathetic to 'Norwich' art, than Norwich itself, where by the 1820s Cotman found press criticism as adverse as Stark found patronage lacking. Vincent, even more than Stark, pitched his work at a London audience, while Stannard, though based in Norwich, was never formally a member of the Society, and preferred to show in the capital. As for earlier supporters of artists in Norfolk, the two greatest of these, Thomas Harvey of Catton and Dawson Turner of Yarmouth – the one of prime importance for Crome, the latter for Cotman – exerted a kind of double pull on their protégés, encouraging them to stay in their home county while widening their interests far beyond it.

Crome's relationship with Harvey was fundamental to his career and to the development of painting in Norwich.[3] By the close in 1790 of his apprenticeship to a coach and sign painter, Crome had begun painting and drawing, encouraged by a firm of Norwich print-sellers, Messrs Smith and Jagger, on whose premises he perhaps met Harvey. A wealthy master-weaver from a family of merchants and bankers, Harvey was a collector of Old Masters, an amateur artist, and a close friend of Opie, Beechey and other painters including Gainsborough. Much has been made of Harvey's getting Crome to copy his Gainsborough, *The Cottage Door* (Huntington Library), as a prime source for Crome's love of the Picturesque, of woodland scenery, and of the Dutch tradition on which these depended. Certainly Harvey, to whom the dying Gainsborough had written fondly of his 'early imitations of little Dutch Landskips'[4], may have recommended the same practice to Crome and offered pictures in his own collection as examples.[5] But like his Norwich neighbour John Patteson, Harvey also employed an agent in Rome, the painter Jacob More.[6] Besides supplying, copying or restoring Old Masters, More sent his patron examples of his own Italian scenes, three of which were probably among the works by the artist included in Crome's sale in Norwich in 1821. Harvey may have held out to Crome the model of More as artist/tradesman/dealer, with the difference that he remained close at hand. With an influx of pictures from Continental collections coming on to the English market after the French Revolution, logic might have suggested that Crome should base himself in London, the main source of supply. But it doubtless suited Harvey to have Crome nearby, and there were substantial collectors in Norfolk and a market to be exploited.

It was Beechey, an 'intimate' of Harvey and a fellow-connoisseur, who provided Crome's practical and technical training. Later accounts of Crome as 'a poor lad who laid the foundation of his celebrity in cleaning brushes for Beechey'[7] must refer to Beechey's period in Norwich, 1782–7, but additional remarks about Crome's development 'when he returned to his native city' imply that he also followed him to London, and this is confirmed by Beechey's own recollections that 'His visits were very frequent, and all his time was spent in my painting room when I was not particularly engaged ... He always dined and spent his evenings with me.'[8] With a fashionable portrait practice in the capital and much royal patronage, and in 1806 a candidate for the Presidency of the Royal Academy, Beechey was a friend at the heart of London art life. Opie, for his part, was already well known in the capital when he visited Norwich in 1797 and met his future wife, Amelia Alderson, the daughter of one of the city's physicians. While Opie dismissed Beechey's portraits as 'only fit for sea Captains and merchants',[9] he seems to have taken to his young friend Crome,

whom Amelia first met at Catton in 1798, and whose portrait he painted a couple of years later (NCM).

As the Academy's Professor of Painting, Opie held out the direst prospects to the student: 'he may pine in indigence, or skulk through life as a drawing master or pattern drawer to young ladies'[10] – exactly Cotman's lot, as it turned out, and Crome's too, by the time Opie's portrait was painted. But unlike Cotman, Crome did not yet see himself as more than an occasional painter; and he was content enough with Harvey's encouragement and employment from some of his earliest and most important pupils, the Gurneys of Earlham. John Gurney, a prominent Quaker banker in Norwich, never seems to have bought a picture from Crome, but his cousin Hudson, of the Keswick branch of the family, was to be a collector of his work (see cats.28 and 29). As they did also for Cotman, the Gurneys joined Harvey in broadening Crome's horizons – literally so when, in 1802, John Gurney took him on a tour of the Lakes and, probably, reported on his cousin's visit to Paris and the Musée Napoléon the same year. To these Crome had added by the close of the century Dawson Turner, the wealthy partner in the Gurney bank at Yarmouth who became his chief employer, a substantial collector of his pictures, and the main contemporary source for his life and art. As patron and mentor, Turner took over from Harvey, 'for whom', as he declared, 'I entertained a sincere regard'[11] and a group of whose pictures he bought for his own large collection of Old Masters. Besides pictures and books, he collected people, their opinions and autographs, and those who came within his orbit found themselves at the centre of a nationwide web of acquaintances and exchanged ideas. The support of such provincial *haute bourgeoisie*, lacking nothing in sophistication, doubtless compensated for the ruthlessly competitive free market of London.

Moreover, with Beechey among the Academicians who, in 1799, proposed the expulsion of the Professor of Painting, James Barry, on grounds of alleged republicanism, Crome may have known enough of London artists' politics to steer well clear of them, coming as he did from a city renowned for its Jacobin spirit. But of London's wider allure – of fame and patronage – he had probably reached for himself the sort of conclusion that his new friend Teresa Cholmeley urged on Cotman in 1806, that 'the patronage of ye rich and powerful is very rarely so advantageous as it ought to be'.[12] Mrs Cholmeley advised Cotman not to expect too much of a forthcoming visit to the Marquess of Stafford, a celebrated collector and a founder of the British Institution, and instead to cherish Dawson Turner's less prestigious but more reliable support. Ironically Cotman and Crome were to find themselves rivals for Turner's attention, and when Cotman returned to Norfolk he would find just how effectively Crome had cornered the market as a drawing master.

Cotman's own ambitions had been set much higher. He moved to London in 1798, found a job with the print publisher and dealer Rudolph Ackermann, and within a year was working in the evening 'Academy' of the collector and amateur Dr Thomas Monro, just as J.M.W. Turner and Thomas Girtin had a few years earlier. He seems also to have been invited to the artistic gatherings at Monro's country home at Fetcham, and an oblique remark in Farington's diary late in 1799, that the doctor was 'bringing on' a young artist from Norwich, is assumed to refer to him.[13] So, perhaps, does a novel by Jane Porter, *Thaddeus of Warsaw*, an almost definitively romantic account of a young artist's struggles

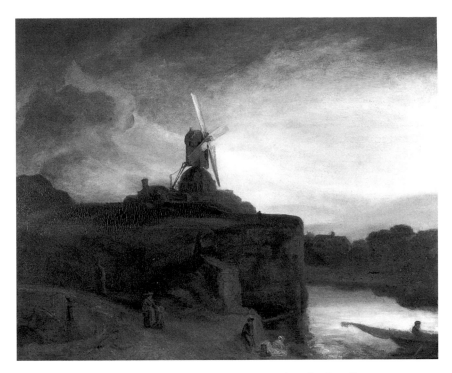

fig.6 Attributed to John Crome, after Rembrandt, *The Mill*
(Norfolk Museums Service)

in the big city. In fact the hero's tribulations are greater than Cotman's and his identity must owe as much to the Polish patriot, Tadeusz Kosciusko, in exile in London in 1797 and a keen landscape draughtsman. But the kindly book dealer who helps Thaddeus may well be Cotman's first real London friend, Peter Norton of Soho Square, and Jane Porter was the sister of Robert Ker Porter, a fellow member with Cotman of the Sketching Society formed by Girtin in 1799. Cotman's membership, and his election as its President in 1802, reflects his ready assimilation into the London art world (see cat.36). In 1800, he had sent his first exhibits to the Royal Academy and had won – like J.M.W. Turner in 1793 – the greater silver palette from the Society of Arts, for a drawing of a mill, perhaps a graceful gesture to the current MP for Norwich, William Smith, a distinguished collector whose most famous picture was *The Mill* ascribed to Rembrandt (National Gallery, Washington), which he had bought from the Orleans Collection. Smith was apparently a patron of both Opie and Cotman, while Crome too may have had access to *The Mill*, if the old attribution to him of a free copy (NCM; fig.6) is correct; Smith probably took a longstanding interest in artists from his constituency. A probable visit with Girtin to Sir George Beaumont's party at Benarth near Conway during a Welsh tour in 1800 would be further evidence of Cotman's growing reputation with the connoisseurs. It may be no accident that at John Constable's sale in 1838 he bought prints after Sebastien Bourdon, an Old Master whom Beaumont especially admired.

From his London base, Cotman's subject-matter and interests were widening greatly. Another member of the Sketching Society, Paul Sandby Munn, was his companion on a tour of Yorkshire in 1803. It was then that Cotman stayed for the first time with the

Cholmeleys at Brandsby, introduced by Mrs Cholmeley's brother, Sir Henry Englefield. It had perhaps been Monro who introduced Cotman to this sensitive antiquary and collector, to whom Cotman's first venture as a printmaker, *Miscellaneous Etchings* (1811), was dedicated. It included in its list of subscribers a roll call of his early associates and supporters – not only fellow artists, Munn, the Varleys and F.L.T. Francia among the Londoners, Crome, Thirtle and Ladbrooke in Norwich, but also the nobility and gentry whose acquaintance he must have owed largely to the baronet and his Cholmeley relatives. Among them were the classical scholar John Bacon Sawrey Morritt of Rokeby Park, where he was taken in 1805 and made some of his finest watercolours (cat. 39 ff.), Lady Carlisle of Castle Howard, and her brother, Stafford. 'I fancy a long line of patrons', Cotman told Francis Cholmeley,[14] and these were brilliant feathers in his cap. Their society, collections and libraries polished him, much as the new landscapes of their parks and estates liberated his art.

Cotman certainly did not appear among them as a backward provincial. Teresa Cholmeley thought him '*maniere'd* and gentlemanlike',[15] while as early as 1802 the Scottish miniaturist Andrew Robertson had listed him with Turner and Girtin as one of the three most innovative watercolourists in London. Girtin's breadth, abstraction and sombre palette, refined by a classic simplicity, are the foundations for Cotman's best early watercolours, while Cotman's fascination for Turner is evident from his surreptitious pencil copies of some of his most celebrated early works, including the 1801 *Bridgewater Sea-Piece* (private collection; on loan to the National Gallery) which, from 1803, belonged to Stafford, and the large watercolour, *The Passage of Mont St Gothard, taken from the Centre of the Teufels Bruch* (Abbot Hall), which he must have seen in 1804, at the opening exhibition of Turner's Gallery.

When, in 1804, the Society of Painters in Water-Colours was formed in London, Cotman naturally sought his rightful place in it, but reversal lay in store. Perhaps the striking originality of his Greta watercolours, exhibited at the Academy in 1806, intimidated his colleagues, but the technicality on which he was denied membership that year – and until 1825 – seems to have been connected with his supposed moral character.[16] In what still appears tantamount to professional suicide he quit London and returned to Norwich. But at least the Norwich Society offered unparalleled opportunities for exhibiting his work, and he became Vice-President in 1810 and President the following year. He had high hopes of the drawing and painting school that he established in the city; he found a wife; and money went further. His familiarity with a grand circle in the north had raised his expectations, and after a visit to London in 1811 – when the watercolour exhibition sold badly and artists were 'in despair' – he wrote to Francis Cholmeley: 'Look at all the first landscape professors, how do they live? In filth and dirt to me comfortless.'[17]

To his new associates back in Norwich, Cotman must have seemed from another planet. But it must not be supposed that Crome, by remaining in the city, appeared a bumpkin by comparison. From 1805, his exhibits at the Society included, besides Norfolk subjects, views of such established Picturesque territory as Goodrich, Chepstow, Tintern and the Lakes, and views of gentleman's seats well beyond the county. In London meanwhile, Cotman's rejection by the Water-Colour Society in 1806 had coincided with the first

recorded notice of Crome as an exhibitor at the Academy – in Farington's diary and not yet in a published journal, although it was two journalists, John Taylor of the *Sun* and James Boaden of the *Oracle*, whose opinions he quoted.

They were not favourable. Having rubbished Turner's *Falls of the Rhine at Schaffhausen* (Museum of Fine Arts, Boston) – 'Madness' – Boaden turned to an upright landscape by Crome: 'There is another in the new manner ... it is the scribbling of painting. – So much of the *trowel* – so mortary – surely a little more finishing might be born?'[18] The identity of Crome's two landscapes shown that year is unconfirmed, but if we take *Carrow Abbey* (cat.1), certainly hung at the Norwich Society in 1805, and the roughly contemporary *Slate Quarries* (cat.2) as indications of Crome's style at this time – with allowances nevertheless for their subsequent deterioration – it is easy to see what the critics meant. Though they damned Crome's London exhibit as incompetent, they did at least acknowledge its modernity, and it is significant that Boaden recognised it as part of a movement including, if not led by, Turner. As with Turner, the ultimate source is Richard Wilson, and Crome can be counted as another product of the Wilson revival that took place in the 1790s. But the abstracting principle of the Carrow composition seems still closer to Girtin, whose work Crome must have known from exhibitions, through Opie – who painted Girtin's portrait around the time he painted Crome's – and from Cotman. The same influences – Wilson's and Girtin's breadth and Turner's expressive handling – lie behind *Slate Quarries*; the bravura streaks of cool colour laid across the stony foreground or shrouding the mountain in cloud are those of Turner's waves or the foam of the Schaffhausen falls. The palette and handling that were now earning Turner the sobriquet of 'white painter', in Sir George Beaumont's phrase, had also been taken up by Crome.

Clearly Crome's development as an oil painter – no less than Cotman's – took place in full knowledge of the latest developments in art and taste. The artist who, in Paris in 1814, announced his intention of calling on Jacques-Louis David would hardly have been backward in investigating London painters, and among them Turner was pre-eminent. It is usually supposed to have been in 1818 that Crome, in Dawson Turner's words, returned to Norfolk from the Academy exhibition 'with his whole soul full of admiration at the effects of light and shade, and brilliant colour, and poetical feeling, and grandeur of composition, displayed in Turner's landscapes',[19] since that May Dawson Turner applied to bring his wife and friends to his namesake's studio. Turner's *Dort*, shown that year (Yale Center for British Art, New Haven, fig.7) certainly justifies this description, but the pictures he asked Turner to quote prices for, *Frosty Morning* (fig.8) and *Crossing the Brook* (Tate Gallery), were ones that Crome could have seen in 1813 and 1815, or at any time since in Turner's Gallery or studio, and the truth is that his encounters with colleagues' work are as difficult to date as his own. We would, for example, need to know more about when Crome painted his atmospheric *Mousehold Heath* (cat.26), with its foreground frieze of thistles and burdocks, and when he had access to *Frosty Morning*, before we could confirm the connection between the two pictures that their common features seem to suggest. In fact, *Mousehold* is usually dated c.1818–20, so could tie in with Dawson Turner's enquiries about *Frosty Morning*. But Crome's *Blacksmith's Shop, Hingham* (see cat.4) shown at the Academy in 1808, was perhaps already a response to Turner – to the evident competition the previous

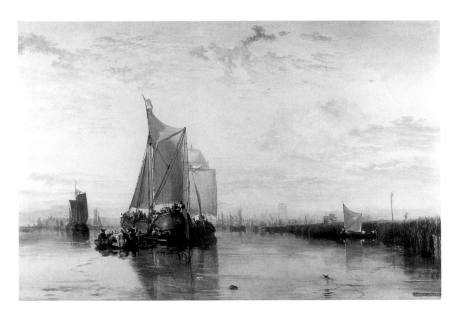

fig.7 J.M.W. Turner, *Dort or Dordrecht. The Dort Packet-Boat From Rotterdam Becalmed*
exh.1818 (Yale Center for British Art, Paul Mellon Collection)

year between Turner's *Country Blacksmith disputing upon the Price of Iron* and *The Blind Fiddler* by David Wilkie (both Tate Gallery) in the new field of rustic genre. Crome's interest in Wilkie is clear from his ownership of subscription impressions of his early pictures, including the *Fiddler*. But with Turner he had mutual connections.

When in 1809 Crome's Academy exhibits received what seems to be their first, and favourable, notice in a London paper, the *Beau Monde*, one of the artists who hung the exhibition was Thomas Phillips, close to Turner since 1803, an intimate of Dawson Turner and, like Beechey, a regular visitor to Turner's patron Lord Egremont at Petworth. Another likely link is Turner's friend the architect John Soane, a member of the Norwich Society, who kept a house in the city and had a number of Norfolk patrons; Crome was to buy part of the collection assembled by one of them, John Patteson, in 1819. And a third, indirectly, is another of Dawson Turner's friends, his Yarmouth rival as a collector, Thomas Penrice. Also in 1809, Penrice's London adviser, the painter Thomas Lawrence, recommended that he set an example of 'patronage of living artists' by buying *Near the Thames Lock, Windsor* from Turner's Gallery. Penrice declined and the picture went to Petworth, but it was surely discussed at Yarmouth with the two leading artists there to hand, Crome and Cotman. And of course it was Cotman himself who was the most informed Turner admirer in Crome's immediate circle. Was it to give a second opinion on the *Windsor* that Cotman visited the same exhibition in Turner's Gallery, and made a drawing of another picture, *Harvest Dinner, Kingston Bank* (Tate Gallery)? He had also been, since 1807, a subscriber to Turner's series of landscape prints, the *Liber Studiorum*.

In 1811, following visits to London, Cotman gave his current opinion of Turner to Francis Cholmeley: 'as usual fine in his pictures, his drawings the compleat opposite of his oils, the latt(e)r pure and silvery, the former yellow and brown, false coloured, as if 'twas done as a foil to painting, which is now getting much in fashion, thanks to good taste.'[20] His admi-

fig.8 J.M.W. Turner, *Frosty Morning* exh.1813
(Tate Gallery)

ration for the luminosity and atmospheric abstraction then being seen in Turner's English pastoral subjects was certainly shared by Crome who, according to Dawson Turner, 'on some occasions even infused into his painting a portion of the magic light of J M W Turner'.[21] Dawson Turner's own verdict on Turner, doubtless influenced by both Crome and Cotman, was of an artist ahead of his time, whose pictures 'will not fail to be acknowledged; though possibly, not till the hand that gave them birth shall be cold'.[22] In that future process, he felt he played a part, by publishing his own and Crome's 'soul-filling' admiration in his book *Outlines in Lithography*, as part of a larger hymn to the British School; he was careful to send a copy to Turner, receiving a grateful letter in reply. His text is not, however, specific as to when and how Crome assimilated his namesake's 'magic light'; nor does it discuss his involvement with other contemporary artists.

Turner aside, the view from Yarmouth was that Crome was largely influenced by the Old Masters, in effect a painter of pastiche. This is sometimes true, as can be seen from the proximity of the (probably) quite early *Yare at Thorpe* (cat.3) to Salomon van Ruysdael or Jan van Goyen. And his etchings (cat.12 ff.), fine as they are, are imitations of earlier masters – but it is worth remembering that Crome did not publish them, and the fact that many were made in Dawson Turner's house doubtless inclined him to attach a disproportionate importance to them when judging Crome's art. In fact Dawson Turner's assessment is as revealing of himself as of his subject. His organising mind was most comfortable when it could relate to precedent. Hence his emphasis on Crome's copying of Gainsborough, as a task that 'improved his taste, and ... corrected his style',[23] on Crome's alleged passion for Hobbema, or his comparison of his own *Moonrise on the Yare* (cat.5) to Aert van der Neer. That Crome was capable of highly original and sensitive synthesis of artists past and present does not seem to have occurred to him, though he must himself have contributed to the education that made this possible. In fact, Turner's influence was mingled

with that of other artists, much as his own work was eclectic in its sources. Thus just as Cuyp had made his own strong contribution to Turner's 'magic light', so too his characteristic luminosity and pink-edged clouds join Turner's atmospherically diffused architecture in Crome's New Mills or St Martin's Gate pictures (cats.7, 8 and 6), appear above the Poringland Oak (cat.25), and are seen to glorious effect in the most Turnerian of all Crome's pictures, *Mousehold Heath* (cat.26).

Likewise, Turner and the Dutch masters lie behind Crome's coast scenes, reaching a climax in the 1820 *Fishmarket at Boulogne* (cat.29), and probably also in the large Kenwood *Water Frolic* (cat.30), now thought to have been begun by him and finished by his son John Berney for exhibition in 1821. Not the least of the lessons to be drawn from this picture (and see also cat.31) is that John Berney was in his youth a precociously talented painter in his own right, with a crisper touch distinct from his father's. But all these pictures serve to introduce another contemporary whose marines and landscapes often seem uncannily close to the Cromes and who was himself a passionate admirer of both Cuyp and Turner – Augustus Callcott. In fact, for proof of how little Crome's art really has to do with Norwich and how close it is to current metropolitan trends, one has only to look at what Callcott was doing in London – and being handsomely paid for. It had been Callcott's large tranquil marine of 1815, *The Pool of London* (Bowood, fig.9), itself an updating of Cuyp's great *Passage Boat* (Royal Collection) bought by the Prince of Wales in 1814, that had been the spur to Turner's *Dort*. Callcott had made his name with coast scenes, wooded landscapes and rustic scenes in a vein of Picturesque naturalism as early as 1805, and was much spoken of as Turner's chief rival; it would have been natural to seek out his pictures in the exhibitions. But there were opportunities for personal contact too.

By 1805, Callcott was one of Opie's closest professional friends and his constant evening companion. From a radical artisan family, he had strong links to the Corresponding Society, whose London branch had many regional contacts. And through his uncle, a famous glee composer, he had one special connection with Norwich, the musician, amateur artist and printmaker Dr William Crotch, who had moved first to Oxford, then to London to follow a fashionable career. Crome sold a set of prints by Crotch in Norwich in 1812, so clearly he knew him by then. Certainly Crotch was already an intimate friend of the Callcott family, so much so that he later took a house adjoining theirs in Kensington Gravel Pits, and he may have been the main link to an artistic circle in Kensington that included not only Callcott, but also William Mulready, John Linnell, William Collins, William Henry Hunt and from time to time the Varleys – just the circle, in fact, in which Crome's own recipe of Picturesque naturalism, outdoor sketching and rustic genre was being given a new and sharper flavour (fig.2).[24]

At this point circles begin to overlap suggestively. When Collins took up marine painting, motivated partly by the scenery of Cromer, which he saw when his friend Stark – fed up with Norwich itself – took him to the town, it was in a style distinctly influenced by Callcott. It was close, also, to that of R.P. Bonington, whose own *Fishmarket near Boulogne* (Yale Center for British Art) Collins saw in Paris in 1824, and whom Callcott greatly admired. Collins, Callcott and Bonington all won success in the 1820s for marine and beach scenes of a type anticipated by Crome's own *Boulogne*, and thus sealed with

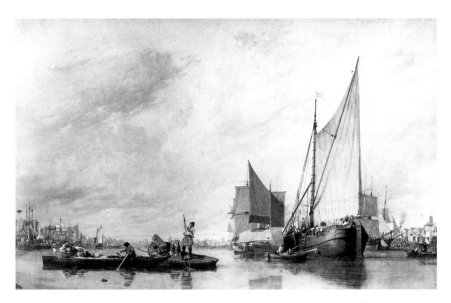

fig.9 Augustus Wall Callcott, *Entrance to the Pool of London* exh.1816
(With the consent of the Trustees of the Bowood Collection)

approval, this brightly lit and meticulously finished style communicated itself back to Stannard in Norwich (cats.109, 110). Besides the local example of the Cromes' *Water Frolic*, Callcott's *Pool* and other tranquil marines, as well as large casts of characters seen in the work of Collins's close friend Wilkie, surely contribute to Stannard's masterpiece, the *Thorpe Water Frolic* of 1824 (cat.109). Stannard's *Yare at Bramerton* (cat.110), a working river landscape, has the intensity and clarity of early landscapes by Linnell, Varley's pupil, and it is surely no coincidence that Stannard, also a brilliant etcher, taught the medium to E.T. Daniell, a local amateur who while still up at Oxford became the patron of Linnell and William Blake, and, later, of Turner.[25] Mulready, with whom Collins shared the newly fashionable brand of narrative genre, was also a student of Picturesque cottage architecture, of which he exhibited small paintings from nature very similar to others by Cotman, who knew Mulready well from the time when they were both members of the Sketching Society. Clover's outdoor sketching of vernacular, forgotten corners may also be a Norwich echo of Kensington (cat.100).

However speculative, these connections are worth stating to show how far Norwich artists were bound up in the wider artistic life of London, and how many of its interests they shared. Before Cotman's return to the capital, in 1834, the closest links between Norwich and London were Stark and Vincent, who lived there for many years. Both were pupils of Crome – the former his favourite – and one wonders what was his role in their decision to move to the metropolis. Besides winning great success with patrons including Stafford, Stark prepared his *Rivers of Norfolk* (1824–34), for London friends who were also friends of Cotman, the engravers George and W.J. Cooke, and for Turner's publishers, Messrs Moon, Boys and Graves, and appeared in the Norwich exhibitions as a visitor, 'so much known and extolled in the great metropolitan marts of talent' that the *Mercury*, in 1825, felt it could add little by its praise.[26] A similar glamour attached to Vincent, who fol-

lowed Stark to London and became his – and Collins's – neighbour in the old artists' quarter of Newman Street. But in his case the acclaim received for grand and historically allusive pictures like the *Dutch Fair* (cat.102) or *Distant View of Pevensey Bay* (cat.105) was attended by hubris, for in 1824 an extravagant London life caught up with him and until February 1827 he lived in the Fleet, the debtor's prison.

To Cotman, ever ambitious but financially precarious, Vincent must have presented an alarming example. Since returning to Norwich he had broadened his income base by establishing his school, taking up oil painting and printmaking. It was likewise in the hope of financial security that he lived from 1812 until 1823 at Yarmouth as the protégé of Dawson Turner. But this was not altogether a period of provincial exile. It was Cotman's own decision to take up antiquarian subjects and a graphic career, and it owed much to the wider circles in which he had moved since his London days, to men like the publisher John Britton for whom he had done some early work, or patrons like Englefield to whom he first broached his ambition to become England's Piranesi.[27] Thus he hoped to retrieve the national reputation he had felt snatched from him by his earlier rejection by the Water-Colour Society.

From the first, Cotman's etched subjects, like his painting, looked beyond Norfolk, and from 'Picturesque specimens' of architecture to 'Landscape Shipping etc.'. His *Antiquities of Norfolk* (cat.62 ff.) was nurtured by his experience of contemporary projects being undertaken in London such as the Cookes' series of views of the Thames (1811) or their *Picturesque Views on the Southern Coast* taken from Turner's watercolours (begun 1814). For the climax of his graphic career, his architectural plates to *Normandy* (cat.72 ff.), he made his only three trips abroad in 1817, 1818 and 1820. While the antiquarian concerns of these projects chimed with those of Dawson Turner and the Gurneys, they reflected the wider creative impulses of Cotman's art, which were sometimes at odds with his patrons' more literal vision. Hudson Gurney – who had succeeded Englefield as Vice-President of the Society of Antiquaries – considered a record of Norman architecture a 'National desideratum', and it was he who secured his fellow Quakers the brothers J. and A. Arch as publishers for *Normandy*.[28]

Like the Cookes, the Arches were among Turner's publishers, and these connections with Turner's milieu doubtless added to Cotman's admiration for the artist. Of Cotman's *Dutch Boats off Yarmouth* (cat.70), its London purchaser, Mr Bridgman of Wigmore Street, wrote in warning, 'By the way, I think you are very partial to Turner. This may be well to a certain extent, as it may be with Cuyp and Claude; from each of whom whatever they may possess – take it. But do not copy them.'[29] But the advice was hardly necessary. Cotman's treatment is characteristically restrained and sinuous, and as is argued in the appropriate catalogue entry (70), it may in fact have been his own historically charged vision of the Yarmouth Denes that inspired a design of Turner's for a set of east coast views. And although one of his own variations on Turner's *Liber*, given to Turner, was sufficiently close to its model to be passed on afterwards in error by the recipient as his own work,[30] it was not Cotman's decision, but that of his publisher, Henry Bohn, to use Turner's title for a late portmanteau edition of Cotman's prints (cat.87). Nor was Cotman's interest in his colleagues as confined to Turner as Bridgman supposed. It was probably the Cookes

who drew Cotman's attention to Bonington, whose coast scenes, landscapes and historical genre seem even closer to his own than Turner's in the later 1820s and 1830s. Cotman would surely have seen Bonington's London exhibits in the mid-1820s, but in 1830 George Cooke probably acquired the first of a number of oils by the artist. That Cotman was not profoundly aware of a painter who had sprung from similar sources, having been steeped in the style of Girtin and his own early friend Francia, seems inconceivable, and further proof of the breadth of Cotman's taste is his passionate response to Wilkie, whose *Chelsea Pensioners* (Apsley House) in the 1822 Academy struck him as 'the most finished effort of human art, either ancient or modern'.[31]

But it seems to have been Turner who helped secure Cotman's appointment as drawing master at King's College School in 1834. This late return to London was the fulfilment of a dream. The previous year, Cotman had sold all his works in London exhibitions, and now found himself received 'like a prince' by Turner's dealer Thomas Griffith, and winning new friends and collectors, among them the Revd William Bulwer, of St James's Chapel, Piccadilly, and the manufacturer and amateur painter J.H. Maw, also a collector of Turner, Girtin, Bonington, Cristall and others whom Cotman had long regarded as his peers. London brought disappointments of its own – among them the low prices fetched by his work in Bulwer's sale in 1836. But Cotman had already seen the paintings in his Norwich property at St Martin at Palace Plain knocked down for derisory sums in the sale preceding his move, and meanwhile there was a fitting symbolism in that it had been in that same house, in 1833, that the Norwich Society had last met and officially disbanded. Cotman had been its last President. Among its younger members, and the pupils and followers of Cotman and the Cromes, Norwich art did not die. But it retained the diversity of its first moving spirits, while lacking the concentration around their teaching activity that had been the city's main claim to a 'School'. And as this essay has tried to show, even during the three decades of the exhibiting Society, Norwich artists had looked far beyond the city and what Cotman called 'all its little associations'. With due respect to regional or civic pride, they must be reclaimed for what, at their best, they are – truly masters of Romantic landscape.

NOTES

1 *Norwich Mercury*, 26 May 1827.
2 Cotman to his wife, 15 January 1834, in Kitson 1937, p.307.
3 See F. Hawcroft, 'Crome and his Patron; Thomas Harvey of Catton', *Connoisseur*, January 1959.
4 Gainsborough to Harvey, 22 May 1788, in M. Woodall, *The Letters of Thomas Gainsborough*, 1963, p.91.
5 A. Moore, *Dutch and Flemish Painting in Norfolk. A History of Taste and Influence in Fashion and Collecting*, exhibition catalogue, NCM, 1988, pp.26ff.
6 For Harvey and More see P. Andrew, 'Jacob More: A Biography and Checklist of Works', *Walpole Society*, LV, 1989–90, pp.105ff.
7 Gunn to John Flaxman, 4 May 1821, in Moore, 1985, p.19.
8 Beechey in J. Wodderspoon, *John Crome and his Works*, 2nd ed., 1876, p.6.
9 Farington, *Diary*, 1795.
10 Opie, *Lectures on Painting*, in Kitson 1937, p.10.
11 Quoted by Hawcroft, *loc. cit.*, p.232.

12 Cholmeley to Cotman, 14 July 1806, in Kitson 1937, p.96.
13 Farington, *Diary*, 15 December 1799.
14 Cotman to Francis Cholmeley, 20 December 1810, in Holcomb, 1980, p.39.
15 *Ibid.*, p.13.
16 *Ibid.*, p.32.
17 Cotman to Francis Cholmeley, 5 June 1811, in *ibid.*, p.48.
18 Farington, *Diary*, 5 May 1806.
19 Turner, 1840, p.25.
20 Cotman to Francis Cholmeley, 5 June 1811, *loc.cit.*.
21 Turner 1840, *loc.cit.*.
22 *Ibid.*
23 *Ibid.*
24 A book of watercolour copies by Crotch after pictures in Callcott's executors' sale in 1844 is in Norwich Central Library. For Callcott and his friends see D.B. Brown, *Augustus Wall Callcott*, exhibition catalogue, Tate Gallery, 1981 and for the Kensington circle, and possible connections with Crome, M. Pointon, *William Mulready*, exhibition catalogue, Victoria and Albert Museum,

National Gallery of Ireland and Ulster Museum, 1986–7.
25 At some later date Daniell acquired another Turner, *Mortlake Terrace, the Seat of William Moffatt, Esq.* (National Gallery of Art, Washington).
26 *Norwich Mercury*, 6 August 1825.
27 For Cotman as a printmaker see A. Hemingway, '"The English Piranesi" – Cotman's Architectural Prints', *Walpole Society*, XLVIII, 1982.
28 For the publishing history of *Normandy* see A. Hemingway, 'Cotman's "Architectural Antiquities of Normandy": Some Amendments to Kitson's Account', *Walpole Society*, XLVI, 1976–8.
29 Bridgman to Cotman, in Kitson 1937, p.252.
30 According to Kitson (*ibid.*, p.138), Turner gave Cotman's drawing to Delane, the editor of *The Times*, and on reframing it was found to carry an inscription from Cotman to Turner.
31 Cotman to Dawson Turner, 21 June 1822, in Kitson 1937, p.168.

CATALOGUE

Paintings, watercolours and prints by each artist are grouped in approximate chronological order.

Books and documentary material are listed separately in the endmatter.

Measurements are given in millimetres, height before width.

The accession numbers of works from Norfolk Museums Service (Norwich Castle Museum) are preceded by the initials NCM; works from the Tate Collection carry accession numbers only. Other lenders are described in full.

Full references to publications are to be found in the Bibliography.

The authors are identified by their initials:
DBB David Blayney Brown
AL Anne Lyles

JOHN CROME 1768–1821

1 Carrow Abbey, near Norwich
*c.*1805

Oil on canvas 1337 × 990
NCM 1951.235.705. Russell James Colman
Bequest 1946

Crome is effectively the founder of the 'Norwich School'. From an artisanal background, and always active for much of his life as a picture restorer and dealer, he emerged as a painter in his own right, sending his work for exhibition in Norwich and London. He was encouraged by local collectors and patrons, Thomas Harvey of Catton and Dawson Turner of Yarmouth, as well as by the Gurney family of Earlham, and built up a busy practice as a drawing master. His pupils included his son John Berney Crome, George Vincent and James Stark. He took a leading part in the foundation of the Norwich Society in 1803. Although he first began painting in oils in the mid-1790s, Crome's first securely datable oils, of which this is one of the most important to be identified, are from a decade later. Carrow Abbey, a twelfth-century Benedictine convent, stood at Bracondale, near Trowse outside Norwich, in the grounds of a property belonging in Crome's time to a surgeon, Dr Philip Meadows Martineau, the first owner of this picture. The building shown is in fact not the abbey, but the lodging house built in the sixteenth century by the last prioress, Isabel Wyggan (see F.R. Beecheno, *Carrow Priory, commonly called Carrow Abbey*, privately printed, 1886). The landscape designer Humphry Repton had recently prepared plans for its surroundings in the fashionable Picturesque style. Goldberg (1978, p.179) speculates that Crome's pic-
ture was probably more a gift to the doctor – perhaps in lieu of payment of a medical bill – than a commissioned or sold work, but this might underestimate both Crome's own view of its importance and its likely appeal to its owner's taste. In the first exhibition of the Norwich Society in 1805, it was the only one of Crome's twenty-four contributions marked as being for sale. Since he considered it especially marketable, and painted it on a larger scale than he often used, it is tempting to identify it as a candidate for the 'upright landscape' that he sent as one of two exhibits to the Royal Academy the following year. Unfortunately, the picture's present condition is not a reliable guide to its original appearance, so it would be unwise to read too much into its apparent correspondence to the 'scribbling', 'mortary' and unfinished look of the Academy canvas described by two journalists in the hearing of Joseph Farington (see above, p.29). Nevertheless enough may survive of broad handling, monochrome palette of browns and slaty grey-blues, and almost abstract deployment of mass to indicate Crome's study of Richard Wilson and more recently of Turner, with whose Academy diploma picture, *Dolbadern Castle* (Royal Academy), there seems some connection in the upright format and treatment of the foreground. In subject and style, the picture may well have conformed closely to contemporary Picturesque taste, with its preference for a sketchy, spontaneous technique and for strongly contrasted effects of texture and light. Martineau's own taste, if judged by his plans for his grounds, lay in the same direction.

DBB

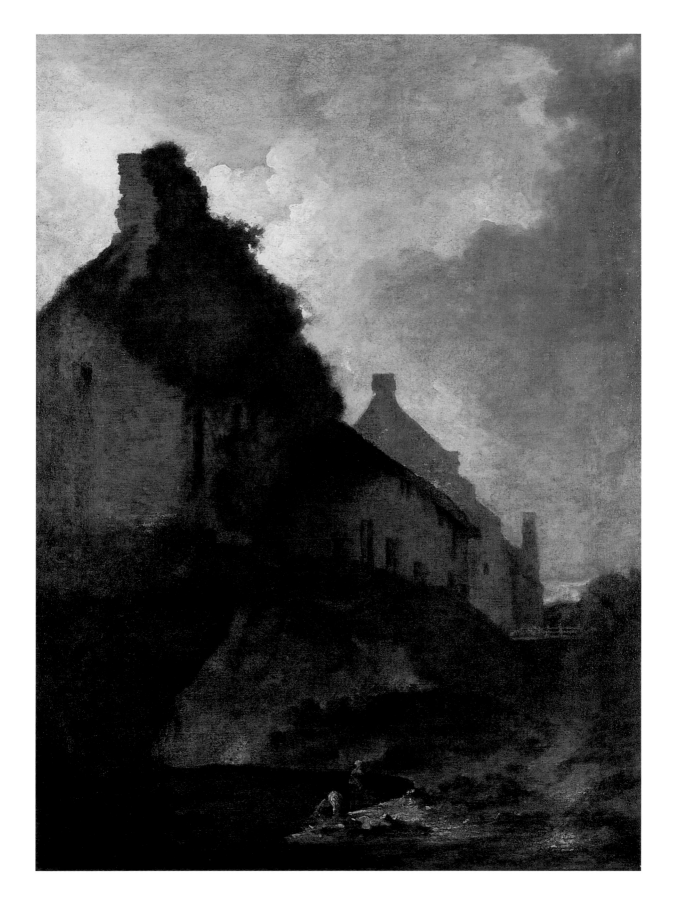

2 'Slate Quarries' c.1805

Oil on canvas 1238 × 1587
NO1037. Tate Gallery. Purchased 1878

Neither the subject nor the early history of this picture is certain, and the title retained here, which became attached to it between 1858 and 1864, does not really describe its content. According to a letter from a Dr Caleb Rose of Great Yarmouth to W. Cosmo Monkhouse (James Reeve archive, British Museum Print Room), it was owned by Dawson Turner, who sold it to J.N. Sherrington, also of Yarmouth, under the title 'The Cumberland Sketch'. This may further indicate that it was the work of this description said to have hung, unframed and unloved, on Turner's staircase – proof, supposedly, of his failure to appreciate the very free handling that is certainly evident here. Crome visited the Lake District in 1802 and 1806 with his patron John Gurney of Earlham, and exhibited a 'Scene in Patterdale; Cumberland' and 'View on lakes in Cumberland' at the Norwich Society in 1805 and 1806, one of which, probably the first, may be identical with a Cumberland subject in the National Gallery of Scotland which Gurney seems to have bought. To some observers the scenery of the Tate picture has looked more Welsh than Cumbrian; Clifford (1968, p.188) identified it as a quarry at Ffestiniog, north Wales, and Goldberg (1978, p.178) located it to the borders of Snowdonia as seen from Moel Hebog. Such speculations may well remain unconfirmed as Crome's purpose seems not to be literally topographical, but rather to create a personal interpretation of a type of scenery hitherto unfamiliar to him. The breadth and sweep of the composition, and vivid handling of paint, recall Thomas Girtin and Richard Wilson, and most recently Turner. It was doubtless the latter's habit of attaching quotations to his pictures that prompted Crome to cite a passage from John Collins's *Ode on the Poetic Imagination* to his 1806 Cumberland exhibit in Norwich, which seems very appropriate to the Tate picture:

Cliffs to heaven upheld,
Of rude access, of prospect wild,
Where tangled round the jealous steep,
Strange shades o'erthrow the valley deep.

If *Carrow Abbey* (cat.1) is an essay in the contemporary Picturesque, this bleak mountainscape is presented – unprecedentedly for Crome – in terms of its grander counterpart, the Sublime, and once again its relatively large size suggests he intended it for exhibition. Both canvases show him in tune with some of the most advanced trends in landscape painting.

DBB

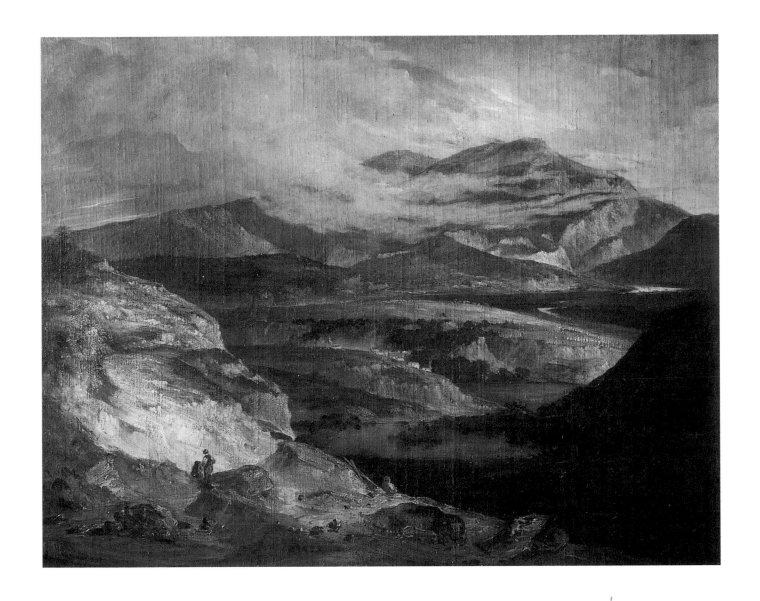

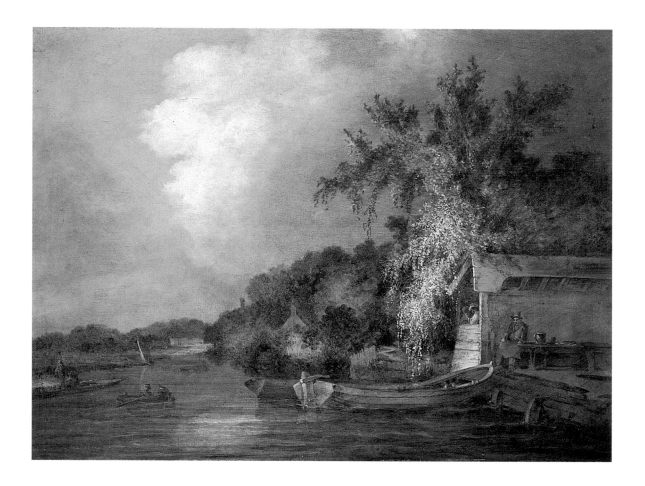

3 **The Yare at Thorpe** c.1806

Oil on mahogany panel 423 × 577
NCM 1951.235.707. Russell James Colman
Bequest 1946

The likely date of this small oil can be gauged from a drawing of the same composition, dated 3 July 1806 and described as a 'View from King's Head Gardens at Thorpe' (British Museum). The water traffic on the Yare at Thorpe and the pleasure grounds and tavern gardens by the riverside there were to be fruitful subjects for Norwich painters, appearing in many different guises (see Cotman, cat.88 and Stannard, cat.109). Here it has been elaborated from the preparatory drawing. Crome showed a 'Sketch in oil, view on Thorpe river' – possibly identical with this – at the Norwich Society in 1806. A letter from Charles Norris of Norwich to James Reeve, 22 December 1886 (James Reeve archive, British Museum Print Room),

describing a view of 'Cattermole's at Thorpe' belonging to his father may also refer to this and throw further light on its subject. Crome's development as a painter is multifaceted and here his exploration of Picturesque effects has taken him, from the raw modernity of *Carrow Abbey* (cat.1) and the *Slate Quarries* (cat.2), in an archaising, old masterly direction. The fluent, thin pigments laid almost transparently across the grain of the panel and treatment of the foliage are close to the seventeenth-century Dutch painter Jan van Goyen. The weeping willow, falling to the water like a shower of silver, is a particularly lovely passage. The luminous naturalism of the picture may also show Crome's awareness of new developments in the work of Turner, who was now attracting the nickname of a 'white painter' and similarly referring to Dutch models – chiefly Aelbert Cuyp – for the hazy, atmospheric light effects of views of Thames river scenery begun in 1805.

DBB

4 The Blacksmith's Shop, Hingham c.1807

Pencil and watercolour on paper 541 × 442
NCM 1942.123. Percy Moore Turner Gift
1942

Now rather faded, this remains an impressive watercolour and was surely an exhibition piece. It shows Crome's handling of the medium just before it was transformed by his experience of Cotman's work. Crome took up the theme of the blacksmith's shop – here gable-ended and tumbledown, in true Picturesque mode – in three exhibits at the Norwich Society in 1807 and one in 1811. Two of the 1807 exhibits are described as 'from nature' and the third as a view at the village of Hardingham, which lay adjacent to Hingham, both near Norwich. Another watercolour, showing what appears to be the same building, is in the Doncaster Museum and Art Gallery, and its composition is repeated in an oil in the Philadelphia Museum of Art, which is likely to be the oil shown at the Royal Academy in 1808 and could also have been one of the 1807 Norwich exhibits. Opinions differ as to whether the NCM watercolour was itself one of these; Goldberg (1978, p.254) thought it was, but Moore (1985, p.22) thought it more likely to have been shown in 1811. It is of course possible that Crome showed the same work on repeated occasions. His interest in rural buildings of this type was very much of the moment, and far from being dependent on his copying of Thomas Harvey's Gainsborough, *The Cottage Door* (Huntington Library, San Marino), as has sometimes been supposed. Among his direct associates it was a preoccupation of Cotman, and, among London artists, of William Mulready, John Linnell and A.W. Callcott, whose upright *Water Mill*, shown at the Royal Academy in 1805 and bought by Sir John Leicester (private collection) had become an icon of the Picturesque. Turner had been tackling similar subjects in watercolour for a decade or more, and his own *Blacksmith's Shop* (Tate Gallery), itself a summary of current fashion and a comment on the rustic genre subjects now being shown by David Wilkie, made a controversial appearance at the Academy in 1807.

DBB

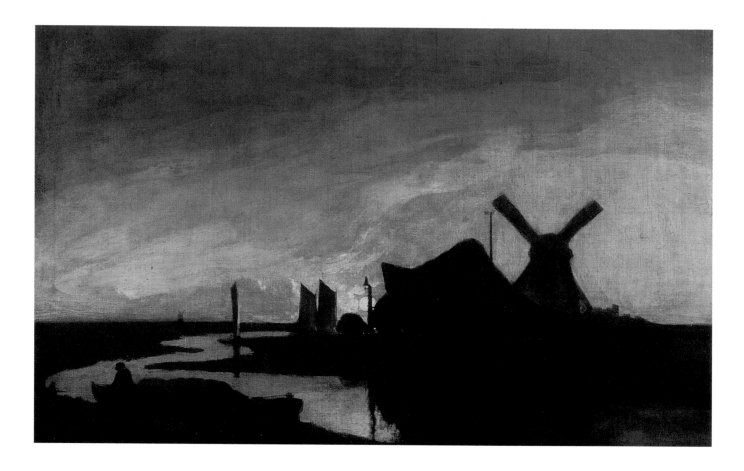

5 **Moonrise on the Yare** *c.*1808

Oil on canvas 711 × 1111
N02645. Bequeathed by George Salting 1910

This is one of a number of moonlight subjects painted by Crome, eleven of which he exhibited between 1805 and 1820. Here the dark, flat landscape, barge and mill set against the pale sky and winding river create a striking effect of chiaroscuro. The broad and sketchy handling, and strong pattern of flat bands of colour, may show the impact of Cotman's watercolours and first experiments in oil, which had appeared in the exhibition at Norwich Society from 1807. Dawson Turner, who paid £7 for the picture at an unknown date, included it in a group of his Cromes painted between 1811 and 1816, but also located the scene as near the junction of the Yare and Waveney rivers between Norwich and Yarmouth (Turner 1840, p.19), which might identify it as the 'Moonlight Scene on the River between Beccles and Yarmouth' exhibited at the Norwich Society in 1808. This date is very plausible, but the river may actually be the Yare's narrower and more winding tributary, the Bure. Crome's treatment of the subject was compared by Dawson Turner to the moonlight scenes of Aert van der Neer, and rather criticised for being less finished. Among other artists it probably also depends on Rembrandt's *Mill* (National Gallery of Art, Washington), which Crome may have copied (see *passim*, p.27, fig.6), and on some recollection of Girtin's famous watercolour of the dusky Thames, *The White House at Chelsea* (Tate Gallery).

DBB

6 **St Martin's Gate, Norwich**
*c.*1812–13

Oil on mahogany panel 508 × 383
NCM 1955.170. National Art Collections
Fund Gift from the Ernest E. Cook Bequest
1955

In this picture and cats.7, 8, 18, 19, 27, Crome turns his attention to the townscape of Norwich, seen from its hidden corners of rivers, mill ponds, waterways and rustic lanes where the country crept into the city. The title usually given to this picture is misleading as the arched building in the right background is not St Martin's Gate, which was demolished in 1808, before its likely date. The scene may instead be Fuller's Hole, just outside the original gate, but Fuller's Hall, the most prominent building then standing in the area, is not visible. Of the ten pictures shown by Crome at the Norwich Society from 1807 with St Martin's in their titles, none refers specifically to the Gate, but most are said to be river scenes – that is, on the banks of the Wensum in the parish of St Martin's at Oak. Crome lived not far away, in St George's Colegate. Topographical accuracy does not seem to be Crome's concern here, but rather a lyrical and very personal interpretation of an intimate corner of the city, overgrown, untidy, quaintly old-fashioned and lived-in. His gift for the telling detail – which was to reach its climax in the later *Italian Boulevard* (cat.28) – is evident in the woman hanging out her washing and the dog barking at an elderly couple in the street. Though the treatment of this upright architectural subject is reminiscent of Adriaen van Ostade, it is no mere pastiche, and the delicate handling and subtle gradations of atmosphere show a marked advance in Crome's powers. Once again, the mellow, golden light suggests knowledge of Turner's English landscapes and Thames pastorals. For extensive discussion of Crome's Wensum pictures, noting their Picturesque approach to the urban scene and their progressive brightening of colour, see Hemingway 1992, pp.261ff.

DBB

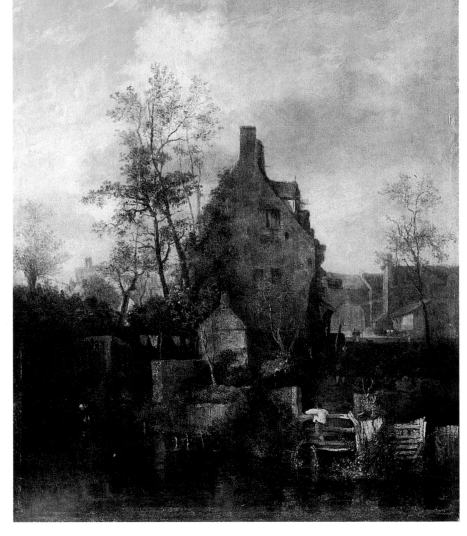

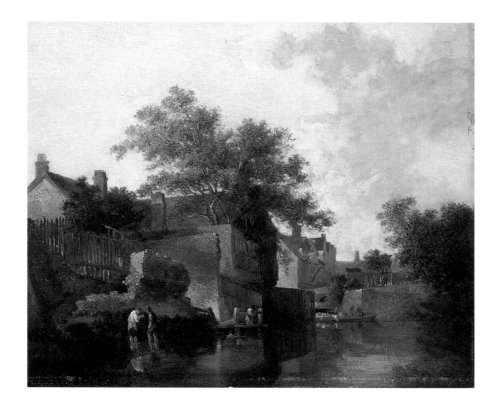

7 New Mills: Men wading ?1812

Oil on pine panel 298 × 357
NCM 1970.531. Purchased with the aid of the
Victoria and Albert Museum Purchase Grant
Fund, the Friends of the Norwich Museums
and the National Art Collections Fund 1970

The New Mills stood on the River Wensum
to the north-west of Norwich's city centre.
The buildings painted by Crome were
rebuilt in 1709 and replaced four water
mills destroyed in a riot in 1440. Since the
end of the sixteenth century they had sup-
plied the city with water. They are seen
more clearly in the following picture. Like
the area around St Martin's (see the pre-
ceding oil), the New Mills were for Crome a
favourite subject, allowing him to explore
similar backyards and hidden corners of
vernacular or industrial buildings beside
water. While Cotman was drawn to the
city's ancient architecture or public spaces
(cats.48, 49, 50), Crome's preference was
for its obscure and workaday quarters,
which he nevertheless transformed by his
instinct for the Picturesque and now con-
siderable mastery of atmospheric effect.
Contemporary topographical prints show
the New Mills area in a much more literal
and uninspiring light, but Hochstetter's
Norwich map of 1789 (see p.154) shows the
essential features of Crome's picture in
place, a creek, flowing between the New
Mills and St Michael's Bridge. It is thus
likely to be the 'Creek Scene, near the New
Mills, Norwich', exhibited at the Norwich
Society in 1812 and the third of three New
Mills scenes shown since 1806. Though
the clouds are reminiscent of Cuyp, the
interpretation throughout is less old mas-
terly than in the preceding St Martin's sub-
ject and shows a correspondingly greater
naturalism. Crome may by now have regis-
tered the developments in Constable's
London exhibits, especially his scenes of
navigable waterways. This subject was
etched by Crome in 1813 (cat.19).

DBB

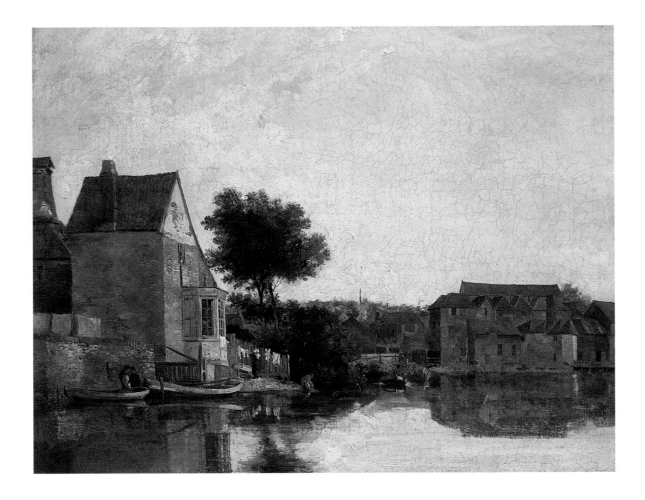

8 **Back of the New Mills** c.1814–17

Oil on canvas 413 × 540
NCM 1899.4.2. Jeremiah James Colman
Bequest 1898

Here the New Mills appear more prominently, seen from the north across the River Wensum. The building on the left, with its prominent bay window overlooking the water, is also present on the right in Crome's etching (cat.18), in which the viewpoint is reversed, looking from the Mills towards open country. This picture was apparently not exhibited by Crome in his lifetime, but was presumably one of the six New Mills subjects included in Crome's Memorial Exhibition in 1821, of which five were dated between 1814 and 1817. One of these, of 1817, lent by Samuel Paget, was a 'View of the Back of the New Mills near the Manufactury of C Higgins Esq.' – a title which may throw light on the large factory or mill-like building seen here on the right.

DBB

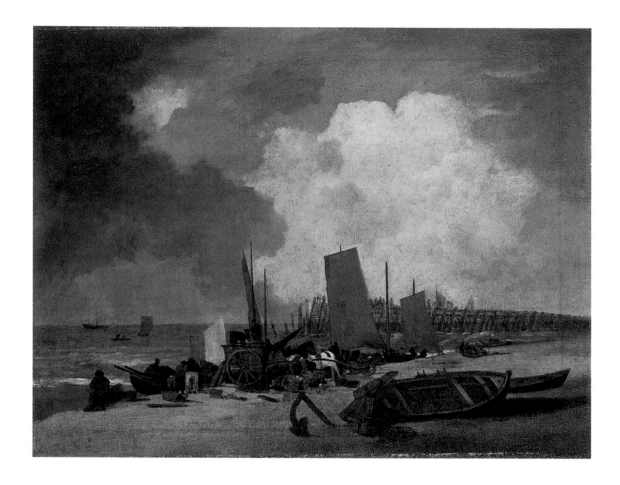

9 **Yarmouth Jetty** *c.*1807–8

Oil on canvas 445 × 578
NCM 1899.4.1. Jeremiah James Colman
Bequest 1898

Yarmouth Beach and jetty were popular subjects with Norwich painters, beginning with Robert Ladbrooke's view of the jetty shown at the Norwich Society in 1806. Beach scenes exhibited in London by Turner and A.W. Callcott are likely to have encouraged them, and their views of Yarmouth fall within a national trend embracing contemporary views of Hastings, Brighton and the like – though, as pointed out by Hemingway (1992, p.197), the town differed from these in being a thriving industrial centre and port as well as a budding middle-class resort. Crome's interest must have been spurred by visits to the town in connection with his teaching duties for Dawson Turner and his family. He exhibited six pictures of the jetty as well as other Yarmouth scenes between 1807 and 1819. Surviving examples show a breadth of handling and a realism and modernity in their observation of work and leisure somewhat different from his Picturesque conception of Norwich and the Wensum, suggesting that the change of scene had a liberating effect. First built late in the sixteenth century, by the early nineteenth Yarmouth jetty had fallen into a dangerous state of disrepair. A drawing of the old structure by Crome is in the British Museum. New Year's Day 1809 saw the completion of extensive repairs, at a cost of £5000, reflecting its importance to the naval fleet, which was victualled and watered from it when lying in Yarmouth Roads. This picture must date from early in Crome's Yarmouth series as the jetty is still seen in a ramshackle condition, with some of its wooden piles detached from the main structure. The rather flat, broad brushwork perhaps reflects the influence of Cotman's early use of oils. The picture was copied in oil by the Norwich painter Thomas Lound (NCM).

DBB

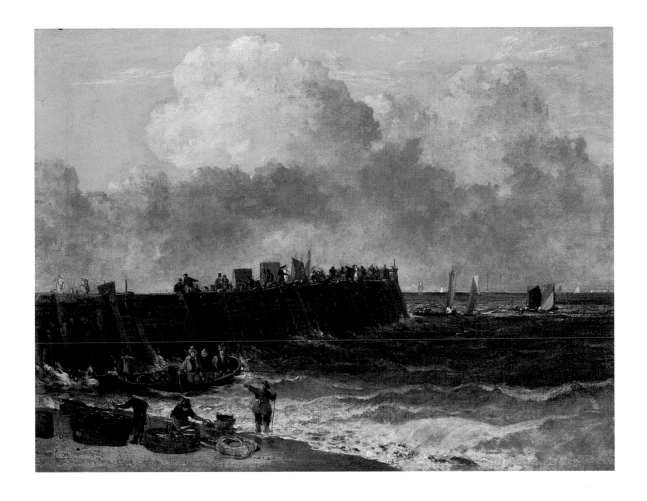

10 **Yarmouth Jetty** c.1810–14

Oil on canvas 448 × 583
NCM 1945.92. Purchased with the aid of
the Beecheno Bequest Fund 1945

As pointed out by Moore (1985, p.25), the robust condition of the jetty here would suggest that this picture dates from after its repair in 1808–9. Hemingway (1992, p.205) notes the absence of hand rails, as installed on the new jetty, but adds that Crome could have left them out for the sake of simplicity. More than the preceding picture, this one is very broadly and freely painted, and has an almost *al primo* fresh-ness, as if either painted from nature or designed to appear as if it had been. The foaming waves and billowing clouds are especially boldly brushed, while the figures are very lively. As well as workaday types they include two women in pale dresses, one of whom seems to be carrying a para-sol; a similar couple appear in Crome's drawing of the jetty in the British Museum, and in both cases they reflect its additional role as a promenade and the town's appeal as a resort. The colouring is rich and warm. Both palette and figure types anticipate the later and more finished *Fish Market at Boulogne* (cat.29).

DBB

11 **Dock Leaves** c.1810–13

Oil on canvas laid on panel 165 × 353
NCM 1951.235.716. Russell James Colman
Bequest 1946

James Stark was the first owner of this, one
of a small group of plant studies from
nature. Crome is best known as a painter of
woodland scenes, influenced by the Dutch
School and especially Meindert Hobbema,
but his interest in tree and plant forms was
more original and complex, underpinned
by a growing instinct for naturalism and,
almost certainly, religious conviction. Both
botany and natural theology were much
studied at Norwich, where the Linnaean
collections of natural history were then
kept in the Surrey Street house of Sir James
Edward Smith, a botanist, author and
frequent lecturer in the city; and at nearby
Costessey the Baptist Simon Wilkin had
made a garden on Linnaean principles. A
year before his death, Crome acquired a
complete set of the works of William Paley,
including his *Natural Theology* and *Evidences of Christianity*. Meanwhile his pupil
Elizabeth Gurney liked to quote Alexander
Pope's famous line about looking 'through
Nature up to Nature's God', and as a lesson
for his other pupils, the Misses Jerningham
of Costessey, Crome is said to have made an
oil sketch of flints (NCM). This study may
also have been made in connection with
teaching activities, but the larger and more
finished *Study of a Burdock* including butterflies and other plants (also NCM) seems
a more considered appreciation of the
wonders of Creation. It may have been the
'Docks' exhibited at the Norwich Society in
1813 – one of only two such plant studies
exhibited in Crome's lifetime, the first
having been seen in 1810. Studies like
these must have informed the beautiful
parade of wild plants across the foreground
of Crome's later *Mousehold Heath* (cat.26)
(see Fawcett 1982).

DBB

12 Mousehold Heath, Norwich

*c.*1810

Etching 209 × 289; on paper 250 × 337;
plate mark 228 × 301
NCM 1921.25.8. H.S. Theobald Gift 1921

Crome etched thirty-four plates but did not publish them; he issued a prospectus inviting subscribers to prints in 1812 but must have decided to abandon the issue. The earliest date on a plate is 1809, the latest 1813, suggesting a fairly concentrated period of activity in the medium. The plates were subsequently issued by his widow and son in 1834, and republished by Dawson Turner in 1838, with additions that seemed to him to render them more acceptably finished but are today considered ruinous. Dawson Turner's edition included a 'Biographical Memoir' written by himself, judging Crome 'singularly ignorant of the art of Chalcography and singularly unfit-

ted by nature to acquire it'. However, he allowed that Crome's etchings 'deserve a place near those of the best masters of the Dutch School, a school in which the ideas of their author embodied every description of excellence. The faults they have are the faults of genius'. Crome's etchings, of all his works, are certainly those in which he came closest to direct imitation, and it is clear that he had made a close study of Dutch prints; Turner, at whose house many of Crome's etchings were made, 'will never forget the smile of self-satisfaction which beamed on his brow, when bringing him an impression from a new plate printed on soiled paper, he called out "What think you of this Ruysdael?"' But it is also significant that Crome did not see his prints as fit for publication, but as a private hobby, and while etching was to be a shared enthusiasm of many Norwich artists, it is hard to estimate how influen-

tial they actually were. For Crome himself, they probably arose from interests shared with his patrons – Thomas Harvey and Dawson Turner's wife and daughters all being keen amateur etchers – and were often a means of assimilating the landscape imagery of the Dutch masters before giving it a more personal interpretation in his paintings. The plate of Mousehold Heath is likely to precede by some years his oil of the subject (cat.26), and is much closer in spirit to Dutch dune landscapes. The heath lay to the north-east of Norwich, and derived its name from the Old English term 'Moche-Holt' or 'thick wood' (see Kennedy Scott 1998, p.50). This is the first state of Crome's plate, before alterations by Crome himself – and showing the sky with a billowing storm cloud before alterations added at Dawson Turner's behest (see cat.13).

DBB

13

13 **Mousehold Heath** *c.*1810/34

Etching 208 × 280; on paper 312 × 399;
plate mark 228 × 302
NCM 1952.174

The fourth state. In the third the sky was
rebitten by the Norwich artist Henry Nin-
ham, and Crome's impressive sky removed.
For this Ninham blamed a local engraver,
W.C. Edwards of Bungay, who then added a
ruled sky and burnished out some of the
play of light and shade across the standing
water to produce this final state. These
interventions were to satisfy the reserva-
tions of Dawson Turner, to whom Edwards
wrote (8 May 1837) that he had 'much
improved' the plate to make it 'more
applicable to the public taste'; Crome's
other etchings, he added, 'want the same
treatment, but I have not time to under-
take them'. Cotman's published prints
were also to fall under Dawson Turner's
critical scrutiny, becoming more restrained
in conception as a result of his advice.

DBB

14 **Copper plate for 'Mousehold Heath'**

Copper 229 × 305; etched subject
210 × 285
NCM 84.4.99

Crome's plate, with subsequent alterations
as described in cat.13.

DBB

15

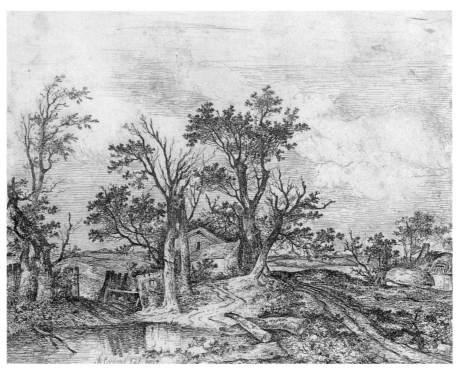

15 **At Hackford** 1812

Etching 170 × 217; on paper 213 × 260;
plate mark 178 × 226
Lettered within image at l. lower corner 'J.
Crome, fct. 1812'
NCM 1921.25.41. H.S. Theobald Gift 1921

The third state of four worked by Crome
himself. The title was added to the fifth and
last.

DBB

16 **Copper plate for 'At Hackford'**

Copper 178 × 230; etched subject
173 × 224
NCM 95.4.99

DBB

17 **The Hall Moor Road, Near
Hingham** 1812

Etching 170 × 217; on paper 210 × 282;
plate mark 177 × 225
Lettered within image at r. upper corner
'J. Crome Fecit 1812'
NCM 1921.25.47. H.S. Theobald Gift 1921

The second state of three worked by Crome
himself, adding foliage to the tree on the
left. The title 'Near Hingham' was added to
the fourth state at the time of rebiting by
Henry Ninham.

DBB

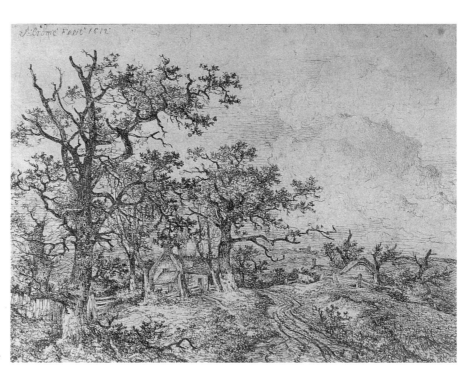

17

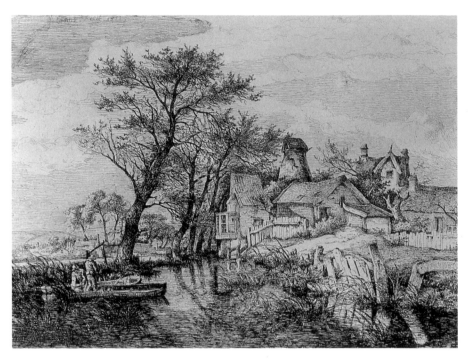

18 Back of the New Mills 1812

Etching 217 × 287; on paper 278 × 381;
plate mark 228 × 303
Lettered within image at l. upper corner
'J. Crome, Fecit 1812'
NCM 1921.25.14. H.S. Theobald Gift 1921

The second state of two worked by Crome himself, as published in Mrs Crome's 1834 edition of the plates. In this state the plate has darkened, and heavier lines have been added to the sky. The title was added to the third state at the time of rebiting by Henry Ninham. The subject is a more partial and reversed treatment of the view painted by Crome probably several years later (cat.8); thus modified it is likely to show the Wensum curving towards Hellesdon (see Hemingway 1992, pp.262, 340 n.127), and despite the title does not actually include the New Mills buildings. A drawing of the same composition, perhaps related to a lost painting as well as to the etching, is in the NCM.

DBB

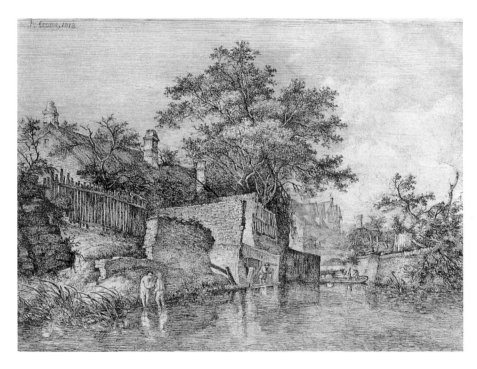

19 Front of the New Mills 1813

Etching 215 × 291; on paper 278 × 381;
plate mark 226 × 303
Lettered within image at l. upper corner
'J. Crome. 1813'
NCM 1921.25.15. H.S. Theobald Gift 1921

The first state, and the most delicate and silvery, of two worked by Crome himself. The title was added to the third state at the time of rebiting by W.C. Edwards. The subject is a quite faithful repetition of Crome's painting of a year or so earlier (cat.7).

DBB

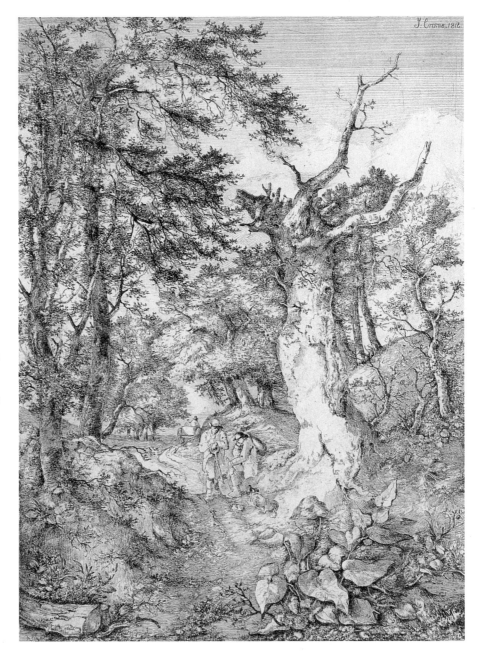

20 Composition; A Sandy Road through Woodland 1813

Etching 370 × 268; on paper 550 × 378;
plate mark 406 × 302
Lettered within image at r. upper corner
'J. Crome. 1813' (the last digit reversed)
NCM 1898.41. Mrs Hodgson Gift 1898

The second state of two worked by Crome
himself, as published in Mrs Crome's 1834
edition of the plates. This large plate is the
most elaborate of Crome's etchings, rich in
natural detail and human incident. The
large dock plant in the foreground – given
additional shading to its leaves in this state
– is a characteristic motif, seen also in
Crome's paintings (see the oil sketch,
cat.11).

DBB

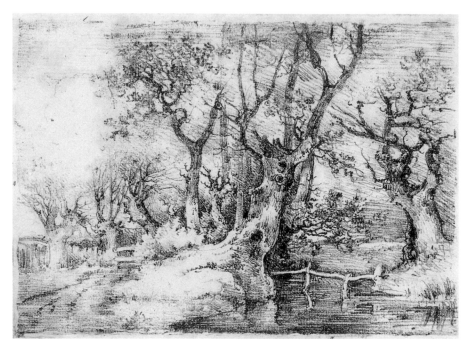

21 **Bixley** c.1809–10

Soft-ground etching 157 × 221; on paper
193 × 254; plate mark 166 × 224
NCM 1921.25.72. H.S. Theobald Gift 1921

The only state. Nine of Crome's etchings,
and the earliest to bear a date, are in soft-
ground, and show considerable assurance
with the drypoint medium as well as a
greater naturalism and independence from
the Dutch masters than his other plates. In
these he may have been influenced more
by Gainsborough. This composition of pol-
lards and gnarled trees by a pool is based
on a pencil drawing (British Museum).

DBB

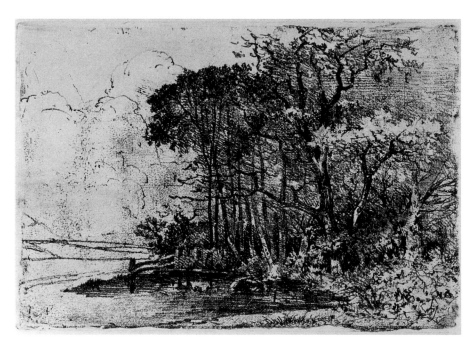

22 **Hoveton St Peter** c.1810

Soft-ground etching 163 × 233; on paper
191 × 260; plate mark cut
Lettered within image at r. lower corner
'J.C.'
NCM 1921.25.69. H.S. Theobald Gift 1921

The only state. Another composition of
trees by water, but starker and more con-
temporary in feeling as a result of the open
area of field and sky to the left.

DBB

23 **Postwick Grove** c.1814–17

Oil on millboard 489 × 406
NCM 1951.235.728. Russell James Colman
Bequest 1946

The village of Postwick lay about four miles
east of Norwich, among trees on a stretch
of the Yare often visited by 'water parties'
from the city. By the time James Stark
illustrated it in his *Rivers of Norfolk*, 1834,
many trees had been felled for 'the destruc-
tive encroachment of the mattock and the
plough', and a new chalk quarry had been
dug. Earlier, the Grove had been popular
with painters. With other Norwich artists
like Joseph Clover (cat.100), Crome was
taking up the practice of outdoor oil
sketching, and also exhibiting oils 'from
nature' or 'painted on the spot'. The mill-
board support and impromptu handling of
this sunlit study might suggest it was one
of these – perhaps, as noticed by Moore
(1985, p.30), the 'sketch' of Postwick Grove
that appeared in J.B. Crome's sale at Nor-
wich in 1834 (5 September, day 3, lot 101).
Its relationship to the 'View of Postwick
Grove' dated 1816, lent by Mrs de Rouillon
to the Crome Memorial Exhibition in 1821,
or to the 'Postwick Grove' lent by the Mar-
quess of Stafford to the Norwich Society's
Loan Exhibition in 1828, is unknown.

DBB

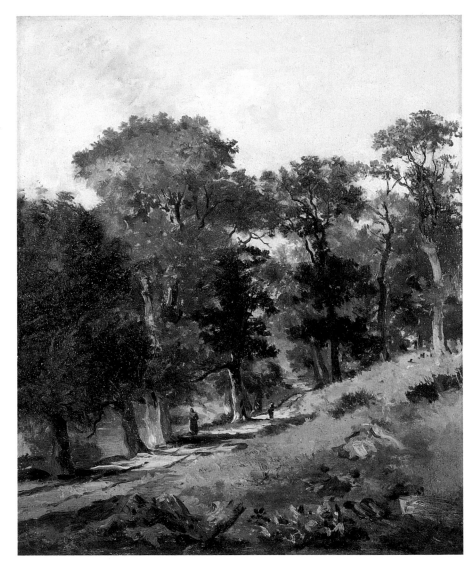

24 **A Road with Pollards** *c.*1815

Oil on canvas 759 × 1118
NCM 1951.235.722

This beautifully articulated arrangement of three groups of pollarded willows beside a track and set against a wide expanse of sky cannot be identified with any of Crome's exhibited works. Though cooler in colouring than some of his pictures of the period, it probably dates from around the middle of the second decade of the nineteenth century, when the Dutch influences on his tree subjects had given way to a greater naturalism. Rather similar groups of pollards appear in his somewhat earlier oil *The Beaters* (fig.1, p.14), perhaps exhibited in 1810 (Edinburgh, National Gallery of Scotland) and in his soft-ground etching *Bixley* (cat.21).

DBB

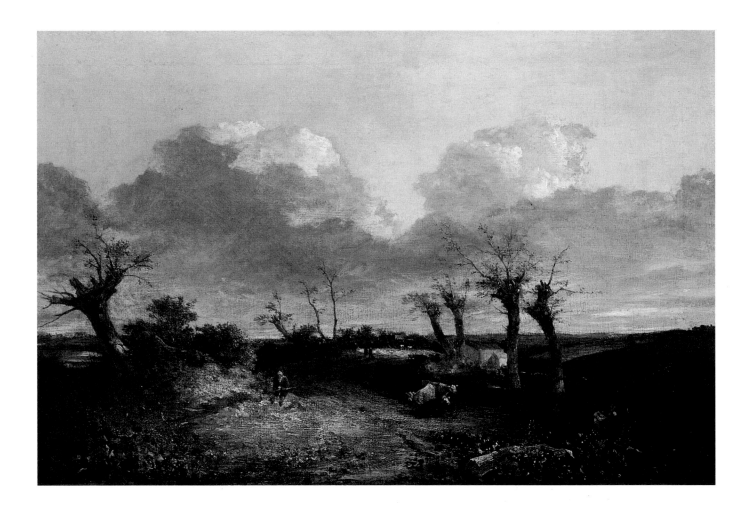

25 **The Poringland Oak** 1818

Oil on canvas 1250 × 1113
N02674. Tate Gallery. Purchased 1910

Here again Crome's fondness for the woodland manner of Hobbema and Ruysdael yields to a new concern for naturalism and for the isolated motif. An oak at Poringland – a village to the south-east of Norwich adjacent to the Framingham property of his friend and first employer Dr Edward Rigby – becomes the subject of a careful portrait. The tightly structured composition can be seen as a development from Crome's etched trees (cats.17, 21), but the fresh colour, luminous atmosphere and meticulously observed branches and foliage surely reflect recent experience of outdoor painting. Especially effective is the play of light through leaves – an effect to which Cotman was soon to find very different technical solutions (see cats.82, 85). Splendidly individualised, Crome's tree seems more a noble work of Creation – see cat.11 for his interest in natural theology – than a local or national symbol. The brushwork is reminiscent of Richard Wilson – and it is interesting to compare Crome's picture with the similarly fresh *Oak Tree* by Wilson's pupil Joseph Farington (Tate Gallery) – but the warmer tonality shows affinities with Cuyp and Turner.

Crome appears on the verge of his final flowering as a painter. The picture is usually associated with the 'Scene at Poringland' shown at the Crome Memorial Exhibition in 1821 and said in its catalogue to date from 1818. Probably the same picture appeared at the British Institution in 1824, when it had acquired the significant additional description 'Study from Nature'. It was acquired at auction in 1823 by Crome's friend William Freeman (see cat.28). Goldberg (1978, p.223) repeats but rightly rejects the claim made by the Revd Charles Steward, who acquired the picture by 1874, that the foreground figures were painted by another friend of the artist, the London-born portraitist Michael Sharpe. This may have been a misunderstanding arising from the tradition that the boys include two of Crome's sons, one of them Michael Sharpe Crome, who had been born in 1813. If this legend is true, it is tempting to connect the motif of the artist's children standing in water with Turner's *Crossing the Brook* (Tate Gallery), in which Turner's own daughters are included, and in which Dawson Turner took an interest at Crome's behest probably in 1818. The remaining youth in Crome's picture is supposed to be the son of a Mr Aldous, a mail-coach driver.

DBB

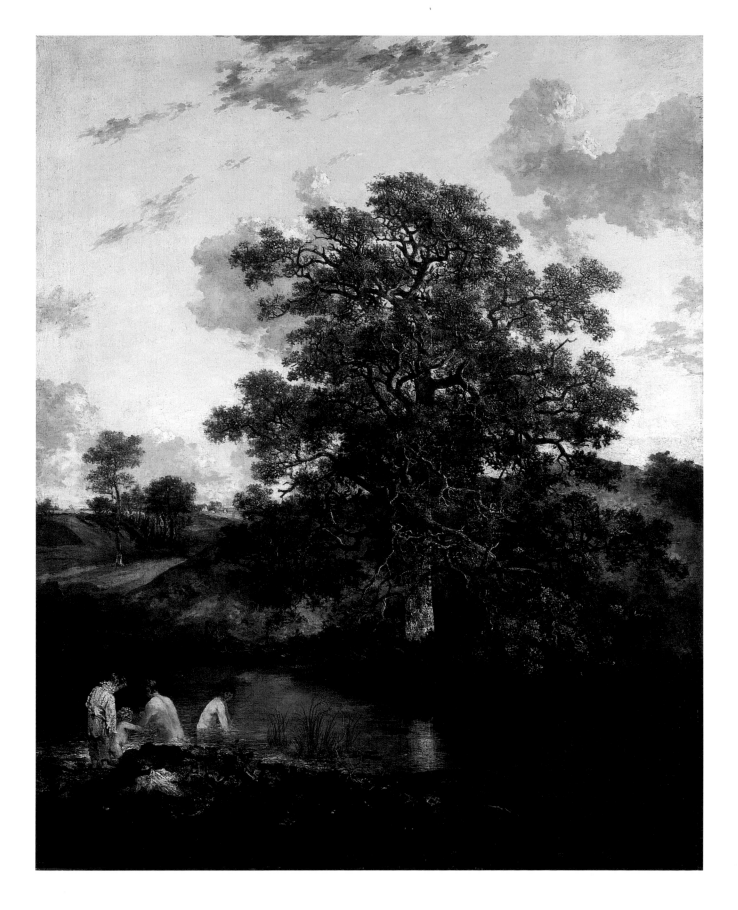

26 **Mousehold Heath** c.1818–20

Oil on canvas 1099 × 1813
N00689. Tate Gallery. Purchased 1863

Though it has no exhibition history in Crome's lifetime, this has usually been considered a late work of Crome's final maturity, in which the influence of Dutch painting can still be felt, while the atmospheric clarity and carefully observed naturalism are very contemporary. Crome's probable interest in Turner's *Frosty Morning* (fig.8) around 1818 or earlier may help to account for the open, horizontal composition and groups of wildflowers across the foreground (see above, p.29), and Cotman's even more economical watercolours of Mousehold (cats.53, 54) may also be compared. Some early accounts suggest that the picture was found to be hard to sell and was divided into two upright portions, apparently by Crome himself. This at least would be supported by a vertical join to the left of centre. Another story claims that the Windsor dealer French had a local painter add a butcher's boy driving three sheep up the central road, to add interest to the composition. There is, however, no evidence of this today, and these traditions are unconfirmed as the picture's history is not certain before c.1840, by which year it was definitely in the possession of the Yarmouth iron-founder William Yetts. It may have been sold by J.B. Crome to Joseph Stannard after Crome's death, and sold by Stannard to French, or acquired by John Berney Ladbrooke and sold by him to William Freeman. What is certain is that Crome's depiction of Mousehold as a landscape is as archaic and nostalgic as his aesthetic conception is contemporary. For centuries it had been a wasteland stretching from the city limits of Norwich to the north-east, serving only for fuel, building materials and summer pasture, and dotted with marl, chalk and gravel pits, the occasional windmill and – from 1792–3 – a cavalry barracks. Apart from the soldiers, who exercised on it, and the poor, who used it for forage, it was little used. This is how Crome shows it – as the traditional heath of open, uncultivated ground and winding, irregular tracks, and wild plants instead of cultivation; his foreground weeds are a microcosm of the larger landscape disappearing into abstract distance. But the reality was now very different, the heath having been enclosed since 1799, in line with national agricultural policy, and the land divided, in rectangular, gated fields and fenced farms, serviced by new, straight roads. Controversial as these 'improvements' were – in that they removed vital sources of food and fuel from the rural poor and effectively led to the extinction of the former yeoman class – Crome may have had more than aesthetic reasons to banish them from his picture. His library included Nathaniel Kent's *General View of the Agriculture of the County of Norfolk*, (1796), which while broadly in favour of enclosure had urged concessions to the policy to protect the rights of small farmers, and his picture probably dates from not long after the poet Robert Southey had published an essay giving a more uncompromisingly adverse account of its effects as they had since become apparent (see Fawcett 1982, and Payne 1993–4, pp.12 and 69 n.32).

DBB

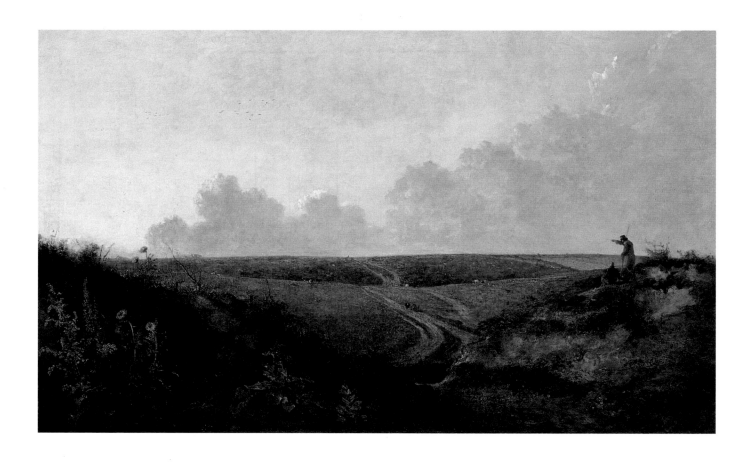

27 Norwich River: Afternoon

*c.*1819

Oil on canvas 711 × 1003
NCM 1994.189. Purchased with the aid of
the National Heritage Memorial Fund, the
Museums and Galleries Commission, the
National Art Collections Fund, a private
Family Trust, the Hilda Bacon Bequest
Fund, the Friends of the Norwich Museums
and the Norwich City Council Museum
Bequest Funds 1994

A late date is likely for this majestic composition, which might be identified with the 'Scene on Norwich River – Afternoon' shown at the Norwich Society in 1819. It can be seen as the consummate synthesis of Crome's series of Norwich riverscapes and of his pictorial influences, which seem to add Claude, in the splendid arching trees on the right, to Cuyp, Turner and Callcott. The river is the Wensum, probably near the New Mills at St Martin's at Oak, and Crome has painted it in the sultry heat of a summer afternoon with its surface glassily smooth. The luminous atmosphere, pink-edged, Cuyp-like clouds and still air may be a response to Turner's *Dort* which Crome would have seen in the Royal Academy in 1818, and would certainly justify Dawson Turner's statement that Crome brought into his later pictures an 'infusion' of Turner's 'magic light'. Hemingway (1992, p.265) notes the significance of the pleasure boat excursion as an instance of Crome's assimilation of leisure and free time into his imagery of Norwich.

DBB

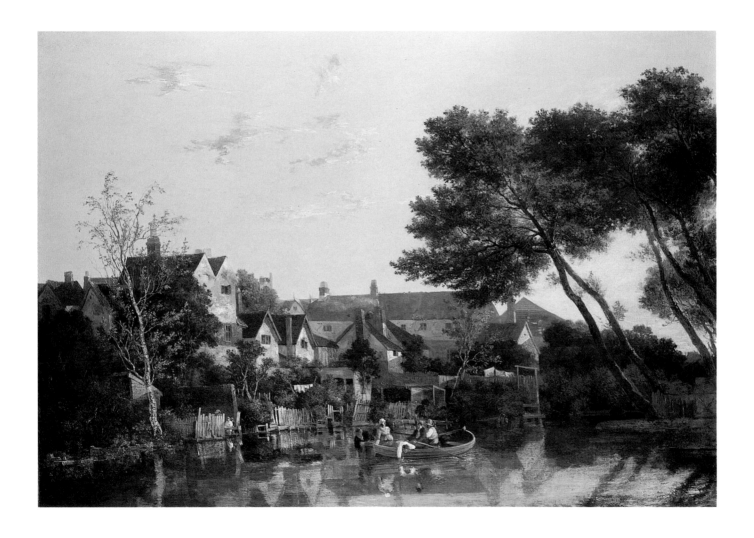

28 Paris – Italian Boulevard (Boulevard des Italiens) 1815

Oil on canvas 546 × 872
Private Collection, loaned to NCM

Crome visited Paris and the Continent in 1814, and afterwards painted three pictures based on material gathered during the tour: this (the first), the following and a moonlight view of Bruges (NCM). The Paris scene caused a 'sensation' when shown at the Norwich Society in 1815, as a 'subject very different from those he had hitherto been painting'; the *Norwich Mercury* described it as a 'spirited sketch', and in 1860, when the picture's attribution was questioned during an exhibition in Norwich in which it appeared, a correspondent to the paper claimed that 'the greater part was painted on the spot' (see Hemingway 1992, pp.208, 333 n.155). In Paris Crome lodged at 17 rue Vivienne, near the Boulevard des Italiens, and was thus able to observe the comings and goings of this busy and fashionable thoroughfare with its street stalls and diverse crowds. He has responded with unprecedented realism and vivid characterisation of the figures such as the uniformed officer and his elegant partner with her two dogs on the left, and the street traders plying their wares, from vegetables to Old Master pictures – the latter an acknowledgement of Crome's own interests in Paris as a *marchand amateur* who, as he wrote home to his wife, would 'make this visit pay'. While promoting his own career as a painter by exhibiting a 'Vue des Environs de Norwich' to an exhibition at the Musée Royal des Arts in November 1814, he was also busy, with his companions Daniel Coppin and William Freeman, scouting out opportunities as a dealer and restorer. He evidently managed to smuggle some pictures back to England, and he was keen to develop his art-historical knowledge by visits to the Louvre, where the 'Musée Napoléon' of looted treasure had not yet been dispersed. He also visited French painters, announcing his intention of calling on Jacques-Louis David, and it is tempting to speculate that he saw the lively Parisian street scenes of Louis-Léopold Boilly, by whom a 'Drawing, finely coloured' had been included in the sale of his collection at Yarmouth in 1812 (25 September, day 3, lot 426). Moreover his unprecedented interest in costume may have been prompted by fashion plates seen in print dealers – for example, those published in the *Nouvel Almanack des Modes* or the series of *Incroyables et Merveilleuses* designed by Horace Vernet and engraved by Georges-Jacques Gatine (1810–18). Nevertheless, this is one of his least derivative pictures, progressing far beyond the conventions of Dutch or French townscape in its bold, double perspective, divided by rows of market stalls and avenues of trees swaying rhythmically in a light summer breeze. Detail and incident are minutely observed, and the palette, with its pinks and yellows, is markedly clearer and sharper than hitherto, utilising, no doubt, purchases at Parisian colourmen's shops. Continental urban scenes like this were soon to become a popular genre as the end of the Napoleonic War brought a surge in tourism and a middle-class market for engraved illustrations and topographical books; Dibdin's *Biographical Antiquarian and Picturesque Tour in France* (1821) contained an engraving after G. Lewis of a comparable view of the Boulevard des Italiens, and see Warrell 1999, pp.243 and 262 n.210 for others including Turner's. Crome's, however, is among the earliest if not actually the first, and was not to be exceeded in its freshness and spontaneity. By 1821 it was in the possession of Hudson Gurney, who had visited Paris in 1802 and 1814, and who perhaps acquired it as a gesture to his wife.

DBB

29 **Fish Market at Boulogne** 1820

Oil on canvas 527 × 864
Private Collection, loaned to NCM

This, the third and last of Crome's Continental scenes based on his 1814 tour, was exhibited at the Norwich Society in 1820 and acquired by his travelling companion in France, William Freeman. It later joined the 'Italian Boulevard' in the collection of Hudson Gurney. The location of Boulogne itself has been questioned, and Crome's title may indicate only the general area of his subject. By comparison with the earlier picture, it shows a further advance in brightness of colour – especially in yellows ranging from ochre to lemon-peel – and

freedom of handling. The airy effect of the background, with its cliffs receding into a summer haze, can be traced to the influence of Cuyp – to whom a 'Fishmarket at Scheveling' (*sic*) in Crome's sale at Yarmouth in 1821(25 September, day 1, lot 60) was attributed – but, together with the treatment of the foreground figures, seems to have puzzled Crome's Norwich audience. While the *Norfolk Chronicle*, whose admiration for the Paris scene was noted above, commended his diversity in being able to turn from his usual 'rural landscape' to the 'equally skilful and still more interesting delineation of national character and costume', it considered that the lack of 'forcibleness and animation' in the

figures produced 'only the impression of a sketch'. While lack of finish was a common cause of critical complaint at the end of Crome's life, his late, unrestrained style was increasingly appreciated by his fellow painters. Though they could not have known each other's work at this stage, his luminous and animated approach to the French coast, with its varied figures and still life of fish on the beach, can be compared with the *Fishmarket at Boulogne* shown by Bonington at the Paris Salon in 1824 (New Haven, Yale Center for British Art), suggesting a near-parallel development by the two artists in a vein of Anglo-Dutch naturalism.

DBB

30 Yarmouth Water Frolic – Evening: Boats assembling previous to the Rowing Match
1821

Oil on canvas 1060 × 1727
English Heritage (Kenwood)

John Berney Crome was a precocious and successful pupil and follower of his father, who before the older Crome's death had become President of the Norwich Society and after it took over his teaching duties in the city and probably some of his pictures as well. This is likely to be the case with this picture, which is based on an oil sketch still widely accepted as by John Crome (private collection) but was exhibited at the Norwich Society in 1821, the year of his death, as by the son. It shows significant developments from the sketch, with a rowing boat, buoy and raft introduced into the foreground, and a steam-boat moored on

the right – a remarkable instance of modernity not so far found in any other major oil up to this date. By comparison with the broad and creamy brushwork achieved by the older artist in the previous year's picture of Boulogne, it is much drier and crisper in handling though retaining the essentially Cuypish tonality and lighting. Though usually compared to Turner's *Dort*, exhibited at the Royal Academy in 1818, the execution and composition are actually much closer to A.W. Callcott's large tranquil marines *The Pool of London* (Bowood) – admired by Turner himself in the Academy in 1816 – and *Rotterdam* (private collection), shown there in 1819. However, as observed by Hemingway (1992, p.281), it differs from all of these in its compositional symmetry. Hawcroft (1968, p.15) speculated that the exhibited picture could have been the six-foot canvas that both Dawson Turner and John

Wodderspoon stated had been originally prepared by John Crome, shortly before his death, for a picture of the water frolic at Wroxham; this could imply either a connection or a confusion with a large picture of the Wroxham frolic that James Stark had shown at the British Institution in 1819. Water frolics with sailing and rowing competitions were a feature of Norfolk life, and the subject of several large compositions by Norwich artists. See cat.109 for Joseph Stannard's view of the frolic at Thorpe, exhibited in 1825. The event at Yarmouth, the most important, is described in the letterpress to Stark's *Rivers of Norfolk* (1834). It occurred in July, when the mayors of Norwich and Yarmouth met in their state barges on the Yare at Hadley Cross, near their civic boundaries, and then progressed to Breydon Water, where the Yare, Waveney and Bure meet, to host 'a dance of ships ... a fair afloat'.

DBB

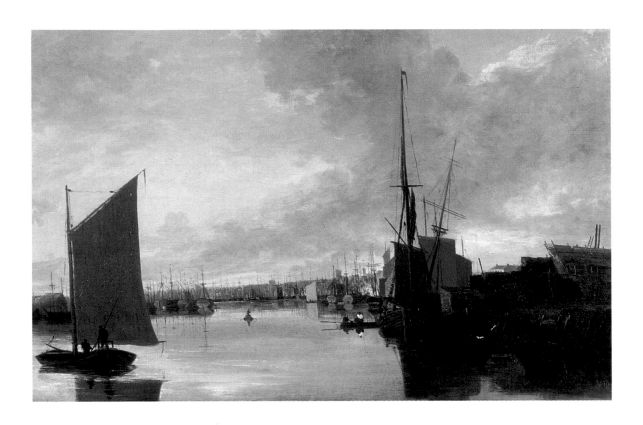

31 **Yarmouth Harbour, Evening**
*c.*1816–21

Oil on canvas 406 × 660
N05361. Bequeathed by S. Arthur Peto
1942

Usually attributed to the older Crome – and by a previous owner to Turner – this beautiful riverscape is here attributed to John Berney Crome on the basis of comparison with the preceding picture. The dry paint and sharp definition of form, together with the brilliant, crystalline lighting, are common to both pictures. Between 1814 and 1818 John Berney had made a practice of exhibiting works described as oil sketches, some said to be 'painted on the spot', of which this could perhaps be one. It might also be identifiable with his 'View on the River at Yarmouth' recorded in the possession of the Yarmouth collector Samuel Paget.

DBB

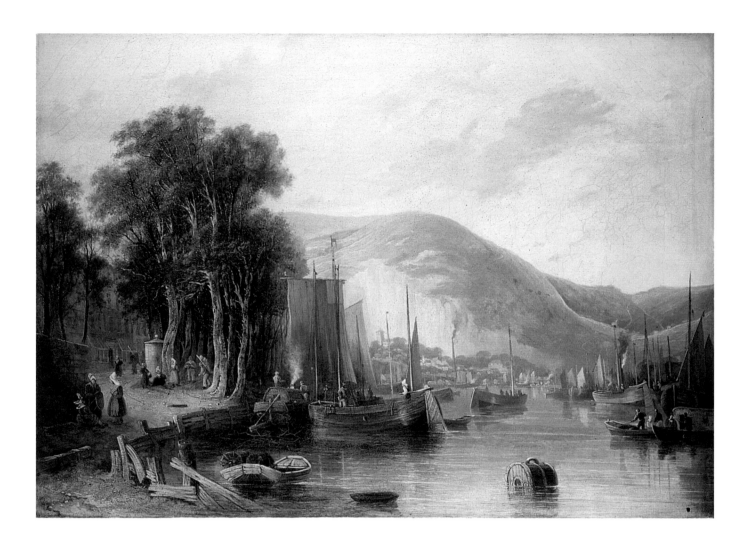

32 **Rouen** ?1822–3

Oil on canvas 740 × 1022
NCM 1935.131. Purchased with the aid of
the Beecheno Bequest Fund 1935

The younger Crome visited France for the
first time in 1816, with George Vincent and
a surgeon friend, Mr Steele, who was later
to become his brother-in-law. Like his
father, he investigated his French contem-
poraries but remained unimpressed, and as
John Crome dryly reported to James Stark,
'I believe he is not petrified from having
seen the French School. He says in his
letter something about Tea-Tray painters'.
Like his father, he owed more to the Dutch,
but also followed his own impressions in
his Continental scenes, which included

eight Rouen subjects, shown at the Nor-
wich Society from 1817 to great acclaim.
Rouen indeed became one of his most
popular themes, of which he also showed
pictures in Hull, Manchester, London (at
both the Royal Academy and British Insti-
tution) and Dublin between 1827 and
1841. Reflecting its importance as a stop
on the new steamer tours of the Seine, and
as a medieval city with a famous cathedral,
now transformed into a modern industrial
hub, it was already becoming a familiar
subject at the Royal Academy, beginning
with views by Stark's friend William
Collins, and Henry Edridge, in 1818 and
1819, before becoming the object of close
scrutiny by Turner (see Warrell 1999,
pp.166ff. for Turner at Rouen, and Warrell

1997, p.206 n.9 for contemporary views by
other artists). Among Norwich colleagues
Crome's survey coincides closely with
Cotman's (cats.73, 75, 76), but concen-
trates on the river scenery of the Seine
rather than the architectural antiquities of
the city. The view is up river from a point
beyond the famous bridge of boats (which
appears in another view in NCM) looking
towards Mont Ste Catherine; the Quai du
Havre and the steamer landings are on the
left and the Ile Lacroix on the right. The
stone Pont d'Angoulême was not yet built.
Best known for his moonlight views of the
Continent, Crome opts for a daylight effect,
echoing his father's French subjects,
especially his Boulevard des Italiens in the
glimpse of the busy, tree-lined Quai.

DBB

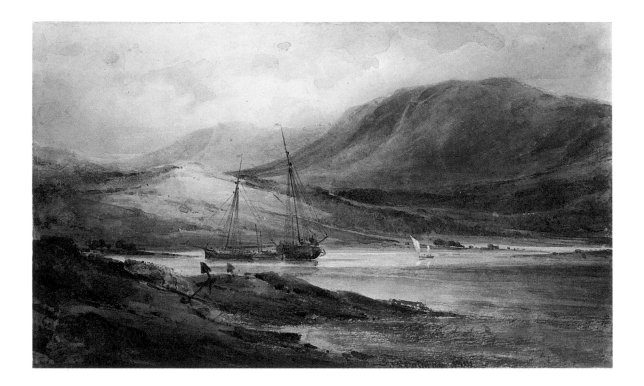

33 **Barmouth Estuary** 1801

Pencil and watercolour with some gum on
paper 174 × 288
Signed and dated in black ink lower right
'J S Cotman 1801', and on verso in pencil
'John S Cotman 1801 | Barmouth, N
Wales'
NCM 1947.217.125. Russell James Colman
Bequest 1946

If Crome was the foremost figure amongst
the oil painters of the Norwich School,
Cotman was undeniably its most talented
watercolourist. Born in Norwich in the
parish of St Mary Coslany, he was fond of
drawing from an early age, though he
appears to have had little in the way of for-
mal training before his arrival in London
in 1798 at the age of sixteen. Such was the
development of his artistic skills over the
following two years, however, that in 1800
he was awarded the large silver palette by
the Society of Arts.

Whilst based in London over the next six
years, Cotman embarked on a number of
sketching tours around Britain. The first
two of these, in 1800 and 1802, took him

to Wales, a popular destination at this date
for travellers and artists alike; for whilst, as
one contemporary guidebook put it, 'the
beauties of South Wales are certainly well
worthy of attention', 'the whole complex-
ion of North Wales is bold and sublime'
([E.D. Clarke], *A Tour through the South of
England, Wales, and Part of Ireland*, 1793).

This finished watercolour was worked
up by Cotman from pencil sketches he had
made on his first tour to Wales in 1800 and
shows the estuary from Barmouth sands,
with Cader Idris in the distance. With its
subdued, near-monochrome palette it is
very typical of the watercolours he made in
the period 1800–1, whilst there is a
breadth in the rendering of space and
atmosphere which suggests that he had
been looking at the work of his contempor-
ary Thomas Girtin (see cat.34). In 1804
Cotman made a much larger and more
ambitious version of this subject, with
cattle and fishermen, which he exhibited at
the Royal Academy in the same year (Eton
College Collection).

AL

34 **Llanthony Abbey** 1801

Watercolour on paper 438 × 330
Signed and dated in brown watercolour
wash lower right 'Cotman.1801', and
inscribed on verso in ink 'Llantony Abbey |
S.Wales'
T00970. Presented by the National Art
Collections Fund from the Herbert Powell
Bequest 1967

Given that the Continent was more or less
closed to foreign visitors during this period
owing to the French Revolutionary and
Napoleonic Wars (1793–1815), British
artists and travellers increasingly turned
their attention to exploring landscapes and
monuments close to home. Wales and the
Lake District were popular destinations
thanks to the beauty and drama of their
natural scenery. However, given the
contemporary fashion for picturesque
topography and the flourishing market in
antiquarian views, another incentive for
artists to visit Wales at this date was to
make sketches of its many castles, Gothic
cathedrals and ruined abbeys. Their
sketches could then be worked up into
finished watercolours suitable for sale or
exhibition, or translated into engravings
and used as illustrations to guidebooks or
historical surveys of medieval architecture.

Cotman visited the ruined abbey at
Llanthony in Monmouthshire in July 1800,
and exhibited this watercolour at the Royal
Academy the following year. Contem-
porary guidebooks tended to stress the
abbey's isolated and striking position,
'wholly encircled by an amphitheatre of
bleak and lofty mountains'. Cotman,
however, has chosen to depict a close-up
section of the ruins, positioning himself
under the crossing of the central tower and
selecting a low viewpoint so as to exagger-
ate the impression of soaring masonry.
Similar watercolours stressing the monu-
mentality of ancient ruins were produced
by J.M.W. Turner and Thomas Girtin in the
1790s. Cotman would have become famil-
iar with their work from 1799, when he is
recorded as attending the informal 'Acad-
emy' set up by the collector and patron Dr
Monro at his house in Adelphi Terrace,
London, to further the careers of promising
young artists.

AL

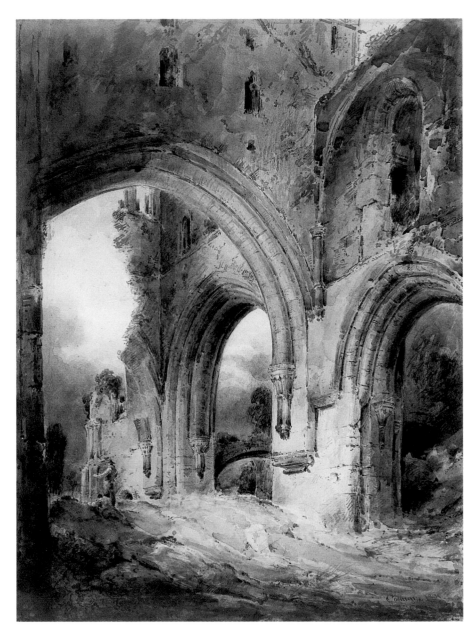

35 Doorway of the Refectory, Rievaulx Abbey 1803

Watercolour over pencil on paper
319 × 255
Inscribed twice in pencil along upper edge
'Ivy' and lower right 'Rivaulx Abbey Augt
8 1803', and numbered in pen and brown
ink lower right '6'
T08248. Purchased as part of the Oppé
Collection with assistance from the
National Lottery through the Heritage
Lottery Fund 1996

In the summer of 1803 Cotman set off on another sketching tour, this time to Yorkshire, travelling with his friend and fellow artist Paul Sandby Munn, with whom he had also visited Wales the previous year. Their destination was Brandsby Hall, some fifteen miles north of York, and home of the Cholmeley family to whom Cotman had been given an introduction by an earlier patron – Sir Henry Englefield – who was Mrs Cholmeley's brother. Here Cotman was to spend three successive and very happy summers, teaching drawing to members of the family and exploring the impressive scenery of the North Riding. It was during this period – perhaps the most impressionable of his life – that he developed the distinctive, simplified watercolour style for which he is especially remembered today.

Cotman first made drawings of the ruined Cistercian abbey at Rievaulx near Helmsley in July 1803, when sketching alongside Sandby Munn – Mrs Cholmeley recorded that it was 'altogether the finest ruin they had ever seen'. This study, however, was made by Cotman the following month when he returned to the site on his own. It is an important transitional watercolour which shows him abandoning the sombre palette and strong tonal contrasts of his early work (cats.33, 34) and beginning to suggest local colour by superimposing cleaner and flatter wash layers. Seven years later he made an etching of this subject and then sent a proof impression to the young Francis Cholmeley at Brandsby, who singled it out for special praise, declaring that it was 'a work of art I prefer to any'.

AL

36 **Behold Yon Oak** 1804

Pencil and grey wash on paper 312 × 447
Signed and dated in brown ink lower right
'J S Cotman' and inscribed on old mount
'Jany. 26 1804 – Thursday | Subject-
Behold Yon Oak – | How stern he frowns,
and with his broad brown horns | Chills
the pale plain beneath him. Mark yon
Altar, | The dark stream brawling round its
rugged base: | These cliffs, these yawning
caverns CAR-ACTACUS. | J.S.Cotman,
prest. – P.Munn – J.Varley – J.Powell –
Visitor, | Stevens.'
NCM 1951.235.296. Russell James Colman
Bequest 1946

The long inscription which was once
recorded on the old mount of this drawing
(see above) shows that it was executed at
one of the meetings of an artistic fraternity
known as the Sketching Society. This Soci-
ety had been founded in 1799 by a group of
young painters – mainly watercolourists –
with the aim of 'establishing by practice a
school of Historical Landscape, the subjects
being original designs from poetical pas-
sages'. The artists met in the evening and
each member of the Society took turns in
being host, thus selecting the literary
quotation they would illustrate and also
providing the venue and the materials.
They executed their imaginary designs in
dark monochrome washes, perhaps heed-
ing Sir Joshua Reynolds's advice to obtain
'grandeur of effect ... by reducing colours
to little more than chiaroscuro' (4th Dis-
course, 1771).

In the early years, Thomas Girtin seems
to have been the Society's leading figure,
but in about 1802 it reformulated itself and
came under Cotman's direction. According
to the inscription, Cotman was President
on the evening this drawing was made, so
he himself would have selected the passage
for illustration. He chose an episode of
ancient British history as told in William
Mason's tragedy *Caractacus* (1759) which
concerns the Roman occupation of Britain
during the reign of Claudius. In his own
composition he has given his imagination
full rein, including a menacingly dark sky,
a blasted oak with a fantastically shaped
branch and – in the distance – a group of
ancient dolmen-like stones perhaps sug-
gested to him by the 'mighty piles of magic
planted rock' referred to in the poem's
opening lines.

AL

37 **Harlech Castle** c.1804

Pencil and watercolour with scraping out
on paper 264 × 427
Signed in brown watercolour wash lower
right 'J S Cotman'
T00969. Presented by the National Art
Collections Fund from the Herbert Powell
Bequest 1967

The magnificent setting of Harlech Castle, high on a precipice overlooking the sea at Tremadoc Bay, made it a natural stopping place for visitors touring north Wales in the late eighteenth and nineteenth centuries. In addition, Paul Sandby had helped to popularise the location of the castle by including it in his influential series of aquatints, *XII Views in North Wales*, published in 1776. Cotman himself was sufficiently attracted by the subject that he exhibited a version of it – at the Royal Academy in May 1800 – even before he appears to have visited the castle for himself in late July of that same year.

That early exhibit must have been based on a print or drawing by another artist. This watercolour, however, was almost certainly worked up by Cotman from his own sketches of the castle made on the spot in July 1800 showing the castle from its southern aspect (NCM; Rajnai and Allthorpe-Guyton 1979, nos.7 and 8). In the sketches, Cotman shows the castle from close to, but here he has placed it in its wider panoramic context and includes the striking backdrop of Snowdon's high peaks.

This drawing can probably be identified with the version of Harlech that Cotman exhibited at the Norwich Society of Artists in 1807. Like many of his early watercolours, it has lost its indigos through fading – as is confirmed by the survival of a thin strip of blue along the left-hand edge. Not only has the colour balance of the design therefore been altered, but the action of fading has left a range of pinkish-brown tones which Cotman never originally intended.

AL

38 St Botolph's Priory, Colchester
*c.*1804–5

Pencil and watercolour on paper 357 × 521
NCM 1947.217.128. Russell James Colman
Bequest 1946

The ruins of the Norman priory at Colchester in Essex were of considerable interest to the late eighteenth-century antiquarian. This was especially true of the western façade, prominent in Cotman's watercolour, with its tiers of small arches incorporating Roman brick and half the perimeter of a circular window above. The round-headed arches interlace to create an impression of pointed arches where they intersect, a pattern 'from which the idea of a pointed arch is thought by some to have been conceived' (ed. J. Britton and E.W. Brayley, *The Beauties of England and Wales*, 1803, vol.v; quoted Conner 1984, p.82).

All these architectural details are thoroughly legible in Cotman's watercolour, as one might expect from an artist who was later to develop such an interest in antiquarian subject-matter. Yet whilst his eighteenth-century predecessors had tended to represent the western façade from a position close to, and aligned directly in front of, the great portal, Cotman adopts a more distant, low and slightly oblique viewpoint. This helps not only to give the surrounding landscape equal weight, but it also serves to emphasise the grandeur of the ruins which form a striking silhouette against his boldly painted sky. In 1811 he published a print of St Botolph's – 'etched decidedly for the Piranesi effect', he told his friend Francis Cholmeley – in which he reduced the landscape setting so as to emphasise the subject's antiquarian interest (see cat.61).

Cotman's biographer suggested that he sketched the ruins of St Botolph's Priory on his way from London to stay with his patron Dawson Turner at Covehithe on the Suffolk coast in July 1804 (Kitson 1937, p.67). However, Cotman could have sketched the priory on any of his journeys between London and Norwich around this date.

AL

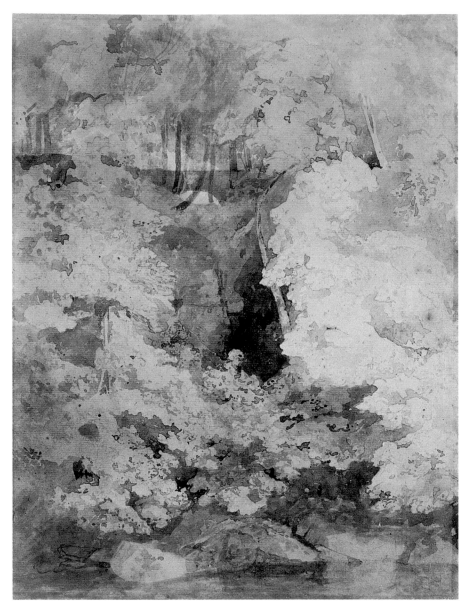

39 **Greta Woods** *c.*1805–6

Pencil and watercolour on paper 435 × 334
Private Collection

In the summer of 1805 Cotman embarked
on his third and last visit to stay with the
Cholmeley family at Brandsby Hall in York-
shire. In many ways this last visit was to be
his most productive for, in addition to the
watercolours he made in the vicinity of
Brandsby that year, Cotman also gathered
a wealth of material on the River Greta
near Rokeby Hall on the Yorkshire-
Durham border – material which was to
inspire what have been described as 'the
most perfect examples of pure watercolour
ever painted in Europe' (Binyon 1931,
p.132; see also cats.40–3).

Cotman arrived at Rokeby at the end of
July, and remained in the area nearly five
weeks. For the first three of these he was
the guest, with his friend Francis Cholme-
ley, of the Morritts of Rokeby Hall. The rest
of his stay was spent at the local inn. All
the while he was absorbed in sketching,
inspired by the remarkable beauty of the
wooded slopes and winding paths close to
the River Greta in and near the Park at
Rokeby Hall. Indeed a guidebook published
in 1803 had singled out the attractions of
this very area, remarking in particular on
the 'fine transparency of the stream, its
amber colour, and rapid but silent course',
as well as the 'beauty of the banks, shaded
with oaks; and the rocks and rich hanging-
wood' (Richard Garland, *A Tour in Teesdale*,
York, 1803, p.14). Not only, in the author's
opinion, was the walk along the Greta
'highly romantic', but the beauties of Tees-
dale in general had 'powerful claims on the
Painter and the Tourist' alike (ibid. p.11).

This watercolour is one of the very few
of the Greta drawings which can be identi-
fied with certainty as a site within Rokeby
Park itself. It is only a short walk from the
Hall, with the small bridge still in position
and the river bank bordering Mortham
woods as luxuriant as ever (Rajnai et al.
1982, p.67). 'A gully on the steep bank of
the river is spanned at the top by a little
stone foot-bridge, which stands up dark
against a blue sky', writes Cotman's biog-
rapher of this watercolour. 'The trees cling
to the rocks, and obtain a root-hold where
they may ... The picture is there, composed
by Nature: Cotman saw it and endowed it
with a magic quality which was all his
own' (Kitson 1937, p.84).

AL

40 **Pool** *c.*1805–6

Pencil and watercolour with some blue
bodycolour on paper 306 × 226
NCM 1951.235.270. Russell James Colman
Bequest 1946

In a number of watercolours belonging to
the Greta series – whether made within or
outside the boundaries of Rokeby Park
itself – Cotman chose to concentrate on
close-up views of the riverbank, their com-
positions consisting of little more than the
apparently unpromising ingredients of
water, boulders, tree trunks or overhang-
ing foliage. No other British artist had
previously attempted to make complete
designs like these featuring such humble,
isolated natural motifs seen from so close a
viewpoint. That Cotman was able to make
so much from so little was thanks partly to
his intuitive pictorial sense but also, above
all, to his remarkable control in the hand-
ling of the watercolour medium itself.

By this date Cotman was using pure,
translucent wash layers, and applying
them without any underpainting and with
the minimum of shadow. His wash layers
are laid one over the other in a very careful
and controlled way, without any evidence
of blotting, so that they leave clean, crisp
edges which help to define form and shape.
He tends to avoid any effect of movement in
his watercolours, and – in denial of tradi-
tional methods of creating depth in a
picture – reduces natural forms to simple,
flat shapes, arranging them in planes very
close to the picture surface (Stainton 1985,
p.58). In this way he succeeds in creating
semi-abstract images which are curiously
compelling in their combination of shape
and pattern. This example, painted in
attractive shades of yellow, soft greens and
grey, is almost austere in its simplicity yet –
at the same time – decorative in its pictori-
al rhythms. Indeed, one author has telling-
ly described Cotman's work in this period
as 'a compound of logic and poetry'
(Hardie 1967, vol.2, p.81).

The touches of blue bodycolour in this
drawing – that is, watercolour pigment
mixed with lead white to make it opaque –
are uncharacteristic of Cotman's work at
this period, and thought by some writers to
have been added later by another hand
(Rajnai and Allthorpe-Guyton 1979, p.56).
However, there are touches of white body-
colour in cat.41 as well, a Greta drawing
which dates from about the same time.

AL

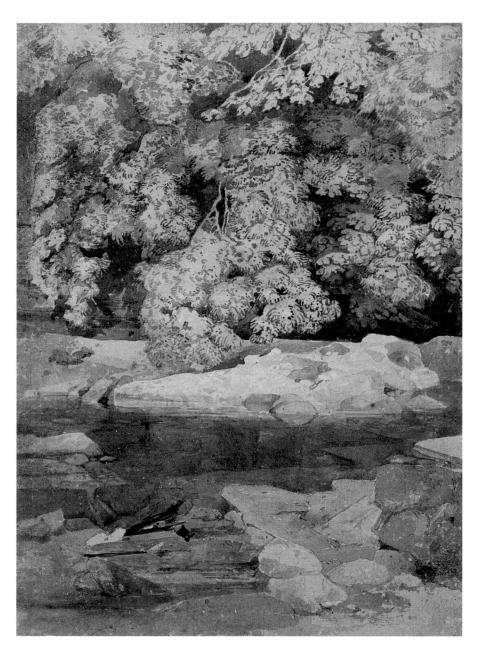

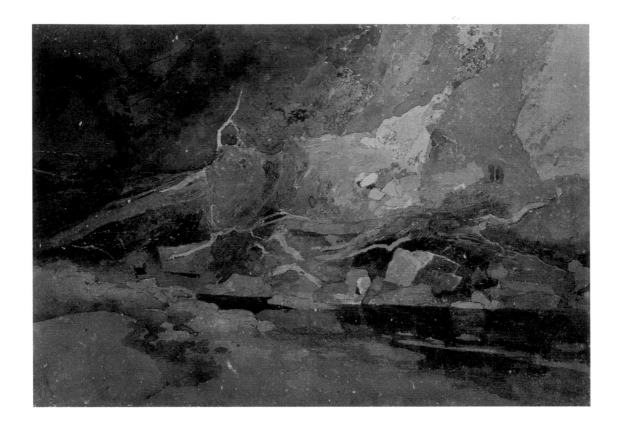

41 **On the Greta** *c.*1805–6

Pencil and watercolour with some white
bodycolour on paper 228 × 333
Inscribed in pencil on verso 'On the Greta'
and numbered in pen and brown ink '20'
T08145. Purchased as part of the Oppé
Collection with assistance from the
National Lottery through the Heritage
Lottery Fund 1996

When gathering material on tour, most
landscape watercolour painters in this
period chose to make pencil or chalk
sketches on the spot. They would then
work up these studies into finished compo-
sitions in the comfort of their studios at a
later date. Some of Cotman's Greta water-
colours relate very closely to monochrome
sketches of this sort – for example, cats.42,
43 and 58 – and are therefore almost
certainly works evolved in the tranquillity
of the studio.

However, at the end of 1805, Cotman
wrote in a letter to his patron Dawson

Turner that his 'chief study' the previous
summer in Yorkshire and Durham had
been 'colouring from Nature', and that
many of the sketches he had made were
'close copies of that ficle Dame, conse-
quently valuable on that account'. This
letter has given rise to much speculation as
to which of the extant Greta watercolours
might have been coloured by Cotman in
the open air, and indeed opinion still
remains divided on this subject. Some writ-
ers have argued that all the Greta drawings
are too formal in their designs and too con-
trolled in their execution to be the products
of outdoor work. Others, such as Andrew
Hemingway (1997, pp.196–7), have tended
to make a distinction between those water-
colours 'which have an improvisatory and
sketch-like quality' and could well there-
fore be *plein-air* works, and those which
look more finished and are more likely to
be products of the studio.

This watercolour is exactly the sort of

image which might be interpreted either as
an on-the-spot sketch or as a later, finished
design. It is, perhaps, unlikely that conclu-
sive evidence will ever materialise to prove
the case in either direction (sixteen sheets
of so-called Greta drawings which turned
up on the London market in the 1980s
with an attribution to Cotman have since
been firmly discredited). However, it is per-
haps worth citing Paul Oppé's observation
that close-up studies of bank, water, tree
trunks and rock, without any sky or dis-
tance, would have been an especially con-
venient choice of subject-matter for an
artist when attempting to colour from
nature, being comparatively independent
of atmospheric change (Oppé 1923,
pp.viii–ix).

AL

42 'Devil's Elbow, Rokeby Park'
*c.*1806–7

Pencil and watercolour on paper 451 × 351
NCM 1947.217.134. Russell James Colman
Bequest 1946

Cotman's friend, Francis Cholmeley, left
Rokeby Hall on 20 August 1805 and, con-
fronted also by the imminent departure of
his hosts, the Morritts, Cotman moved out
of the house and settled at the local inn at
Greta Bridge where he remained until early
September. It greatly saddened him to have
left the Hall – he wrote a letter to Cholme-
ley in late August explaining how he felt
'quite wretch[e]d' every time he passed the
house or park gates. Things improved,
however, once he had decided to 'avoid it
systematically' and he then went on to tell
Cholmeley that he had been making all his
studies 'in the wood above the bridge' –
that is upstream, away from Rokeby Hall –
and that 'it grows upon me in my regard
every day, it realy is a delicious spot'. In
fact, he wrote, he could not recall being
more happily occupied than during that
past week, 'industriously employed upon a
subject that call[s] forth all my powers'.

Despite the traditional title of this water-
colour identifying the site of the 'Devil's
Elbow' as within Rokeby Park itself, it is in
fact more likely that the true location of
this view is beyond the boundaries of the
park upstream of Greta Bridge, somewhere
between Mill Wood and the so-called
'Scotchman's Stone'. With its curious air of
enchantment and its 'timeless monumen-
tality', it has been described as 'without
doubt one of his greatest drawings and one
of the most original contributions to Euro-
pean art of its time' (Rajnai and Allthorpe-
Guyton 1979, p.60).

AL

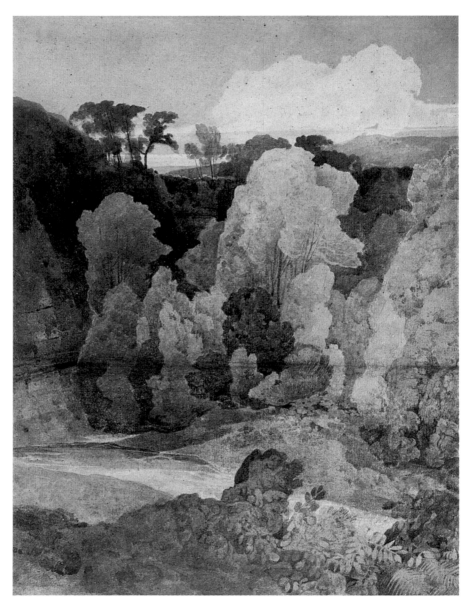

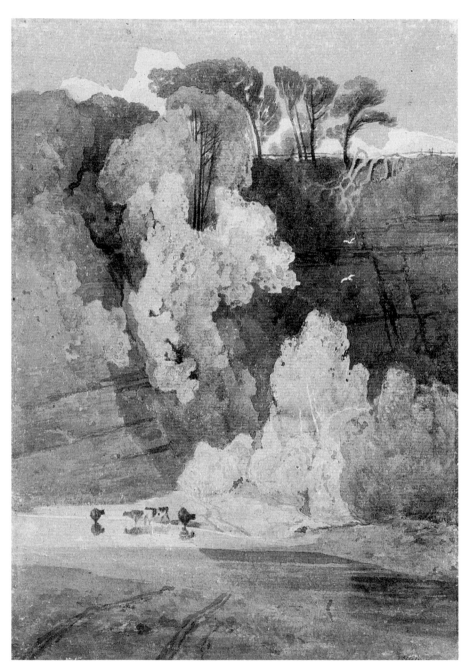

43 On the River Greta, Yorkshire
*c.*1806–7

Pencil and watercolour with some scraping
out on paper 326 × 229
Signed in brown watercolour lower right
'J.S.Cotman'; and on verso, backing paper
numbered, inscribed and signed in brown
ink 'No 68 | On the River Greta | Yorkshire
| J.Cotman'
NCM 1961.84. Col. H. Littlewood Bequest
1961

Four years after Cotman's visit to Rokeby
Park, the poet Sir Walter Scott was to find
himself similarly captivated by the extraor-
dinary beauty of the scenery there, declar-
ing it to be 'one of the most enviable places
he had ever seen'. Scott's visit in 1809 was
followed by a second stay in 1812, shortly
after which he composed a long poem,
Rokeby, dedicated to John Morritt and
which, though set in the period of the
English Civil War, contained some faithful
descriptions of the local scenery. For exam-
ple, one of the stanzas describes a site in
the park known as 'the romantic glen',
which by tradition was supposed to be
haunted by a female spectre known as the
'Dobie of Mortham':

> The cliffs that rear their haughty head
> High o'er the river's darksome bed,
> Were now all naked, wild, and grey,
> Now waving all with greenwood spray;
> Here trees to every crevice clung,
> And o'er the dell their branches hung;
> And there, all splinter'd and uneven,
> The shiver'd rocks ascend to heaven;
> Oft, too, the ivy swath'd their breast,
> And wreathed its garland round their crest,
> Or from the spires bade loosely flare
> Its tendrils in the middle air ...
>
> (Canto II, viii, lines 1–12)

Although this drawing by Cotman, like
cat.42, is probably identifiable with the
stretch of the river outside the park
between Mill Wood and the Scotchman's
Stone where it is bounded by cliffs and
high, steep banks, together the two water-
colours capture something of the eery,
rather 'Gothic' connotations associated
with the Rokeby area and so well evoked in
Scott's verse (see Hemingway 1997,
pp.193–4).

AL

44 The *Mars,* riding at Anchor off Cromer *c.*1807

Pencil and watercolour with some scraping out on paper 308 × 220
Signed in brown ink at r. lower corner 'J S Cotman'
NCM 1947.217.139. Russell James Colman Bequest 1946

Cotman was drawn to Cromer, on the Norfolk coast, by his courtship of Ann Miles of nearby Felbrigg (for other Norwich artists and Cromer, see p.132 below). For Cotman, Cromer and Yarmouth together inspired him to broaden his range from landscape and antiquarian topography to marine subjects. This watercolour is the best documented of all his marines. The subject must date to 31 July 1807, when the *Mars,* a naval warship of seventy-four guns, anchored off Cromer during a break from duties in Scandinavian waters. Cotman must have known of the ship as its captain, William Lukin, was the brother of the Revd John Lukin, who married him and Ann in 1809. His watercolour, however, must be a largely imaginary conception since a ship of this size would have had to anchor much further off shore, especially in the squally conditions that records show prevailing that day. Using the same upright format that he had favoured for many of his Yorkshire subjects, Cotman has achieved a design of noble simplicity, based on the interplay of verticals and slanting diagonals; beached boats, beachcombers, the warship's rigging and the three birds wheeling over the shore all echo the upward thrust that reaches its climax in the mass of cumulus cloud. All is centred on the *Mars,* and attendant smaller boats, rendered in transparent washes as almost ghostly presences. The watercolour was probably shown at the Norwich Society in 1808.

DBB

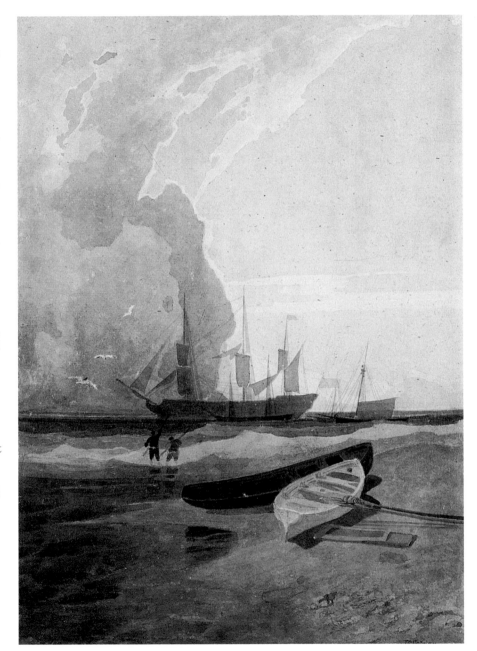

45 Interior of Trentham Church, Staffordshire c.1807–8

Pencil and watercolour on paper 545 × 410
Signed in brown watercolour lower left
'J.S.Cotman'
NCM 1947.217.133. Russell James Colman
Bequest 1946

Trentham Hall near Stoke on Trent was the country seat of the 2nd Marquess of Stafford, an important English collector and patron of the arts. Cotman was invited to stay at the hall in 1806, his entrée presumably engineered by the Marquess's sister, Lady Carlisle, whom he had met the previous summer at Castle Howard when staying with the Cholmeleys at nearby Brandsby. Mrs Cholmeley wrote to Cotman in July to warn him not to expect too much from the phenomenally wealthy Marquess – 'the Patronage of ye most rich and powerful is very rarely so advantageous as it ought to be' she cautioned. Indeed, although the Marquess did purchase a watercolour by Cotman of *Croyland Abbey*, now untraced, little else seems to have materialised for the artist in the way of commissions. In fact, the only known surviving record of Cotman's stay at Trentham is this striking large watercolour of the interior of St Mary and All Saints Church, worked up by him a year or two later following his return to Norwich.

 With his unerring eye for pictorial design, Cotman has selected his viewpoint to make the impressive Jacobean chancel screen the composition's key focus. Subtle tones of grey, buff, ochre, pale gold and russet are offset by the sumptuous colours of the pulpit hangings with their 'tissue of gold and silver embroidery on rich velvet' – these had been made up from 'a Moorish saddle cloth presented by the Emperor of Morocco to George III', and later acquired by the Marquess of Stafford who presented it to the church (Rajnai and Allthorpe-Guyton 1979, p.68). The strong cast shadow in the foreground draws our attention to the subtle patterns Cotman has created by exploiting the irregular size, uneven surface and varied hues of a number of flagstones leading up to the chancel screen.

AL

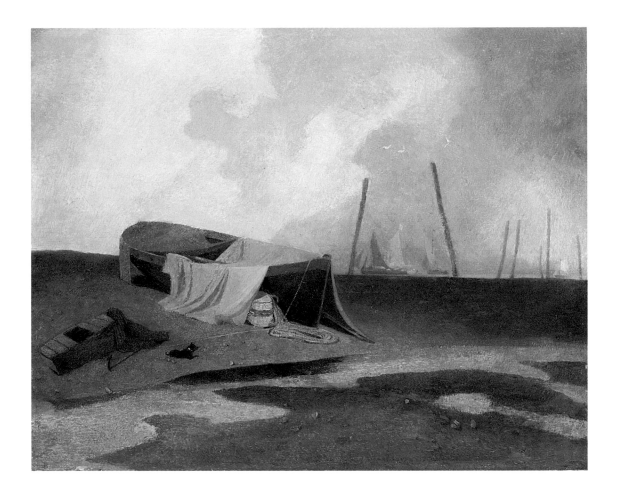

46 **Boats on Yarmouth or Cromer Beach** ?1808

Oil on mahogany panel 370 × 467
NCM 1951.235.96. Russell James Colman
Bequest 1946

Cotman took up oils mainly after his return to Norwich in 1806. On 8 December that year he wrote to Dawson Turner of his intention of 'studying painting, which of late, I have done but little, having been engaged too much in other things'. He had already, on 15 October, described his first effort, a beach scene at Yarmouth, 'Dealers waiting the coming in of the Herring Boats'. His choice of a marine subject doubtless reflected his admiration for Turner, whose *Dutch Boats in a Gale* of 1801 (private collection, on loan to National Gallery) and *Shipwreck* of 1805 (Tate Gallery) he had copied and whose beach scene, *The Sun rising through Vapour* (National Gallery), was exhibited in 1807. Cotman's early oils, almost all of modest size, show the same breadth of handling, instinct for pattern-making in flat bands of colour, and economical treatment of mass and form to be found in his watercolours, and it is clear that he found the medium congenial for sketching from nature, in common with many of his contemporaries in London, as well as with Crome. He also experimented with small pictures intended for exhibition, but retaining the impromptu feel of outdoor sketches even if not made before the motif. This oil, which may have been the 'Cromer Beach' exhibited at the Norwich Society in 1808, has its origin in a pencil and wash drawing with colour notes, conforming to its palette, of the main, covered boat (NCM); that the drawing is a Cromer subject is confirmed by Cotman's inscription on a later drawn copy. The drawn copy exhibited at the Norwich Society in 1809, 'Boats on Cromer Beach', described as a specimen from his 'Circulating Portfolios', was perhaps based on the more pictorial composition of the oil.

DBB

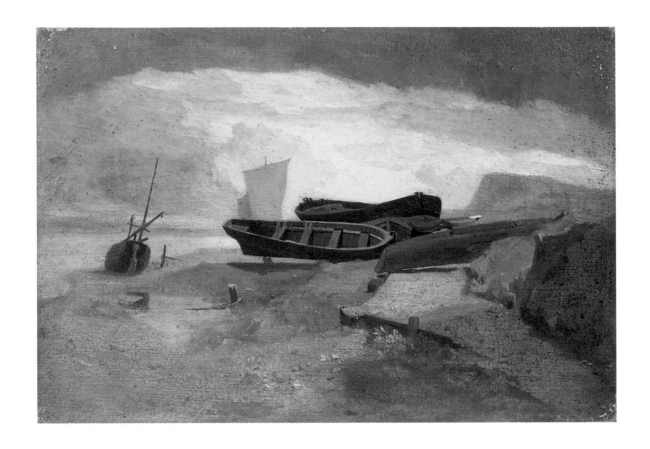

47 **Seashore with Boats** *c.*1808

Oil on panel 283 × 410
NO4785. Tate Gallery. Purchased 1935

Possibly another Cromer subject, of which
Cotman exhibited two in Norwich in 1808
(see the preceding oil) and one in each of
the two following years. This shows the
same bold, abstract patterning as his
watercolour of the *Mars* (cat.44), setting
forth the composition in horizontal planes
with strong contrasts of light and shade
cast from a clouded sky.

DBB

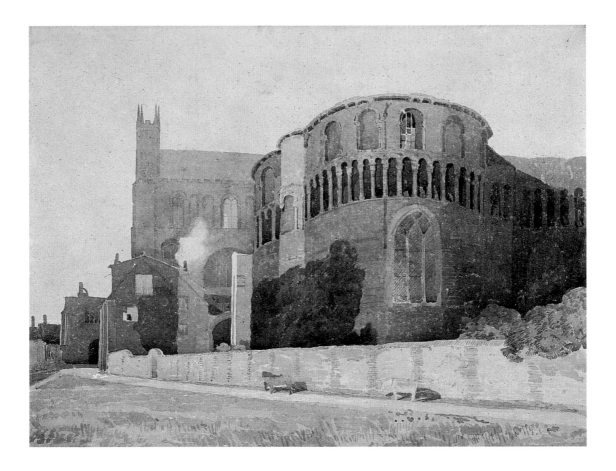

48 St Luke's Chapel, Norwich Cathedral, East 1808

Pencil and watercolour on paper 352 × 461
Inscribed, dated and signed in pencil on old
backing paper, 'St. Lukes Chapel Norwich
Cathedral, East 1808 | J S Cotman' and,
partially trimmed, 'Mr J.S.Cotman | [ta]kes
the liberty of presenting | ... to Sir H
Englefield | ... is sorry he has not the
pleasure | [of] seeing him as he has much
to | [thank] him for – | ... goes to town on
Saturday | ... Mail | No 4 M field Rd |
Soho.'
NCM 1899.4.19. Jeremiah James Colman
Bequest 1898

This is one of a number of views of both the
exterior and interior of Norwich Cathedral
which Cotman painted shortly after his
return to the city at the end of 1806,
although he does not seem to have exhibit-
ed any of them at the Norwich Society. It is
a curious hybrid of topographical accuracy
and utter disregard for verisimilitude. On
the one hand, for example, he faithfully
records the cathedral's south transept, the
arched passage in front of it, and the small
building adjacent – formerly a chapel, but
in Cotman's day the precinct's gaol. On the
other hand, he has omitted a number of
important architectural features such as
the cathedral's tower with its spire, whilst
also vastly aggrandising St Luke's chapel
itself so that it takes the place of the entire
east end.

No doubt such liberties were taken by
Cotman partly for compositional reasons –
in later years he was to advise his son to
'Draw sternly and true, *Leave out, but add
nothing*' – and indeed in *St Luke's Chapel* he
has produced a design of simple yet austere
monumentality. However, he may also
have wanted to concentrate on the earliest
and most Norman part of the cathedral
and, perhaps, to emphasise deliberately
its massive quality and the 'chasteness' of
Norman design. For a number of early
nineteenth-century antiquarians and
architectural historians regarded Norman
architecture as a symbol of a vigorous
civilisation which had overthrown the
degenerate Saxons, and two major guide-
books of the period specifically singled out
St Luke's Chapel as part of the cathedral's
original Norman foundation (Hemingway
1984, p.71). Despite the carefully judged
contrasts of light and dark masses, the
light itself is gentle and suffused, and
contributes to the drawing's understated
mood.

An inscription on the old backing paper
refers to one of Cotman's early patrons, Sir
Henry Englefield, but there is no reason to
believe that he ever owned this drawing.

AL

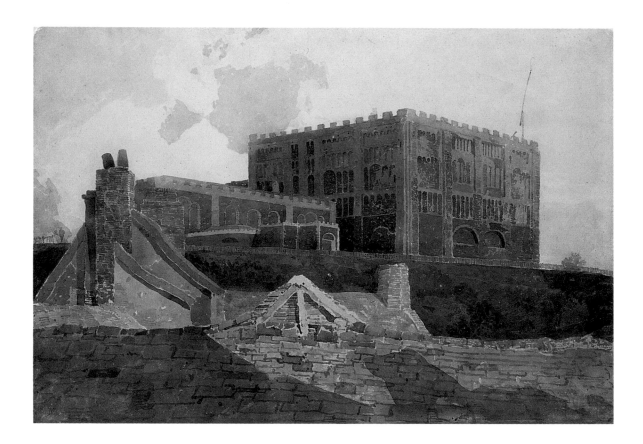

49 Norwich Castle c.1808–9

Pencil and watercolour on paper 324 × 472
Inscribed on old backing board in pencil
'Castle Norwich'
NCM 1960.98

When painting the castle at Norwich around this date, most artists chose a viewpoint from the south-east or south-west so as to allow for the inclusion of Sir John Soane's recently constructed gaol (1789–93). Cotman, by contrast, has here selected the highly unusual viewpoint from the north-west, looking across to the castle's familiar stone keep from over the rooftops of houses in Castle Ditches (now Castle Meadow). This elevated and some-what idiosyncratic angle helps create an impression of great immediacy – almost of a snap-shot – and brings to mind compar-able studies of rooftops made in oils by the Welsh artist Thomas Jones in Naples almost thirty years before. At the same time, the attention which Cotman pays to the variegated surfaces of bricks and tiles in the foreground is, as one author points out, decidedly Picturesque (Warrell 1992, pp.134 and 225) – an effect which is enhanced by the play of light and strong cast shadow across their surface.

Although a view of *Norwich Castle, a Sketch* was among Cotman's first-ever exhibits with the Norwich Society in 1807, it cannot be identified with this water-colour since Cotman has included the railings around the top of the castle mound which were not installed until 1808. Beyond a section of the railings to the left Cotman shows the Shirehouse built by Matthew Brettingham in 1749. It was here that the novelist and poet Amelia Opie – wife of the portrait painter John Opie – excitedly watched the judicial trials of her period. The building was demolished in 1827–8.

AL

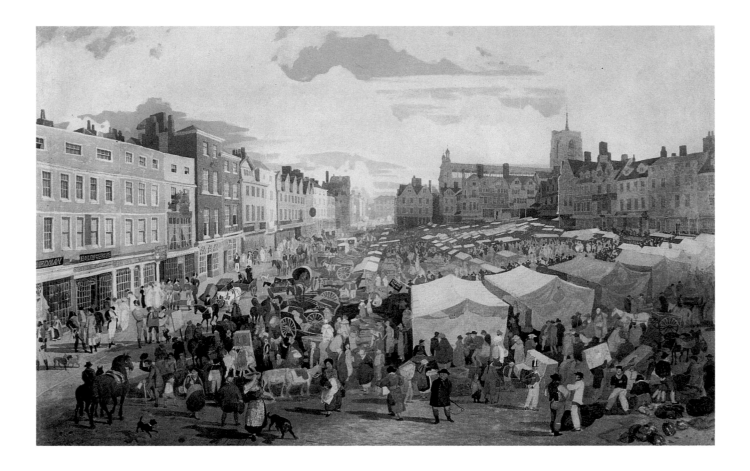

50 **Norwich Market Place** *c.*1809

Pencil and watercolour on paper
406 × 648
Signed faintly in brown wash lower right
'J.S. Cotman'
N05636. Presented by F.E. Halsey 1945

In 1807, only a few months after his return
to Norwich, Cotman made a watercolour
of the Market Place taken from a window
over the shop of the silversmith Mr Cooper,
situated at the north-east corner of the
square. Two years later, he made this, a
larger version of the subject, from a slightly
different – though similarly elevated –
vantage point a little further to the west.
The Market Place had been paved in 1731,
while Gentleman's Walk, which runs along
the lower side of the market – seen in Cot-
man's watercolour to the left, lined with

elegant shops – had been paved in Scotch
granite in 1792. In choosing to depict the
market square, Cotman was celebrating
modern, fashionable Norwich in all its
economic vitality (Hemingway 1984,
p.69).

In both versions of this subject Cot-
man manages to organise a jumble of
buildings and a throng of lively figures
comprising soldiers, sailors, farmers,
labourers and townspeople into a thor-
oughly legible and coherent design. The
decorative shapes and patterns supplied
by awnings, shop signs, window panes
and cart-wheels help to provide rhythm
and accent, whilst also serving to punc-
tuate the composition with vivid notes of
light on dark and vice versa. It is one of
Cotman's most elaborate and complex
compositions, anticipating some of the

watercolours he made in the 1820s and
1830s of the picturesque architecture of
towns in northern France.

Both versions of *Norwich Market Place*
were exhibited by Cotman at the Norwich
Society of Artists, the first in 1807, and
this, the later example, in 1809. The first
version (Abbott Hall Art Gallery) was
owned by the nineteenth-century Quaker
poet Bernard Barton, who addressed a
poem to it in 1845, in which he wrote of its
power to evoke for him a sense of the bustle
and 'loud murmur' of the 'busy market's
ample space' some thirty-eight years
earlier, and telling him more than 'any
printed book'. A lithograph was made after
the Tate version by Norwich artist Henry
Ninham (impression in NCM, Todd collec-
tion), who also worked on Crome's plate of
Mousehold Heath (see cats.12, 13).

AL

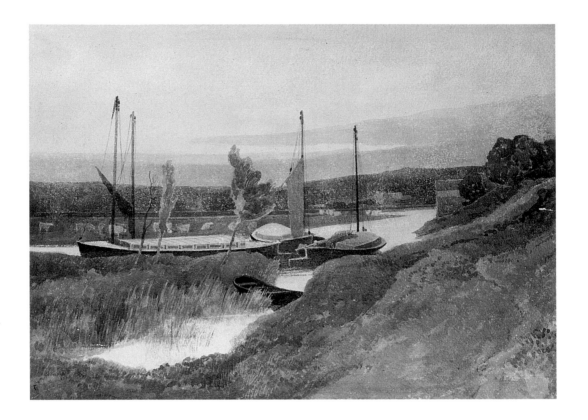

51 'Trowse Hythe, Norwich'
*c.*1809–10

Watercolour with some scraping out on
paper 316 × 442
NCM 1951.235.156. Russell James Colman
Bequest 1946

Although the location of this watercolour
is not securely identified, it is traditionally
thought to show a view of the marshes at
the meeting of the rivers Yare and Wensum
at Trowse, not far from Whitlingham. If
this is correct, then the wherries which
Cotman shows – a type of boat peculiar to
Norfolk which was very efficient at trans-
porting heavy loads – might well have been
used for carrying marl (see cat.52). Marl
could be carried by water much more
cheaply than by land, and it was therefore
often carried by wherries as return freight

back to the port of Yarmouth once they
had deposited their cargo of imported
goods which they had carried up river from
Yarmouth as far as Norwich (Hemingway
1984, p.63).

Reviewing a display of Cotman's work
from the Colman collection in 1945, the
writer and art critic Paul Oppé singled out
this watercolour for its spontaneous
simplicity and also for the sheer power of
its remarkable design, 'so organically
inherent in, and so compelling an element
of, the subject'. 'Here in light brown, green
and blue, somewhat sunk in the distance',
he wrote, 'the pattern follows the broad
curve of the river and the quiet horizontal
lines of the hills and clouds. The near bank
of the river recedes gently, its broken mass-
es and those of the simply drawn reed-beds
on the left framing the cunningly darkened

diagonals of the boats on the water, while
the upright masts and the cattle dotted on
the far bank emphasize without exagger-
ation the intricacies of the distance' (Oppé
1945, p.199).

For a short period in his mid-career –
two or three years between about 1808
until 1811 – Cotman began to adopt a
different technique which gave an added,
lustrous depth to his use of the watercolour
medium. Selecting a rougher paper with a
visibly reticulated grain, he would then
take up a brush charged with dry or dryish
colour and drag it across the canvas-like
texture of the absorbent paper. The
pigment adhered only to the upper sur-
faces of the sheet, leaving tiny crevices of
blank, sparkling paper adjacent to areas of
pure colour. This effect is especially evident
in the sky and distance of *Trowse Hythe*.

AL

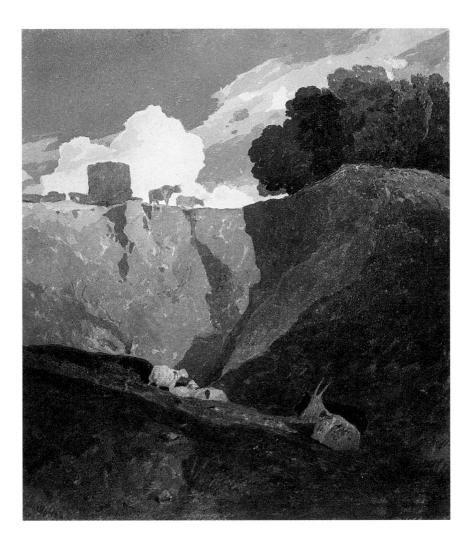

52 **The Marl Pit** *c.*1809–10

Pencil and watercolour with some gum on
paper 295 × 258
NCM 1947.217.154. Russell James Colman
Bequest 1946

Marl is a mixture of clay and lime, and was
dug from pits up to twenty feet deep. It was
spread on the land to act as a fertiliser, and
its natural availability in Norfolk was seen
as an advantage 'of inestimable value',
whilst also contributing to its reputation
for progressive agriculture (Hemingway
1984, p.63). Although there were several
marl and gravel pits in the environs of
Norwich, the best-known of them was at
Whitlingham to the south-east. One of the
pits at Whitlingham is the subject of a late
Cotman watercolour in NCM, and it seems
likely that this watercolour shows a pit at

the same location, especially if the domin-
ant grey shape in the upper left is intended
to correspond with the ruined round tower
of Whitlingham church (for another
representation of the church by Joseph
Clover in oils, see Hemingway 1979, p.46).
The pits at Whitlingham provided subject-
matter for other Norwich School artists as
well. For example, James Stark's *Scenery of
the Rivers of Norfolk* of 1834 (see p.154)
contains a plate, *The Vale of Thorpe, from
Whitlingham*, in which one of the quarries
is featured in the foreground (see Rajnai
and Allthorpe-Guyton 1979, p.82).

Cotman's special appeal as an artist
relies on his extraordinary ability to
combine natural form with an intuitive
feeling for compositional structure and
pattern-making. Such is the ease and
mastery with which he arrives at his har-

monious designs that the formal processes
he employs to achieve them remain essen-
tially concealed. Here he has produced an
image of such astonishing force that the
compelling qualities of the design itself
tend to take precedence over our reading of
its individual motifs. The emphasis is on
shape, contrast and silhouette, and Cot-
man's positioning of the pit's upper edge
towards the top of the composition, where
it forms a high horizon, is a particularly
bold touch. Rajnai and Allthorpe-Guyton
have drawn attention to 'the powerful
interplay of diagonal planes, of flat areas of
intensive colour and of light and shade
with transitions of reflected light' (ibid.).
Here, perhaps, as nowhere else, they
believe, has Cotman drawn so tenuous a
line between observed fact and abstract
pattern.

AL

53 **Mousehold Heath, Norwich**
c.1809–10

Pencil and watercolour on paper 303 × 464
NCM 1947.217.145. Russell James Colman
Bequest 1946

Mousehold Heath was a favourite sketching ground for Norwich School artists, and for Cotman – it seems – in particular. Between 1809 and 1810 he exhibited three views of the heath at the Norwich Society, and indeed three watercolours survive by him of Mousehold which can be dated to around this period – one in the British Museum, based on a pencil sketch dated 1810 in the same collection (Holcomb 1978, no.48), and two in NCM, this example and cat.54. In addition, Cotman made a number of drawings of the heath towards the end of his career, following a stimulating visit to Norfolk in 1841.

Crome's better-known representation of Mousehold Heath in oils (cat.26) is a late work, and probably post-dates Cotman's three watercolours by up to ten years. Yet despite the fact that by the beginning of the nineteenth century the heath was rapidly being enclosed, in both this watercolour and cat.54 Cotman, like Crome, chooses to show it as apparently unenclosed wasteland punctuated by sheep-walks (although a small piece of enclosure encroaches in the lower right corner of the British Museum version, and – uniquely, it appears, because of its subject-matter – Cotman chose to include cultivated land in his representation of *Kett's Castle*, see cat.55). According to contemporary thinking, one of the painter's roles was to record disappearing features of the landscape (Hemingway 1984, p.66).

A comparison between the two artists' approach to their subject-matter is instructive. Cotman uses a much higher horizon line than Crome in all three of his watercolours of the heath, and here his winding tracks are wider and more emphatic, so that the pattern they create across the undulating ground is more insistent. Cotman's forms are also flatter than Crome's and his use of perspective more arbitrary, and thus spatial recession in his work is much harder to read.

AL

54 **Mousehold Heath, Norwich**

*c.*1809–10

Pencil and watercolour on paper 285 × 445
Inscribed verso indistinctly in pencil
'Mousehold Heath | Norwich'
NCM 1947.217.146. Russell James Colman
Bequest 1946

Executed on the rough textured paper
favoured by Cotman in the period
*c.*1808–11, this version of *Mousehold Heath*
differs substantially from cat.53 and from
the other version of this subject in the
British Museum, although all three water-
colours appear to have been made about
the same date. For not only is Cotman's
palette here more naturalistic, based essen-
tially on earth colours, but the handling is
also much freer and more immediate, as
though he were working from nature.
However, this is not likely to have been the
case. For Cotman did not generally favour
the practice of adding coloured washes on
the spot, except for a brief period in his
early career (see under cat.41).

In Cotman's time, Mousehold Heath
had three windmills, situated in close prox-
imity to each other in the section between
Wroxham Road and Shooter's Hill (Rajnai
and Allthorpe-Guyton 1979, p.86). In
cat.53 he shows a single windmill silhouet-
ted against the horizon, whilst in this
version he includes two. In a more fanciful
recollection of the heath drawn in chalks
the same year as his final visit to Norfolk in
1841, he depicts no less than five (British
Museum, repr. Holcomb 1978, pl.100).
Indeed, this last trip to his native county
inspired Cotman to make a number of
drawings of Mousehold Heath. In a letter
to Dawson Turner he describes an episode
on the last day of his visit when he was
irresistibly tempted to stop and sketch even
whilst galloping across the heath in the
middle of a hail-storm *en route* to his
father's house for dinner (see cat.88).
Examples of these late, mainly imaginary
reminiscences of the heath are in the
British Museum and NCM.

AL

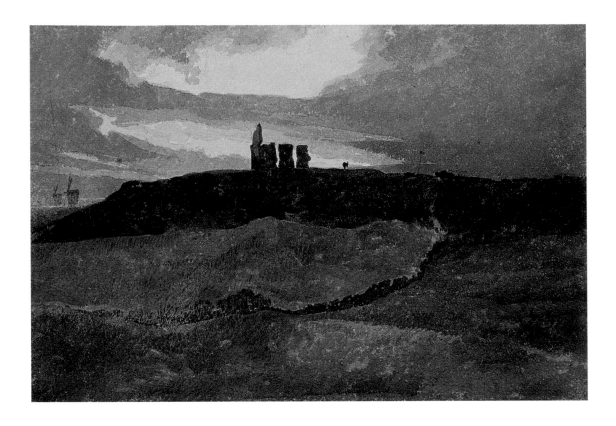

55 **Kett's Castle, Norwich** *c.*1809–10

Pencil and watercolour on paper 221 × 325
NCM 1947.217.144. Russell James Colman
Bequest 1946

'Kett's Castle' was the local name for the
ruins of St Michael's Chapel which stood,
adjacent to those of St Leonard's Priory, on
Mousehold Heath at Norwich; both build-
ings were almost facing the Cow Tower
which stands on the opposite (city) side of
the River Wensum, and which appears in
two watercolours by Thirtle (cats.89, 90).
In 1549, 20,000 yeoman farmers led by
Robert Kett had made their camp on the
heath near St Michael's Chapel, assembled
together in protest about increased rents
and the enclosure of local common land by
wealthy sheepfarmers for grazing. The
rebel army managed to take over control of
Norwich, but they were eventually defeat-
ed by two royal armies. Kett himself was
hung in chains from the walls of Norwich
Castle and left to die.

This is often regarded as one of the most
simplified and 'abstract' of all Cotman's
watercolours, and indeed its power as an
image is the more remarkable for its
having been worked up from such a slight
pencil sketch, though the latter admittedly
carries detailed colour notes (NCM, Rajnai
and Allthorpe-Guyton 1979, no.99). Most
of Cotman's representations of Mousehold
Heath, like Crome's more celebrated pic-
ture (cat.26), show it as open, uncultivated
ground rather than as the enclosed and
fenced-off landscape it had essentially
become by the early nineteenth century.
Here, however, as Andrew Hemingway has
pointed out (1984, p.67), a hedge marking
the line of an enclosure descends across
the drawing from right to left, whilst the

patches of ochre and reddish brown colour
immediately below the brow of the hill
suggest freshly cultivated ground – and
indeed one of the corresponding areas in
Cotman's preliminary sketch is inscribed
'corn'. Given that one of the causes of
Kett's uprising had concerned the enclos-
ure of common ground, Cotman's juxta-
position of cultivated land with the ruins of
Kett's Castle against a heavy, brooding
sunset is unlikely to be coincidental. Never-
theless, Cotman himself would probably
have shared the opinion of most of his con-
temporaries – not to mention contempor-
ary accounts – that the rebellion merited
outright condemnation (Hemingway 1984,
pp.66–8).

This watercolour is almost certainly the
subject of the same title which Cotman
exhibited with the Norwich Society in
1810.

AL

56 Tomb of Sir Edward Clere, Blickling Church, Norfolk

*c.*1810

Pencil and watercolour on paper 279 × 447
NCM 1951.235.245. Russell James Colman
Bequest 1946

The late Elizabethan tomb of Sir Edward Clere stands in St Andrew's Church at Blickling just north-west of Aylsham in Norfolk. Cotman seems to have been attracted to it for its decorative qualities – he takes evident pleasure in painting seven of the sixteen colourful heraldic crests which adorn its sides, tracing Clere's eminent pedigree as far back as 1066. However, the subject also reflects Cotman's growing enthusiasm for antiquarian subjects, an interest which was to encourage him to undertake a number of projects in this vein for his patron Dawson Turner who shared similar tastes in the archaeology and architecture of the past (see cats.62–5 and 72–8).

The attention Cotman pays to the differing colours and shapes of the foreground flagstones recalls other church interiors by him, such as that of Trentham (cat.45), and the strong shadow cast by the young girl to the right is a favourite device with the artist. In this case her shadow overlaps with that cast by a crozier situated somewhere to the right of the composition out of sight, creating a slightly eerie effect.

Another version of this composition by Cotman is known, as well as views of Blickling Hall (Rajnai and Allthorpe-Guyton 1979, p.88). Cotman also visited Blickling on his last visit to his native county in autumn 1841 (see cat.88). His old friend and pupil the Revd James Bulwer had recently returned to Norfolk from London to take up the curacy of Blickling with Erpingham, and since Bulwer shared his passion for sketching Norfolk churches, Cotman wrote to him in advance of his visit to suggest that together they should 'demolish a church or two'. A drawing by Cotman of an old chest in Blickling church survives from this final visit (Leeds City Art Gallery), as does one of the Pound at Blickling (British Museum) and there is also one of the Park (NCM).

AL

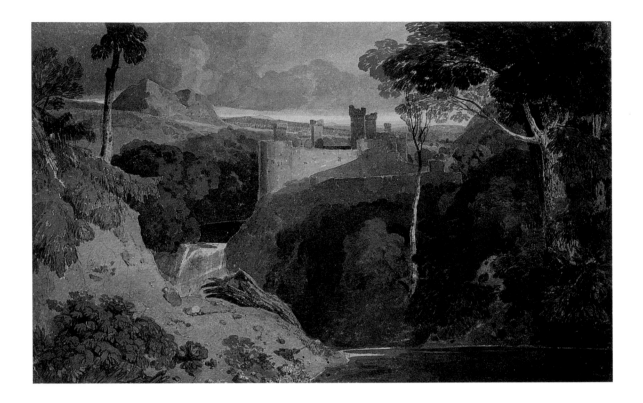

57 **Harlech Castle, North Wales**
*c.*1810

Pencil and watercolour with some gum on
paper 331 × 527
NCM 1951.235.163. Russell James Colman
Bequest 1946

Cotman had visited Harlech on his tour to
Wales in 1800, making a number of pencil
sketches showing the castle from the
south, from which he then worked up a
finished watercolour in 1804 (cat.37). In
this later, larger reworking of the subject,
he again shows the view from the south,
but the castle is now set in an imaginary
setting reminiscent of the work of the clas-
sical landscapists Nicholas and Gaspard
Poussin, and the whole composition
bathed in a golden, arcadian light. Prob-
ably exhibited at the Norwich Society in
1810, it is one of a number of classically

inspired landscapes Cotman produced in
his mid-career in watercolour and oils, as
well as in soft-ground etching for his series
of prints, the *Liber Studiorum* (1825–38).
Indeed, Cotman produced two versions of
Harlech Castle for the *Liber* itself, one – an
upright version – with a distinctly classical
air.

Once Cotman had used his accurate,
on-the-spot sketches for one or more true
representations of a given subject, he
would tend to feel free to adapt and manip-
ulate them as he chose, for the sake of pic-
torial variety. In a version of Harlech he
drew in the 1830s, for example, the castle
is even further removed from its true
appearance – towers are shorn off and
walls straightened out – and set in a less
classical but still highly fanciful landscape
(Birmingham Museum and Art Gallery;
see Rajnai et al. 1982, p.138).

AL

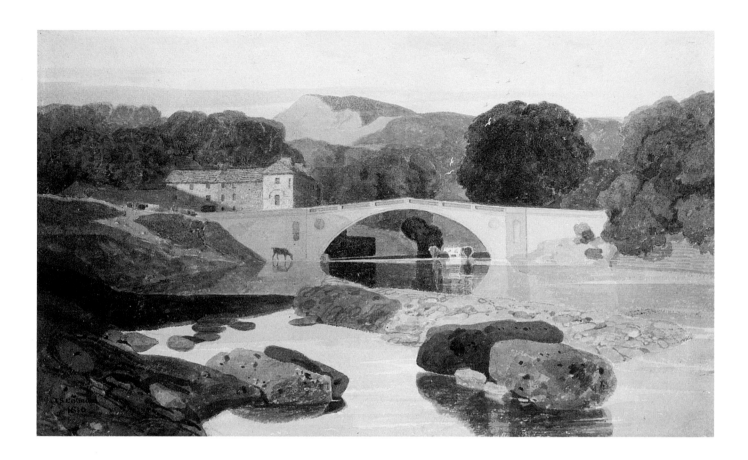

58 **Greta Bridge, Yorkshire** 1810

Pencil and watercolour with some gum
and scraping out on paper 300 × 501
Signed and dated in brown watercolour
lower left 'J S Cotman | 1810'
NCM 1947.217.159. Russell James Colman
Bequest 1946

This watercolour and an earlier version of
*c.*1805–7 in the British Museum are not
only perhaps the best-known examples of
Cotman's entire œuvre, but are also
amongst the most celebrated British water-
colours ever painted. With his intuitive
ability to blend natural form with precon-
ceived design, Cotman has here produced
one of the most subtle and refined of all his
landscape designs, in which all the individ-
ual elements are brought into exquisite
harmony and balance.

Greta Bridge was built in 1773 to the
designs of the neo-classical architect John
Carr of York (1723–1807), and spans the

river at the south gates of Rokeby Park in
North Yorkshire. It was at the inn by the
bridge that Cotman had stayed for over a
week in 1805 after an extended visit to
Rokeby Hall as a guest of the Morritt family
(see cat.39). At some stage that summer he
made an on-the-spot sketch of the bridge in
chalks, on which he based the first version
of this subject in the British Museum (Hol-
comb 1978, pp.48–9) and, ultimately, this
subsequent reworking as well. Perhaps
surprisingly, Cotman apparently exhibited
neither version, though he did show a
more distant view of Greta Bridge at the
Royal Academy in 1806 (probably identifi-
able with the faded watercolour in the
Tate, N03633).

This later version differs from that in the
British Museum in its larger size, hotter
colouring and its anachronistic inclusion
of a distant mountain peak. Some writers
have found the earlier version the more

lyrical, yet both watercolours are masterly
works of picture making, and they share
the beauty and resolution of the final
design. The composition's effectiveness and
sense of repose is produced by the contrast
between, on the one hand, the geometric
forms of the four-square house and the
ovoid shape created by the arch of the
bridge and its reflection and, on the other,
by the apparently random – but in fact
carefully calculated – patterns made by the
river banks and foreground boulders
(Stainton 1985, p.59). It has also been
pointed out that the 'frontal composition of
balanced masses' is one associated with
the classical tradition, and that Cotman
may have been deliberately referring here
to that tradition because the bridge stood
on an ancient Roman site, whilst at the
same time paying homage to John Sawrey
Morritt's classical tastes as scholar and
collector (Hemingway 1997, pp.195–6).

AL

59 Duncombe Park, Yorkshire
1811

Etching 202 × 140; on paper 423 × 280;
plate mark 216 × 144
T06448. Presented by Richard Godfrey
1991

Cotman took up etching after his return to
Norwich to further his reputation and gain
a wider circulation for his work. Unlike
Crome, whose contemporary venture into
etching was essentially private and whose
etchings were not circulated in his lifetime,
Cotman set high store on his graphic work
and devoted more and more of his time to
it. His plates were aimed mainly at the
growing fashion for antiquarian and
architectural topography, but he also
included landscape in his first series of
prints, *Miscellaneous Etchings* (1810–11).
This view of Duncombe Park, published as
plate 5, referred back to his visits to York-
shire. It was probably based on 'Trees,
Duncombe Park, Yorkshire', a watercolour
shown at the Norwich Society in 1811. His
old pupil Anne Cholmeley admired it as
'most like Rembrandt's', but while Cotman
certainly admired Rembrandt (and the
Dutch etchers of the seventeenth century),
he did not intend to imitate him as Crome
did Ruysdael, and replied that 'it would not
do to follow that master in my subjects'.
The plate reappeared in Cotman's *Liber
Studiorum* published by Henry Bohn (see
cat.87).

DBB

60 The Old College House, Conway 1811

Etching 293 × 207; on paper 495 × 355; plate mark 305 × 215
Lettered at lower centre within image 'THE OLD COLLEGE HOUSE CONWAY | Etched & Published May 30th 1811 by J.S. Cotman. Norwich'
NCM 1975.474.52. Duncan Cotman Gift 1974

Plate 18 of Cotman's first series of prints, *Miscellaneous Etchings* (1810–11). Cotman seems to have been in Conway in mid-August 1800 and a watercolour of this subject may have been one of his exhibits at the Norwich Society in 1811 and 1824. A watercolour dated 1802 is in the Cecil Higgins Art Gallery, Bedford. The building was also drawn by Cornelius Varley and David Cox. Cotman has given the subject an emphatically Picturesque character, revelling in the different surfaces of the building and its evident descent into dereliction with shattered windows and grass-grown roof.

DBB

61 St Botolph's Priory, Essex 1811

Etching 246 × 357; on paper 354 × 492;
plate mark 258 × 365
Lettered at lower centre within image
'ST-BOTOLPHS-PRIORY-ESSEX | Drawn and
Etched by J.S. COTMAN', and below image
at l. lower corner 'Norwich Published Feby
20th by J.S. Cotman St. Andrews Street.
1811'
NCM (unregistered)

Plate 26 of *Miscellaneous Etchings*
(1810–11), Cotman's first series of prints.
This subject is taken from Cotman's earlier
watercolour (cat. 38), and considerably
enhances its depiction of crumbling decay.
Cotman wrote to Francis Cholmeley (5
March 1811) of 'aiming decidedly for the
Piranesi effect' in his etching, acknowledg-
ing the printmaker who had most to con-
tribute to his architectural subjects – 'the
model I intended most religiously to bend
my mind and judgement too'. Cotman had
been given six of Piranesi's plates by Sir
Henry Englefield, to whom he had first
broached his etching project and the
Miscellaneous Etchings were dedicated, and
also in 1811 tried to introduce himself to
see the set of Piranesi belonging to Hudson
Gurney.

DBB

62 Saxon Arches in the Tower of Castle Rising Church, Norfolk 1812

Etching 250 × 359; on paper 330 × 459;
plate mark 258 × 368
Lettered at lower centre within image
'SAXON-ARCHES-IN | THE-TOWER-OF-CAS
| TLE-RISING-CRURCH [*sic*] | NORFOLK'
and 'To John Gurney Esqr. | This Print is
Respectfully Dedicated by his Obedt.
Humble Servant | John S. Cotman'; at l.
lower corner 'Norwich Etched & Published
by J.S. Cotman Jany. 1812'
NCM (unregistered)

While still publishing his *Miscellaneous
Etchings*, Cotman began collecting material
for his first specialist series of antiquarian
plates, *Architectural Antiquities of Norfolk*.
This was to be issued quarterly, in batches
of six plates, but was in fact not finished
until 1817. Cotman modelled his survey on
contemporary publications such as John
Britton's *Architectural Antiquities of Great
Britain* (1807–26), and was strongly

encouraged by Dawson Turner who, while contributing accompanying text and sharing historical information, urged Cotman to curb his more personal interpretation of his subjects; overall the *Norfolk* plates (see also cats.63–5) show a trend towards a more restrained and literal depiction of architecture. Here Cotman's studies of Piranesi have borne fruit in a wonderfully bold treatment of architectural space, and of the surface texture of structural decay, while the figure appearing from behind a column is a characteristically quirky touch. The plate is interesting evidence of the changing state of knowledge. Dawson Turner's letterpress to the 1818 volume of *Norfolk* corrects Cotman's own title, asserting that the decorated arches are Norman not Saxon.

DBB

63 **Walsingham Abbey Gate** 1812

Etching 279 × 217; on paper 304 × 227; plate mark 300 × 222
Lettered within image at r. upper corner 'Pl. XIX | 1.2.3, The Arms of Walsingham Abbey', and at l. lower corner 'J.S. Cotman'; below image at centre 'WALSINGHAM ABBEY GATE | To Edmund Wodehouse Esqr. This Plate is respectfully dedicated by his Obdt. Servant | J S Cotman'; at l. lower corner 'Yarmouth. Etched & Published', and at r. lower corner 'by J.S. Cotman 1812'
NCM 1951.235.621. Russell James Colman Bequest 1946

64 **Wymondham Church** 1813

Etching 271 × 221; on paper 318 × 236; plate mark 304 × 230
Lettered below image 'To the Rev Thos Talbot MA whose attention has been peculiarly | directed to the Investigation of Norfolk Antiquities. This view of | the Church of Wymondham his native Town is inscribed by | J S Cotman' and 'drawn & etched by John S Cotman Yarmouth 1813'
NCM 1922.135. Leonard G. Bolingbroke Gift 1922

65 East View of the Gateway of St Benet's Abbey 1813

Etching 240 × 372; on paper 354 × 488; plate mark 276 × 381
Lettered below image at centre 'To Mr Dawson Turner to whose knowledge in the polite Arts & to whose judicious | observations | this work is much indebted. J S Cotman most Respectfully & gratefully | Dedicates this East view of the Gateway of St. Bennet's Abbey', and at r. lower corner 'Etched & Published by J S Cotman Yarmouth 1813'
NCM (unregistered)

This abbey-turned-windmill was a favourite landmark and subject for Norwich artists. With its open landscape setting and dramatic sky with strong shafts of sunlight falling on the ruin, this plate anticipates Cotman's later etchings of Normandy subjects which, in contrast to the relative concentration of the majority of the Norfolk subjects, show buildings fully assimilated into their natural settings.

DBB

66 The Grand Bonfire at the Yarmouth Festival 1814

Soft-ground etching 177 × 263; on paper 177 × 263; plate mark cut to image
NCM 1954.138. Mrs Russell James Colman Gift 1954

This separate plate commemorates a festival held at Yarmouth to celebrate the downfall of Napoleon. A banquet of beef, plum-pudding and beer was served to five thousand people who also watched an effigy of the Emperor being burned on the beach, atop a great bonfire piled with faggots and barrels of tar. Cotman's print was issued in the large paper copies of the published account of the event (see p.154), for which he also designed an etched title-page and three further illustrations. His involvement shows his participation in contemporary Norfolk affairs as well as in antiquarian pursuits – though it was a Yarmouth antiquary, Mr Cory, who wrote the text.

DBB

67 **Old Houses, Gorleston**
*c.*1815–23

Oil on canvas 455 × 353
NCM 1899.4.8. Jeremiah James Colman
Bequest 1898

This was in Cotman's sale at Spelman, Norwich, in 1834 (12 September, day 3, lot 120), as 'Old Houses at Yarmouth' and with similar oils and watercolours must belong to his years at Yarmouth working for Dawson Turner. He seems to have exhibited two gable-ended cottage subjects at the Norwich Society in 1823. His antiquarian and Picturesque interests coincided in studies of this sort of architecture, whether in earlier prints (cat.60), oil sketches or this somewhat more finished oil which could well have been an exhibition piece. The fresh colouring and lighting, and broad handling, retain the impression of *al primo* spontaneity found in Cotman's contemporary *Gable End of Old Houses* (NCM). Subjects like this were popular with artists like John Linnell, A.W. Callcott and William Mulready, whether as objects of outdoor study or for exhibited works. They appealed to the contemporary Picturesque taste for ramshackle, vernacular architecture and for the impression of naturalism in small pictures. Cotman's, like Crome's, oils said to be from nature are representative of the fashion for 'the sketch as picture' (see Brown 1991, pp.64–5).

DBB

68 **Sea View, Fishing Boats**
c.1810–20

Oil on canvas 632 × 760
NCM 1899.4.7. Jeremiah James Colman
Bequest 1898

This oil has been given various dates: as
early as 1810, or the 1820s or later since,
as observed by Moore (1982, p.142), there
is a watercolour of the composition dated
1832. However, in view of Cotman's
consistent habit of copying or recycling
compositions – usually for teaching
purposes – this seems less conclusive than
the close proximity to Turner's colouring
and handling much earlier, which Moore
also notes.

DBB

69 **After the Storm** c.1810–20

Oil on canvas 632 × 756
NCM 1951.235.103. Russell James Colman
Bequest 1946

Though often compared to the preceding
Sea View, this marine is in a different, less
overtly Turnerian style, and is painted in a
distinctive range of slaty blue-greys. An
undated pencil and wash study for the
composition was in the collection of C.J.
Watson. Moore (1982, p.142) compares the
general treatment to Cotman's water-
colour *The Dismasted Brig*, of c.1807–9
(British Museum), but dates the picture to
the 1820s. Despite their differences, this
writer would prefer to place both this and
the preceding earlier oil in the range given
above. In each case the cool palette and flat
brushwork relate to the earlier water-
colours, and have little affinity with the
richer tonality and more delicate touch of
oils like the following, which certainly
belong to the 1820s.

DBB

70 Dutch Boats off Yarmouth
?1823

Oil on mahogany panel 435 × 635
NCM 1951.235.115. Russell James Colman
Bequest 1946

This was probably shown first at the British
Institution in 1823, as 'Dutch Prizes off
Yarmouth', and sold to Cotman's London
patron, John Bridgman of Wigmore Street,
who also commissioned the following pic-
ture. Both oils were shown at the Norwich
Society in 1824 when, having returned
from Yarmouth, Cotman showed a large
number of works. The *Norfolk Chronicle*
gave a long panegyric on this picture; 'a
multum in parvo of cleverness for design,
colouring, and management of light and
shade ... not unworthy to stand beside "the
studies" of a Vandervelt or a Backhuysen'.

Nevertheless, it regretted that 'such sub-
jects have not been early cherished ones
with Mr Cotman, composed as they might
be on a larger scale, for the display of his
most finished style'. Cotman had based his
composition on a small pencil sketch made
on Yarmouth sands, looking north across
the Denes to Gorleston, but added more
details of flags, masts, yawls to the right
and, presumably, wartime memory to
recent observation if the vessels flying the
Dutch flag are indeed prizes; a similar
group of boats appears, in a peaceful
context, in George Vincent's *Dutch Fair on
Yarmouth Beach* of 1821 (cat.102). Cot-
man's picture may be a response to this,
and likewise shows the town's Nelson col-
umn, designed by William Wilkins, with its
gilt statue of Britannia supported by Vic-
tories, erected 1817–19. A contemporary of

Wilkins at Norwich Grammar School,
Cotman helped raise subscriptions for the
column's construction by producing an
etching of it as it would appear completed,
with old sailors gathered beneath it and,
among rolling clouds, an apparition of
ships in battle at Trafalgar. The print,
together with the exhibition of this picture
in the British Institution, at just the time
Turner was discussing with Cotman's
friends the Cookes a set of east coast views,
may have helped inspire Turner's
Yarmouth design for the series, in which
the monument is similarly seen across the
sands, with the battle line of Trafalgar
enacted in the foreground by means of a
game with model ships (for Turner's water-
colour, in the Fitzwilliam Museum, see
Shanes 1981, pp.41–2).

DBB

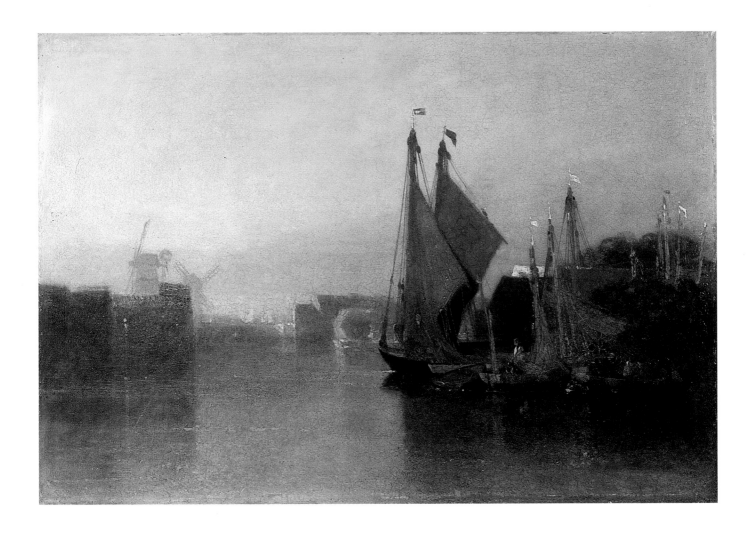

71 View from Yarmouth Bridge, looking towards Breydon, just after Sun-set *c.*1823–4

Oil on millboard 444 × 633
NCM 1951.235.114. Russell James Colman
Bequest 1946

This was commissioned by John Bridgman, who also bought the preceding oil, and shown at the Norwich Society in 1824 when it was greatly praised, though with the typical proviso that it had been 'quitted prematurely by the artist'. 'We are', declared the *Norwich Mercury*, 'no friends to "sketches" in oil painting'. Moore (1982, pp.143–4) thinks Cotman had indeed shown it in an unfinished state. Bridgman, who was kept waiting a year for it, wrote to Cotman on 1 July 1825 in glowing terms of its 'beautifully toned and well preserved' distances and 'masterly handling', but added

I had expected a different sky. You proposed giving – about the centre of the Picture – rays of light from the sun which was just hid by passing clouds. These were to illumine the picture and would have given a fine and natural effect, certainly a more brilliant one than the present. It would seem that, giving up your first intention, you have been undecided about the sky. This deviation has given you considerable trouble. Still the sky harmonises with the foreground and is much better when seen nearer. The objects being small, we are drawn closer to the Picture, and then the clouds appear broken, little, trifling – anything but broad and grand – very like some of the extravagances of Turner.

In its classic, horizontal structure as well as in its golden lighting, this is certainly one of Cotman's most Turnerian conceptions.

DBB

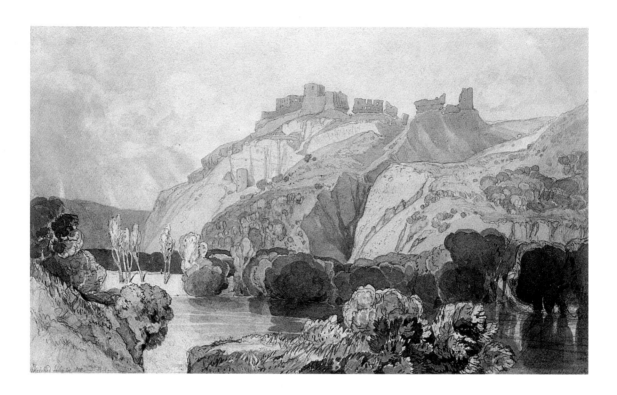

72 **Chateau Gaillard, Normandy**
1818–19

Watercolour on paper 260 × 419
Inscribed and dated 'Sketched July 24 1818.
D. 1819'
NO3328. Presented by Sir Jeremiah Colman
through the National Art Collections Fund
1918

Cotman toured Normandy in 1817, 1818 and 1820. His Norwich colleagues John Berney Crome, George Vincent and Joseph Clover had preceded him in 1816. Cotman's tours represent the peak of his achievement as an architectural draughtsman. The idea of the illustrated publication that appeared as *Antiquities of Normandy* was his own, though it was encouraged and assisted by Dawson Turner and Hudson Gurney. By his third visit, Cotman was planning a separate work, '*a Splendid Book*', on the region's scenery – an element he had certainly not neglected in his architectural subjects. This further project never materialised, and the *Antiquities*, on which he expended immense efforts, was overtaken by other publications using cheaper methods of mass reproduction and presenting a more picturesque vision of historic buildings than Cotman's characteristically austere designs. Cotman's approach, wherever possible realising the full potential of a striking natural setting, is clear in his taut and muscular views of Chateau Gaillard, near les Andelys, which he visited on his second tour in 1818 and described as 'a most magnificent Castle & as magnificently situated'. The castle, built by Richard the Lionheart in the twelfth century and partly demolished from the end of the sixteenth, was in fact a chance discovery of Cotman and of Mrs Turner and her daughters, whose paths in Normandy had now crossed with his, after their guide had dismissed it as 'nothing but a heap of stones'. After a first visit, Cotman returned ten days later from Rouen, and on 12 July wrote to Dawson Turner that the castle had 'given to the party seven Views' – including, presumably, the basis of this drawing. Rajnai and Allthorpe-Guyton (1975, p.49) consider the first of its twin dates to be a mistake for 24 June, when they were all at Chateau Gaillard for the first time; this was presumably added from memory when the drawing was developed a year later for publication. In keeping with the other drawings for the series, it is worked in monochrome. It was etched as plate 81 in Cotman's *Normandy* (1822), and by Elizabeth Turner as plate 37 in her husband's *Tour in Normandy* (1820; see p.154). A copy by an unknown hand is in the Fogg Art Museum, Cambridge, Mass. For J.M.W. Turner's views of Chateau Gaillard, for his Seine series published in 1835, see Warrell 1999, pp.196–202.

DBB

73 Crypt in the Church of St Gervais, Rouen 1819

Pencil and watercolour on paper
184 × 276
Signed and dated at r. lower corner 'J S Cotman July 9 1819'
N03330. Presented by Sir Jeremiah Colman, Bt through the National Art Collections Fund 1918

Cotman spent a number of days in Rouen in 1817 and 1818, and planned – but did not make – a further visit for 1820. The city was rich in architectural interest and allowed him to meet local historians and antiquarians – though to greater benefit in 1818 when Dawson Turner's wife and daughters were on hand to help him with his French. He hoped to show them St Gervais, which he had seen and drawn in 1817, but could not find the sacristan to have it unlocked; this drawing, worked up in 1819, must therefore have been based on one done during his first visit. Cotman had long had a fascination for crypts and vaults with their powerful compositional dynamics of columns, arches and shadow play; it might be traced back to his experience of J.M.W. Turner's watercolour *The Refectory of Kirkstall Abbey*, in Turner's Gallery in 1804 and also in the *Liber Studiorum*, and bought by the wife of Cotman's fellow member of the Norwich Society, John Soane (Sir John Soane's Museum). As noted by Rajnai and Allthorpe-Guyton (1975, p.80), this is likely to be one of two drawings of this subject in Cotman's 1824 sale (Christie's, 1 May, lot 89). It was copied by Elizabeth Turner, and etched by Cotman as plate 53 in his *Normandy* (1822).

DBB

74 The West Front of the Abbey Church of St Etienne, Caen
1819

Etching 460 × 321; on paper 478 × 328; plate mark cut
NCM 1942.135.7

Among the most impressive of the Normandy plates are those of church façades. Though sometimes obtained with some difficulty and a degree of illusionism, Cotman treats these views as elevations, seen frontally and with an austere grandeur that conveys a sense of immensity. This plate is an early state, before reworking and lettering, of the etching eventually published as a double plate in Cotman's series, vol.I, pls.21–2. Cotman was in Caen twice during his 1817 tour, once for a long visit of nearly a month in 1818, and twice again in 1820. His view of the west front of St Etienne (or St Stephen's or Abbeye-aux-Hommes) goes back to 1817, when he confronted the habitual problem of obtaining the desirable complete view from a restricted or partial viewpoint. On 27 July he wrote to Dawson Turner, 'I am sketching St Stephen's Abbey from an awkward position from an oblique window from which I am obliged to lean out'. This window belonged to an English florist, Mr Wheatcroft, and the view was of the front of one of the most important romanesque structures in Normandy and one with particular interest for a British audience, since it had been founded by William the Conqueror and became his burial place. In his own *Tour in Normandy* (1820), Dawson Turner wrote, 'A character of magnificence, arising in a great measure from the grand scale upon which it is built, pervades this front.' Besides this view, Cotman published a further etching in 1819, which he exhibited at the Norwich Society in 1820.

DBB

75 The West Front of the Cathedral Church of Notre Dame, Rouen 1821

Etching 501 × 372; on paper 542 × 403; plate mark cut
Lettered within image at l. lower corner 'Drawn & Engraved by J S Cotman Yarmouth 1821', and at r. lower corner 'JSC' in monogram
NCM 1935.116.61. F.R. Beecheno Bequest 1935

The penultimate state, before address, title and publication details, of the plate published as a double plate in Cotman's *Normandy* (1822), vol.I, pls.51–2. This is the largest in the series. Once again the subject posed problems of access, since the massive structure rose from crowded streets in which a suitably measured view was impossible. Nowhere could one stand far enough back to study it whole. Add to this the complexity and richness of the surface detailing of the cathedral, and it was a challenge indeed. In 1817, Cotman found he was obliged to work on several sheets of paper, with the aid of a *camera lucida*; only subsequently were his sectional studies pieced together to form this single design, which by considerable artistic licence clears a field of open space in front of the façade and shows it towering uninterrupted above the surrounding buildings. It seems that Cotman had with him a specimen of Cornelius Varley's Graphic Telescope, since the architect Charles Barry reported seeing one in his hotel room in Rouen (see Pidgley 1972, p.785). On views of Rouen cathedral by Turner and other contemporary artists, see Warrell 1999, pp.176–86.

DBB

76 The South Transept of the Cathedral Church of Notre Dame, Rouen 1821

Etching 438 × 300; on paper 477 × 325
NCM 1942.135.14. Purchased from the Beecheno Bequest Fund 1942

The penultimate state of the plate published as a double plate in Cotman's *Normandy* (1822), vol.I, pls.49–50. The view is from the Place de la Calende. Two drawings of the south transept were in Cotman's sale, one of which may be the brown wash example recorded in the collection of Mrs L. Newell.

DBB

77 **Domfront, Normandy, View from the Town** 1820–3

Pencil and brown wash on paper
262 × 404
NCM 1951.235.289. Russell James Colman
Bequest 1946

Cotman visited Domfront on his last Normandy tour, in 1820. On his second day there, 21 August, despite a threatening storm, he began this drawing, which he described to Dawson Turner as 'Rocks extremely grand'. The view is from below the castle, looking to the Val des Rochers, the gorge of the River Varenne, and the Tertre Grisière, traditionally the site of the local gallows. (Cotman, whose correspondence shows he knew the Domfront saying 'arrive at noon, hanged by one', had his own brush with the law while there; his last night was spent in prison following arrest on false suspicion of involvement in a 'conspiracy' in Paris.) The drawing was perhaps exhibited at the Norwich Society in 1823. As in his drawings of Chateau Gaillard – with which certain of his Domfront subjects have sometimes been confused – he has responded to the structure of the rocky landscape with particular rigour; the couple strolling with their dog are a charming addition, manifesting, surely, Cotman's own admiration for the scenery of this remote and wild place. The mirror image of this drawing, from Tertre Grisière back over the town to the castle on the opposite peak, dated 1823, is in the Courtauld Institute Gallery. There, the foreground includes a man with a gun and two mastiffs, a recollection of an encounter Cotman had had nearby with one of the local farmers, who used the dogs as protection against wolves.

DBB

78 **The Ramparts, Domfront** c.1820

Pen and brown wash 222 × 321
Inscribed in ink at r. lower corner 'On the
Ramparts at Domfront, France'
T00972. Presented by the National Art
Collections Fund (Herbert Powell Bequest)
1967

According to Rajnai and Allthorpe-Guyton
(1975, p.67), this drawing is probably a
copy of the watercolour in the Bacon
Collection, which may in turn have been
the 'View of a House on the Ramparts of
the Town of Domfront, in Water Colours –
not published', in Cotman's 1824 sale
(Christie's, 1 May, lot 108). At least two
related copies are also recorded. As the sale
catalogue indicates, this subject was not
used for reproduction, either by Cotman or
by Dawson Turner for their Normandy
publications.

DBB

79 The Abbatial House of the Abbey of St Ouen at Rouen

?1824

Pencil, pen and ink, watercolour and gouache with scraping out on paper
423 × 573
Signed and dated at r. lower corner in brown wash 'J S Cotman 182[?5]'
NCM 1947.217.191. Russell James Colman Bequest 1946

Cotman never saw this building, as it had been sold in 1816 and demolished, and must have depended, as noted by Rajnai and Allthorpe-Guyton (1975, p.82), on earlier views, most probably the engraving in J. Pommeraye's *Histoire de l'Abbaye de St Ouen* (1662). This subject was not used for Cotman's *Normandy*, but, later, for exhibition watercolours, four of which – assuming the same work was not exhibited again – were shown in all, in the Norwich Society in 1824 and 1829, and at the Old Water Colour Society in 1825 and 1831. Rajnai and Allthorpe-Guyton (1975, p.83) set out the complicated story of versions and repetitions ordered by Cotman's clients, descending from the original 1824 exhibit – which Cotman said he made 'con amore' – done for the Revd C.P. Burney. No absolute identification of this version is possible, though it is the only one to show the building in the right direction, the others – in the Victoria and Albert Museum, Denver Art Museum, Colorado and private collections – being reversed. Rajnai's tentative dating of 1825 and association with the Water Colour Society exhibition that year cannot be corroborated by the inscribed date as the last digit is unclear. By 1827 Cotman wrote to Burney of his disgust with the 'unaccustomed' necessity of repeating a composition, and of his wish to abandon architectural subjects; 'independent of this I had said I would leave off drawing architecture but wd. leave off with the best subject I *ever touched upon*, so as to shew I did it from choice & not because I cd. not go on with duel subjects'. While the crisp rendering of the elaborate façade seems to show a continuing relish for architecture, the higher colour key and fanciful additions to the foreground of a troubadourish gathering of courtiers and classical statuary are certainly indicative of a changing taste – though whether truly Cotman's own or that of the exhibition public at whom he was now pitching his work is debatable. The mood here approaches that of Bonington's historical compositions, but with a greater emphasis on the setting and less on anecdote.

DBB

80 **Gateway of the Abbey, Aumale** 1832

Pencil, pen and ink, watercolour and gouache on paper 445 × 333
Signed and dated in ink at l. lower corner 'J. S. Cotman 1832'
NCM 1947.217.217. Russell James Colman Bequest 1946

As with the preceding subject, Cotman never saw this building, the gate of the abbey of St Martin d'Auchy, as it had been demolished before his visits to Normandy, and there is anyway no definite evidence that he was ever at Aumale, though he was in the vicinity in June 1818. Originally built in the reign of Francis I, by the Abbot Guillaume de Tilly, it had been carved with portrait medallions and other references to the monarch and his wife. Presumably working, once again, from a print, Cotman has rendered these in some detail, but, if other records of the structure are to be trusted, in an exaggerated manner, while eliminating a Gothic roof over the gate and changing the turrets into cones. Two preparatory drawings (NCM and Whitworth Art Gallery, Manchester) are dated 1830, in which year Cotman exhibited another watercolour of the gate at the Old Water Colour Society. Here he has again added a wealth of foreground activity in the form of a fair or carnival, perhaps meant to belong to Ash Wednesday, enabling him to include colourful *pierrot* costumes, local dress and even performing dogs. All this is in marked contrast to the severe restraint of his earlier style, and directed at the new taste of the exhibition public rather than his former antiquarian audience.

DBB

81 **Storm on Yarmouth Beach** 1831

Watercolour, pen and ink with some
scraping out on paper 368 × 537
Signed and dated in brown watercolour
wash lower left 'J S Cotman 1831'
NCM 1947.217.210. Russell James Colman
Bequest 1946

From the early to mid-1830s, Cotman
experimented with mixing his watercolour
pigment with a thickening agent –
probably flour or rice paste. Not only did
this have the effect of producing a much
greater intensity of colour but the new,
semi-opaque medium remained moist on
the paper for longer, and could therefore be
wiped or dragged, allowing him to create a
variety of different textures. In this view of
the beach at Yarmouth he has used the
medium to remarkable effect, above all in
the dramatic stormy sky. The juxtaposition
of strong blues and golden yellows occurs
in a number of his later watercolours, but
rarely with as much impact as here (Rajnai
et al. 1982, p.171).

Cotman had moved to Yarmouth in
1812, attracted by the patronage of
Dawson Turner, and remained there until
1823. The town and the beach with its
related activities remained a powerful
source of inspiration to him throughout
his career (see cats.70 and 71). This water-
colour, for example, was made after his
return to Norwich. Its subject is a group of
fishermen on the beach who are piling
their nets on to carts as a storm approach-
es; Yarmouth itself is relegated to the far
left-hand distance. The three windmills
which dominate the horizon are probably
the same mills which occur in an earlier
drawing by him (NCM). They are also to be
found in copies from the circulating portfo-
lio of drawings which Cotman first set up
in 1809 as part of his teaching practice,
and which he continued to use throughout
his career (see Moore 1982, p.104).

AL

82 **Silver Birches** *c.*1824–8

Oil on canvas 762 × 627
NCM 1951.235.119. Russell James Colman
Bequest 1946

During the 1820s Cotman showed a
renewed interest in landscape painting in
oil. Planning a visit to London in Novem-
ber 1826 to see pictures from the collection
of George IV – including many works by
Dutch artists – on exhibition at the British
Institution, Cotman told Dawson Turner of
his wish to compare his own work 'with
the standards' of the masters and thus cor-
rect what he and others saw as its particu-
lar defects. 'I can', he added, 'no longer
bear the stigma that Trees I can neither
draw nor paint.' Since 1824 he had been
showing tree subjects at the Norwich
Society, and one, that year, had been pro-
nounced 'as unintelligible to the *virtuosi* as
to the public'. This rhythmical study of the
dancing foliage of silver birches sparkling
with sunlight is hard to reconcile with
such comments. While more tightly struc-
tured, and essentially classical in concep-
tion, as well as more brilliantly coloured
than Crome's treatment of trees which
Norwich taste may have preferred, it bears
correspondingly little imprint of the Dutch
painters' work that Cotman saw in 1826.
With the following four oils, seen here
together for the first time, it forms a related
series of subjects based around trees, some
of which include a loose narrative element
(cats.83, 84); all are small and share a sim-
ilar plastic modelling of the foliage with a
thickly loaded brush, and a bright palette.
Datable to the mid- to late 1820s, these
explore the textural potential of the oil
medium as a vehicle for natural effects and
for the surface reflection of light. Though
this example is said to be a view from a
window of Cotman's house in St Martin's
at Palace Plain, and is sketchy and
impromptu in handling, others seem not
to be studies from nature but, rather,
archetypes of woodland scenery for which
Cotman may have referred to earlier mate-
rial, and have the air of cabinet pictures.
This one belonged to Dawson Turner's
daughter, Mrs Harriet Gunn.

DBB

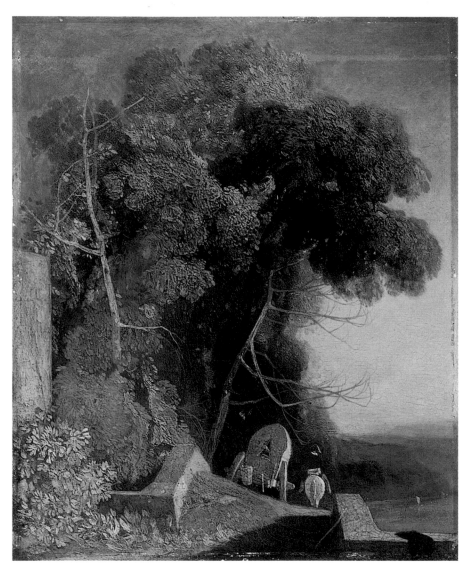

83 The Baggage Wagon c.1824–8

Oil on mahogany panel 430 × 352
NCM 1899.4.5. Jeremiah James Colman
Bequest 1898

With the following oil this forms a pair of
wooded river landscapes to which Cotman
introduced motifs of a laden cart and its
subsequent overturning. This conception
can be traced back to 1824, on the basis of
a dated pencil sketch in the Victoria and
Albert Museum (see cat.84). The same
horses – a white and a bay – cart and
red-coated figure, together with a similar
wooded setting near a stream, link both
pictures, as does the treatment of the
foliage, thickly painted in pale and silvery
tones. While less tightly geometric than
Cotman's earlier compositions, these show
a similar mastery of pictorial design.

DBB

84 **The Mishap** c.1824–8

Oil on mahogany panel 430 × 354
NCM 1899.4.6. Jeremiah James Colman
Bequest 1898

Forming a pair with the preceding oil, it shows the overturned cart and its spilt load. The carter's red coat now lies on the ground by the stream. The upset cart appears in a pencil drawing in the Victoria and Albert Museum, and another in the same collection, dated 27 January 1824, seems to relate to the same episode. A slight composition sketch for the picture is in NCM. The following smaller oil may also be connected with the distant and darker vista in the right distance.

DBB

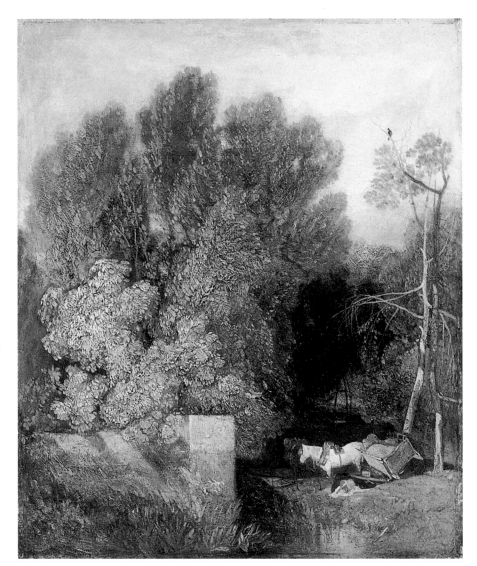

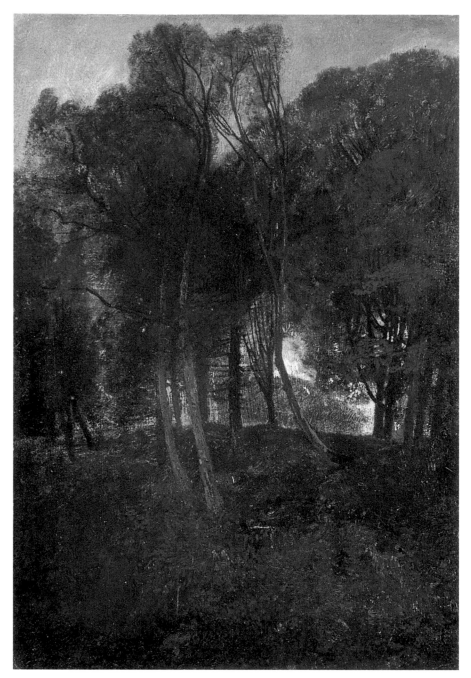

85 Duncombe Park (?'Trees in Duncombe Park, Yorkshire')
*?c.*1824

Oil on paper laid on canvas 416 × 279
N03572. Tate Gallery. Purchased 1921

This little oil has generally been dated to
*c.*1806 or even to Cotman's Yorkshire visit
the previous year (see, for example, Brown
1991, p.66). However, on comparison with
the preceding oil, a later date may be
preferable, since the group of sombre,
greenish-blue trees standing before a
brighter clearing seems very similar in
tone and handling to that seen in its right
distance; and indeed Cotman exhibited a
'Trees in Duncombe Park, Yorkshire' in
1824, the same year as he made drawings
related to the larger oil. He could of course
have referred to, or even exhibited, a much
earlier oil, but the apparent connection
may have some implications for the dating.
On the other hand Cotman had already
shown a 'Trees, Duncombe Park ...' at
Norwich in 1811 – probably the same
composition as his etching (cat.59) – and
there is no certainty that this is indeed a
Duncombe subject.

DBB

86 **The Drop Gate (?Costessey Park)** c.1824–8

Oil on canvas 349 × 260
NO3632. Presented by Sir William
Lancaster 1922

If the preceding small oil is really of Dun-
combe and related in conception and date
to the larger oil of c.1824 (cat.84), it would
be tempting further to associate this com-
position with the drop gate in Duncombe
Park of which Cotman had made a water-
colour in 1805 (British Museum). However,
a watercolour copy of it perhaps by J.J.
Cotman (NCM) is inscribed with the title
'Costessey Watering, Norfolk', indicating
that it is a scene in the Jerninghams'
Costessey Park. Various impressions and
recollections may in fact be combined in
these later oils.

DBB

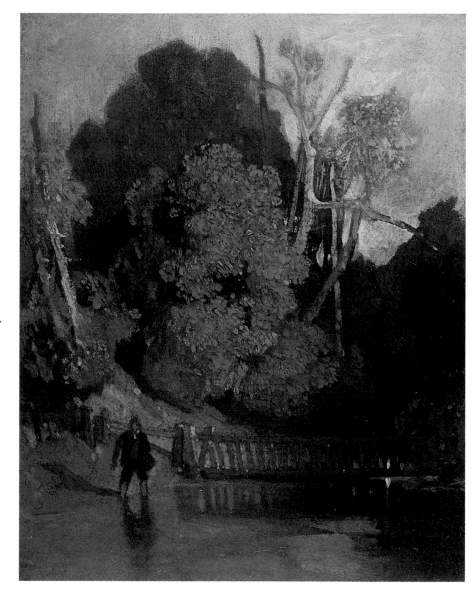

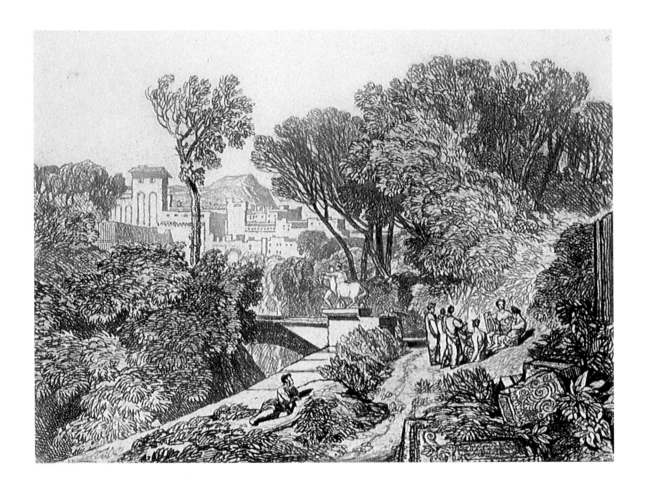

87 **The Judgement of Midas** 1838

Soft-ground etching, plate 6 in Cotman's *Liber Studiorum*, published by Henry Bohn, 1838
T11487–11534 (bound set). Purchased as part of the Oppé Collection with assistance from the National Lottery through the Heritage Lottery Fund 1996 T11492

This classical composition had been painted by Cotman in oil about 1809 (NCM), and showed the clear influence of Turner, both in historic landscape paintings and in similar plates of Turner's *Liber Studiorum*, to the first part of which Cotman had subscribed. Despite this connection, however, the choice of the same title for Cotman's own series of soft-ground and pure etch-ings published by Henry Bohn in 1838 was made by the publisher. These included subjects from various stages of Cotman's career (see also *Duncombe Park*, cat.59), and of them Bohn wrote in the preface that they were 'done more for practice and Amusement than with any view to publication ... Mr Cotman entertained some reluctance to the publication of these early efforts, but the favourable opinions expressed of them by several distinguished artists overcame his objections'. These artists almost certainly included Turner himself. Cotman's inclusion of this composition is evidence of a return towards the end of his life to the classical imagination seen also in the following oil.

DBB

88 From my Father's House at Thorpe c.1841–2

Oil over black chalk on canvas 684 × 940
Dated in pencil at r. lower corner, perhaps
by Miles Edmund Cotman, 'Jany 18. 1842'
NCM 1894.75.1. East Anglian Art Society
Gift 1894

Despite its late date, this unfinished oil is included for sharing the strongly retrospective quality probably seen in the preceding print, and for being one of Cotman's most Turnerian conceptions. The spirit of Turner is seen even more clearly in one of two preparatory drawings, in the British Museum, in which instead of the painted poplars appears a pair of trees resembling Italianate stone pines. Together with the foreground peacocks, these motifs raise the scene, taken from Cotman's father's small terrace looking along the Yare towards Thorpe Hall, to a pitch of classic idealism.

This transforming process is all the more remarkable since the trip to Norfolk on which the drawings were made was marred by heavy rain. It was an extended holiday from Cotman's teaching post in London, and enabled him to revisit old haunts as well as family and friends like the Dawson Turners at Yarmouth and their daughter Harriet and her husband the Revd John Gunn. He made many sketches on what was to be his last visit, and the colour notes on a number of them indicate that he planned to work up others into pictures. His final visit to his father, on his last day, was described to Dawson Turner; 'I galloped over Mousehold Heath on that day, for my time was short, through a heavy hail-storm, to dine with my Father – but was obliged to stop and sketch a magnificent scene ... of trees and gravel pit. But Norfolk is full of such scenes. Oh! Rare and beautiful Norfolk.'

DBB

89 **View of the River near Cow's Tower, Norwich** *c.*1810

Pencil and watercolour on paper
405 × 548
NCM 1951.235.1352.B58. Russell James Colman Bequest 1946

Little is known of John Thirtle's life, and for this reason he is one of the most elusive figures amongst the artists of the Norwich School. Yet, next to Crome and Cotman, he was the most talented watercolourist of his generation. As well as a landscape painter specialising in watercolour, he was also a 'Carver and Gilder' – of frames and mirrors – as well as a drawing master and miniature painter. It was as a frame-maker, indeed, that he was first trained, being sent from Norwich to London at an early age to learn the skills of this trade. In later years he ran a successful framemaking business in Norwich, and there are several pictures by Norwich School artists whose frames bear Thirtle's trade labels – Vincent's *Trowse Meadows* being an example (cat.107).

Thirtle probably returned to Norwich in *c.*1800, though the first concrete evidence that he was back in his native city is the listing of his name in the catalogue of the Norwich Society of Artists' first exhibition in 1805. Judging by examples of his early watercolours in NCM (Allthorpe-Guyton 1977, nos.2 and 3), the dominant influence at the start of his career was Thomas Girtin, whose work he would have come across in London, as Cotman also did (see cat.34). This watercolour, although somewhat damaged in the area of the sky, is one of the most striking drawings of Thirtle's early years, and shows him beginning to emerge from Girtin's shadow. The silvery tonality and the subtle palette of russets, creams, soft greys and sage greens are very much his own and characteristic of the period 1810–12 (see also cat.90). Despite the free handling of some passages in the watercolour and its rather unstructured composition, it is nevertheless a finished work, perhaps identifiable with one of the two Cow Tower subjects Thirtle exhibited with the Norwich Society in 1810.

Andrew Hemingway has pointed out how often Thirtle juxtaposes the decay of medieval monuments with 'modern vernacular developments' in his watercolours featuring locations on the outskirts of Norwich. Here, for example, he contrasts the bulk of the fourteenth-century Cow Tower with a modern villa and boatyard buildings to the left, whilst a wherry with lowered mast is perhaps preparing to negotiate Bishopsgate Bridge which lies downstream (Hemingway 1992, p.270).

AL

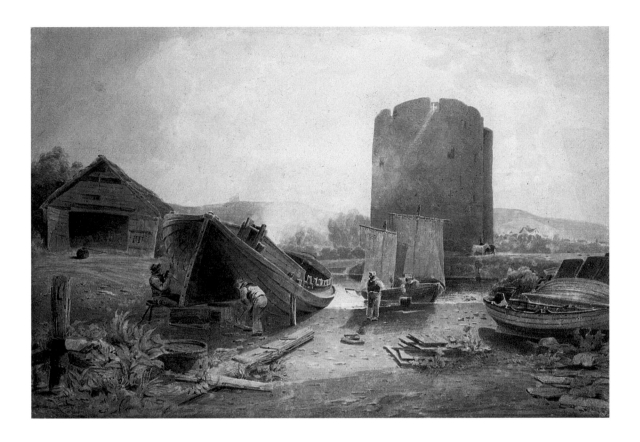

90 Boat-Builder's Yard, near the Cow's Tower, Norwich c.1812

Pencil and watercolour with some scraping out on paper 445 × 654
Inscribed with monogram in brown watercolour wash on boathouse door to left 'IT'
NCM 1974.59.2. Purchased with the aid of the Victoria and Albert Museum Purchase Grant Fund

The Cow Tower stands to the north-east of Norwich on the inner bank of the River Wensum. It was situated opposite the ruins of St Leonard's Priory – visible in Thirtle's watercolour on the horizon to the left – and these in their turn were located close to the ruins of 'Kett's Castle' (see cat.55). The tower was built as part of the city's defences, and was one of the earliest build-ings in Norwich to be constructed from brick. Indeed bills exist dated 1378 for the purchase of the brick – which was used as a facing over flint – as well as for the making of the tower's stone arrow slits (see Allthorpe-Guyton 1977, p.40). Its name derives from the fact that it was used for many years as a shelter for the cows which grazed on the meadows of the Great Hospital nearby. As well as being drawn by Thirtle, the Cow Tower also features in a watercolour by Cotman (Rajnai et al. 1982, no.59).

This watercolour can probably be iden-tified with the work of the same title which Thirtle exhibited at the Norwich Society in 1812. The subdued palette based on rus-sets, browns, greens, greys and creams is close to cat.89, but here Thirtle introduces more dramatic effects of light and shade, orchestrated by the shafts of light which burst through gaps in the cloud to left and right. The rather stocky figures and even the subject of a boat-builder's yard find parallels in the work of the London-based watercolourist John Varley, whose work Thirtle might have known, especially since Varley actually exhibited in Norwich in 1809 (Hemingway 1979, p.39). There is also a suggestion of Cotman's influence in the careful organisation of the compos-ition's shapes, although one author believes that any exchange of stylistic ideas between the two artists was probably recip-rocal (Hardie 1967, p.67). In 1812 they became brothers-in-law, Thirtle marrying Elizabeth Miles of Felbrigg, the sister of Cotman's wife, Ann.

AL

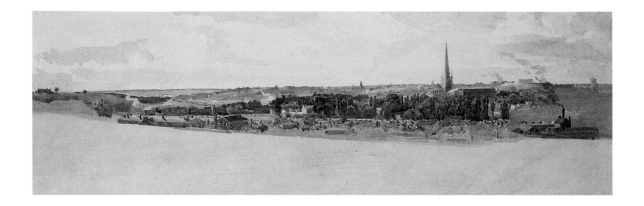

91 View of Norwich from the North-East c.1815–16

Pencil and watercolour with some white
bodycolour on paper 231 × 721
Inscribed in pencil in foreground with
elaborate colour notes
NCM 1951.235.1352.B11. Russell James
Colman Bequest 1946

This is one of three watercolour studies by
Thirtle on a panoramic format which show
distant views of Norwich from the vicinity
of Mousehold Heath, beyond Pockthorpe,
to the north-east of the city; another is in
NCM, and the third is in a private collec-
tion. This example is on paper water-
marked 1815, and it seems likely that all
three relate to the preparation of a finished
watercolour, *View of Norwich from Mouse-
hold Heath – Evening*, which Thirtle exhibit-
ed with the Norfolk and Norwich Society of
Artists in 1816, and which was probably
panoramic in format. Certainly there is a
watercolour with these proportions by
Thirtle in a private collection, signed and
dated 1816, which may well be identifiable
with the exhibited view (see Allthorpe-
Guyton 1977, p.51).

Thirtle appears to have been the only
member of the Norwich School to make
panoramic landscape studies in water-
colour like these. They make a fascinating
comparison with the five watercolour
sketches, in the British Museum, which
Thomas Girtin made earlier in the century
in connection with his vast circular
panorama of London known as the
'Eidometropolis' (Stainton 1985, nos.82a–c
and e–f). Thirtle may have known of
Girtin's panorama – especially if his return
to Norwich post-dated its public exhibition
at Spring Gardens in London between
August 1802 and March 1803 – although
there is no indication that he himself
intended painting a panorama of his native
city on so large a scale. Alternatively, he
may have taken inspiration from a panor-
ama of Norwich from Castle Hill which
Scottish artist Henry Aston Barker was
planning about 1809 (Allthorpe-Guyton
1977, p.52). Although this panorama
seems never to have been executed on a
full scale, the fact that a circular aquatint
engraving of it was published that year
indicates that Barker presumably got as far
as making preliminary drawings (Hyde
1988, p.69). The print was advertised in
the *Norfolk Chronicle* on 13 October 1809.
Impressions survive in NCM and in a
private collection (ibid).

In the foreground of this composition
Thirtle has made elaborate colour notes.
The paper he has selected comes from the
de Montalt Mill near Bath, Somerset, and
was made by Bally, Ellen and Steart, a
papermaker who concentrated on the
manufacture of watercolour and drawing
papers, some of which J.M.W. Turner also
used (Bower 1990, p.65).

AL

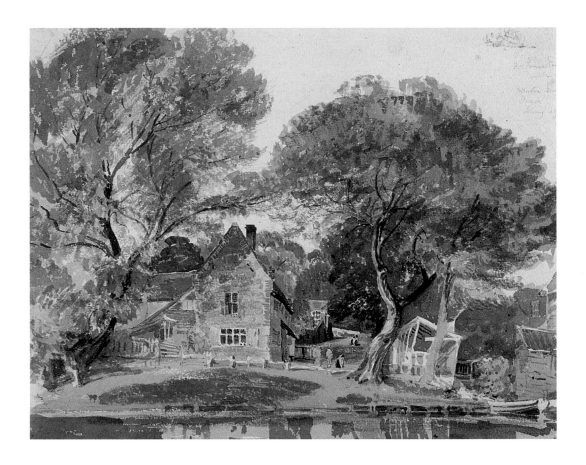

92 Cottage by the River at Thorpe, Norwich c.1814–17

Pencil and watercolour on paper 307 × 393
Inscribed in pencil upper right with colour
notes and a sketch of a boat and figures
NCM 1951.235.1352.BIO. Russell James
Colman Bequest 1946

In view of the lack of documentation about Thirtle's life and his development as an artist, the survival of a manuscript treatise by him on watercolour painting takes on a special significance. Entitled *Hints on Water-colour Painting*, this manuscript (NCM) comprises fifty-one pages of his observations and technical instructions about how best to use the medium. It is discussed and transcribed in full by Allthorpe-Guyton (1977, pp.19–21 and 29–34).

Drawing manuals and technical treatises on watercolour were becoming increasingly popular in the early nineteenth century, and were generally written by teachers of drawing – such as David Cox, for example, or John Varley – for the benefit of amateurs. Thirtle's manuscript, apparently drafted no earlier than 1810, may also have been connected with his teaching practice, for he is described as a Drawing Master in the Norwich Society catalogues during the period 1807–17. Although probably not intended for publication – it avoids, for example, any reference to contemporary notions of the Picturesque – the manuscript does discuss other issues in common with these treatises, such as the proper distribution of light and shade, the properties of various pigments and how to mix them, as well as observations on optical and atmospheric phenomena such as rainbows and storms.

Thirtle also emphasises in his treatise the importance of colouring from nature: 'to become a good Colourist you must Colour your sketches on the spot, & grudge no time they May Occupy ... by so doing youl observe how chaste & rich Nature is & it will Enable you to discriminate between Rich & Gaudy Colourg' (ibid., p.7). The free, loose and open character of the brushwork in this watercolour proclaims its status as an on-the-spot sketch, and indeed it was subsequently worked up by him into a larger, finished drawing (Rowntree Mackintosh Ltd), perhaps identifiable with the *Cottage at Thorpe* he exhibited at the Norwich Society in 1814. A section of the river partly beyond this sketch to the right is shown in another watercolour by Thirtle in the Whitworth Art Gallery, Manchester.

AL

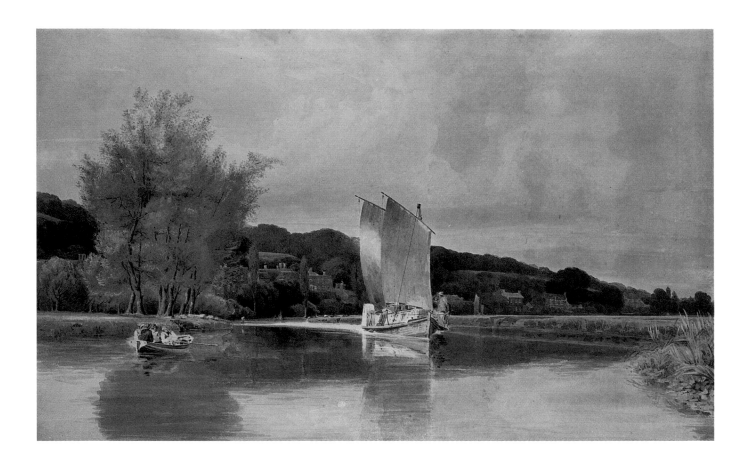

93 A View of Thorpe, with Steam Barge working up – Evening
1815

Pencil, watercolour and some white
bodycolour with slight scraping out on
paper 469 × 768
NCM 1951.235.1352.B16. Russell James
Colman Bequest 1946

The stretch of the Yare depicted here lies
between Thorpe Old Hall – whose chim-
neys are just visible at the extreme left –
and Thorpe Gardens. It was graced by a
number of elegant eighteenth-century
buildings, clearly visible in the distance of
Thirtle's view, which contributed to its
nineteenth-century reputation as the
'Richmond of Norfolk'. In his preliminary
sketch (cat.94) the river is free of traffic but
in this, the finished watercolour, he adds
not only a rowing boat but also a steam
barge, their juxtaposition perhaps intended

to point up the contrast 'between human
muscle overtaken by the product of
mechanical ingenuity' (Hemingway 1992,
p.270). It is possible that Thirtle depicts the
Experiment, the first steam barge to be
launched on the Yare in 1813, although
two barges launched slightly later – the
Telegraph and the *Courier* – are also candi-
dates (Allthorpe-Guyton 1977, p.47).

Many of Thirtle's finished watercolours,
including this example, have suffered
severe chromatic change through fading.
Paul Oppé pointed out that local pur-
chasers seem to have preferred Thirtle's
work to Cotman's (1939, p.115). Not only,
then, would his work have sold more read-
ily than Cotman's, but it would also have
been put on more regular and, perhaps,
long-term display – especially if Thirtle sold
his watercolours ready framed for hang-
ing. Such general fading as would have
been caused by over-exposure to light has

only been exacerbated by Thirtle's use of
the fugitive pigment indigo. In his manu-
script treatise on watercolour painting (see
cat.92), for example, he recommended that
indigo should be mixed with Venetian Red
or 'Maddar Purple' to create warm greys
for clouds. It is the fading of the indigo
which makes his skies now appear pinkish-
red – as is the case for many of Cotman's
early watercolours as well (cat.37). This
explains Oppé's comment that some of
Thirtle's large drawings 'now glare like
fiery furnaces' (ibid.).

This watercolour was exhibited by
Thirtle at the Norwich Society in 1815.
Although it lacks much of the spontaneity
of the original sketch (cat.94) it is, perhaps,
not as 'disappointingly artificial' as some of
the artist's later compositions taken to a
similar degree of finish (see Hemingway
1979, p.35).

AL

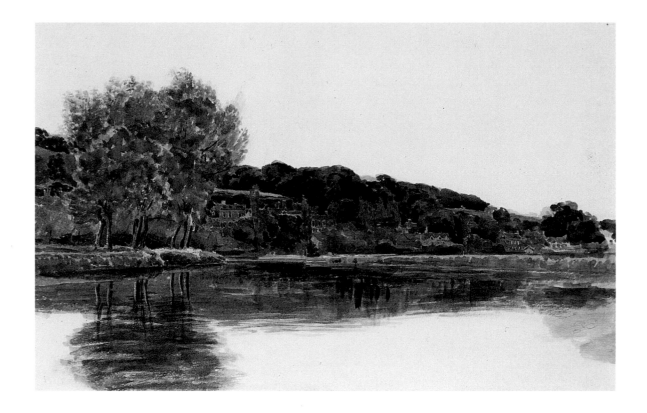

94 **Thorpe, Norwich** c.1815

Pencil and watercolour on paper 263 × 414
NCM 1951.235.1352.B36. Russell James
Colman Bequest 1946

Although Thirtle emphasised the import-
ance of colouring from nature in his
manuscript treatise on watercolour paint-
ing (see cat.92) – and the extent to which
nature 'must be courted and wooed' – he
also stressed that sketches were only
fragments whose ultimate destiny lay in
their potential for translation into finished
watercolours. 'Once yr Eyes are opened to
the beauties of a finished work', he wrote,
'& to the Everlasting delight of Followg.
nature in all her simplest minutiae – you
will despise hasty sketches' (p.40).

This study is one of five which Thirtle
chose to work up into larger, more
elaborate watercolours during the period
c.1814–17. It survives in the NCM collec-
tion together with its finished watercolour
(cat.93), as does another of these sketches

– of a *River Scene with Bridge* – alongside its
related, worked-up design (see Allthorpe-
Guyton 1977 nos.47 and 48). In compar-
ing this study of Thorpe with its finished
watercolour one notices, for example, that
the striking reflections of the tree trunks to
the left have been replaced by a rowing
boat, whilst others to the right have been
sacrificed for a piece of land to provide a
stronger framing device for the compos-
ition (Hemingway 1992, p.267). Thus, in
translating his sketch into a 'tidier' and
more finished watercolour, Thirtle loses
much of its original vitality.

This watercolour, like cat.92, was once
owned by Norwich artist Thomas Lound
(1802–61) who collected over seventy-five
examples of Thirtle's work during his life-
time. The best of Lound's own work, like
Thirtle's, was executed in watercolour, in a
style based on broad, free brushwork. This
may explain why he tended to favour col-
lecting Thirtle's sketches rather than his
finished work.

AL

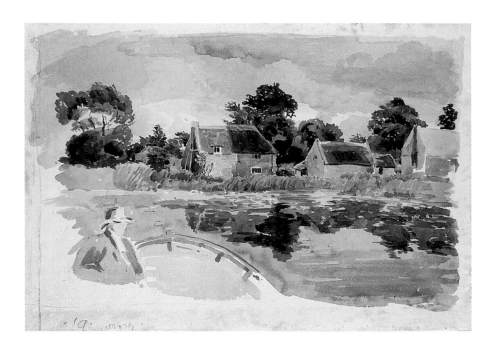

95 **Hoveton Little Broad, Norfolk**
*c.*1815–20

Pencil and watercolour on paper 225 × 328
NCM 1951.235.1343. Russell James Colman
Bequest 1946

Whilst Cotman's experience of making
plein-air colour sketches seems to have
been restricted to his early years (see
cat.41), Thirtle made outdoor watercolour
studies throughout his career. Not only did
he recommend the practice in his manu-
script treatise on watercolour painting (see
cat.92), but he also advised that sketching
from nature should become a regular
activity. 'Whoever flatters himself that he
can retain in his memory all the Effects of
Nature is deceived', he wrote in his *Hints
on Water-colour Painting*, 'for our Memory
is not so capacious; therefore Consult
Nature for Every thing' (p.23).

Hoveton is situated near Wroxham to
the north of Norwich. By 1824, Thirtle had
become drawing master to Mary Catherine
Blofeld, daughter of Thomas Calthorpe
Blofeld of Hoveton House. It is probably
Mary who Thirtle shows sketching under a
tree in a watercolour he painted of
Hoveton House in NCM (Allthorpe-Guyton
1977, no.75) – an indication that he passed
on to his pupils his own practice of sketch-
ing and colouring out of doors. This
especially bold *plein-air* watercolour study
of Hoveton Little Broad is usually dated to
the period *c.*1815–20 or even earlier but it
could, perhaps, have been executed as late
as the 1820s, during the time Thirtle was
drawing master to Mary Blofeld at Hoveton
House.

In 1816 Thirtle joined Robert Ladbrooke
and James Sillett in breaking away from
the Norwich Society of Artists to form a
new group, the Norfolk and Norwich
Society of Artists, sometimes referred to as
the Norwich Society Secession. They held
annual exhibitions for three consecutive
years between 1816 and 1818, though in
1818 Thirtle sent in no watercolours at all,
a fact much regretted by the *Norwich
Mercury* (1 August 1818) which praised
him for standing 'highest and alone in the
particular and beautiful department of
watercolours, in which he has evinced so
much decided excellence'. Thirtle did not
exhibit again with the original Norwich
Society until 1828, though even then he
did not resume his membership. He died of
consumption (the nineteenth-century
term for tuberculosis) in 1839 at the age of
sixty-three.

AL

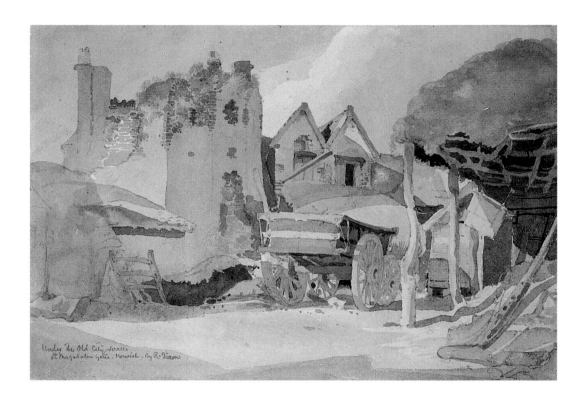

96 **Under the Old City Walls, Norwich** *c.*1808–9

Pencil and watercolour on paper 208 × 309
Inscribed, lower left, perhaps by James
Reeve, 'R. Dixon' and 'Under the Old City
Walls | St. Magdalen Gates, Norwich. By R.
Dixon'
NCM 1904.67.3. James Reeve Gift 1904

Dixon's obituary in the *Norwich Mercury* (7
October 1815), following his early death at
the age of thirty-five, recorded that he had
moved to the city in 1800 after studying at
the Royal Academy. He had shown at the
Academy in 1798, his contribution being
perhaps a theatre design, and in Norwich
he worked for the Theatre Royal and other
East Anglian theatres, as well as establish-
ing himself as a drawing master and
ornamental and decorative painter. He first
showed with the Norwich Society in 1805
and went on to become a member the fol-
lowing year and its Vice President in 1809.
At the same time he kept up contacts with
colleagues in London and tried to provide a
bridge between them and his fellow artists
in Norwich, liaising with them in the win-
ter of 1808 about joint submissions to the
forthcoming exhibition at London's Asso-
ciated Artists in Watercolours. In this he
met with little co-operation and appeared
by himself in the 1809 exhibition in Bond
Street. This very fresh and clearly toned
sketch, likely to have been made on the
spot, may be the preliminary study for one
of his two exhibits, 'Ruins of a Tower on the
City Walls', probably identical with the
finished watercolour also in NCM, which is
signed and dated 1809. The later identifica-
tion of the sketch as Magdalen Gates is
incorrect, dismissing the possibility that
the finished watercolour had been shown
in Norwich in 1805 as 'Near Magdalen
Gates'. There are affinities with Thirtle's
early outdoor watercolours, but the strong
sense of pattern contained by outline, and
limited palette of bright washes, also shows
the influence of Cotman, arguing for a date
after the latter returned to Norwich.
Dixon's choice of an obscure corner of the
city with ruinous buildings, gabled
cottages and broken fences and posts is a
response to Picturesque taste. Similar sub-
jects appeared in his series of soft-ground
etchings, *Norfolk Scenery* (1810–11), which
he described as 'illustrative of the Pic-
turesque Scenery' of the county.

DBB

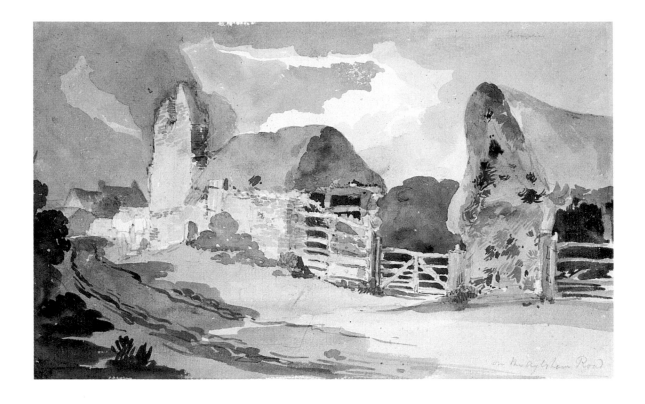

97 The Cromer Road to Aylsham

*c.*1809–10

Pencil and watercolour on paper 148 × 245
Inscribed in pencil at r. upper corner
'Cromer' and at r. lower corner 'on the
Aylsham Road'
NCM 1951.235.965. Russell James Colman
Bequest 1946

Dixon's fondness for Picturesque rural
architecture is again evident here, together
with a very Cotman-like treatment of the
sky. The small coastal town of Cromer was
a favourite subject for him, and he exhibit-
ed Cromer scenes at the Norwich Society
in 1809 and 1810. These seem to have been
based on a campaign of open-air study, to
which this watercolour would certainly
belong. Andrew Hemingway has suggested
that Dixon, Stark and other Norwich
artists were drawn to Cromer by an
amateur member of the Norwich Society,
Edmund Bartell, who in 1806 published a
book, *Cromer considered as a Watering Place*,
extolling its Picturesque attributes (Hem-
ingway 1979, pp.29–30). The appearance
of Cotman's Cromer subjects, for which
there was a more personal explanation
(cats.44, 46, 47), in the Norwich exhib-
itions from 1808 must also have been a
factor.

DBB

98 **Mackerel Boats, Cromer Beach**
*c.*1809–10

Pencil and watercolour on paper 135 × 247
Inscribed in pencil at r. upper corner
'Mackarel (*sic*) Boats Cromer/Morning'
NCM 1951.235.964. Russell James Colman
Bequest 1946

Dixon's freshest and most spontaneous
outdoor sketches at Cromer are beach
scenes, observing the activities of the local
fishermen. These had been described in
enthusiastic and very pictorial terms in
Bartell's book (see cat.97), and appealed to
the same interest in coastal subject matter
taken up by Crome and Cotman at
Yarmouth, by the latter at Cromer itself
(cats.44, 46, 47), or, further afield, by
Turner, A.W. Callcott, Joshua Cristall and
others.

DBB

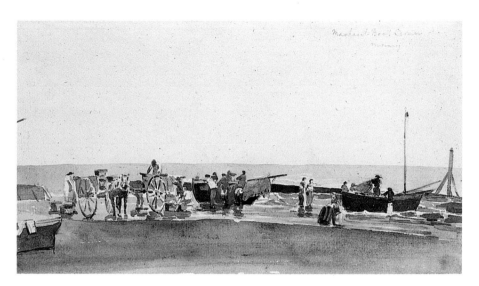

99 **Cromer Hills, Evening Effect**
*c.*1809–10

Watercolour on paper 156 × 274
NCM 1951.235.968. Russell James Colman
Bequest 1946

Dixon's main interest here is the sunset
sky. Once again, this is evidently an out-
door study.

DBB

JOSEPH CLOVER 1779–1853

100 **Corner of a walled Garden with Washing on a Line**

Oil on wood panel 410 × 235
NCM 1939.141.14. Mary Clover Gift 1939

Clover trained as an engraver and was encouraged to take up painting by Opie, whom he followed to London to study as a portraitist. He exhibited at the Royal Academy from 1804, and later shared lodgings with Stark in Newman Street, but was often in Norwich where in 1811 he held an exhibition at Elm Hill to coincide with the hanging at St Andrew's Hall of his portrait of the city's late mayor, Thomas Back. He was also a friend of Thirtle, whose early watercolour style probably contributed to – though it cannot wholly account for – his own extremely vivid and spontaneous handling of the medium in a series of sketches from nature, a number of which, including some sparkling studies of trees in Chipchase Park, seem to belong to a trip to Northumberland and Durham in 1810 (NCM). The same freedom and directness, and a still higher tonal key, are to be found in his oil sketches, like this one, and in all his landscape subjects must arise from their separation from his main or exhibited output as a painter, and his sense of being off duty. Nevertheless this humble garden scene relates closely to the Picturesque naturalism explored by other artists in Norwich and among others in London whom he could well have known – for example, William Collins, a friend of his own friend Stark.

DBB

101 Whitlingham from Old Thorpe Grove c.1830

Oil on canvas 435 × 610
NCM 1951.235.1299. Russell James
Colman Bequest 1946

Born into a Scottish family settled in Norwich, Stark was the favourite pupil of Crome and after his death assumed a position of leadership among the Norwich artists, becoming Vice-President of the Norwich Society during its most critical years, 1828–9, and President in 1829–30. This was despite his having moved to London in 1814, remaining there until 1819, and returning to live in Chelsea throughout the 1830s. His last years were divided between Windsor and lodgings near Regent's Park. He studied at the Royal Academy from 1817, having first exhibited in the capital in 1811 and first shown in Norwich two years earlier. Beginning in a relatively naturalistic vein, he made his reputation with essentially conservative interpretations of Crome's Dutch-inspired woodland landscapes, in which – not surprisingly for an artist who had moved away from Norwich – specific topographical elements are subordinate to Picturesque effect. His lack of interest in the scenery around Norwich, prompting him and his London friend William Collins to move on to Cromer during a visit home to his family in 1815, has already been quoted (p.24). Stark's pictures were very well received in London, sought after by influential patrons including the Marquess of Stafford and the Countess de Grey – most of whom were closely associated with the British Institution and whose taste inclined to Dutch pictures as well as modern artists reinter-preting their styles – and by fellow artists including the Academicians Thomas Phillips and Francis Chantrey. His success, in fact, may be some indication of what might have awaited Crome himself had he made the break to London. When Stark returned to Norwich in 1819, following a bout of poor health, he was to find the contrasting lack of patronage a severe shock. However, this return to his roots had real benefits for his art, prompting a reconsideration of the Norfolk landscape in the light of the greater naturalism and lighter colouring he had observed among his London contemporaries. His designs for a series of engravings of *Rivers of Norfolk*, begun in 1827, show a move towards topographical specificity that is also found, later in the decade and into the 1830s, in the titles of his pictures – once often merely called 'Landscapes' – while this small oil is also apparently the result of study direct from nature. It was made for Stark's sister, Mrs John Skipper, from a spot near her home at Thorpe. The massed and dark-toned trees of Stark's earlier woodland scenes yield here to an open view, brightly lit and broadly painted with a loaded brush. The influence of Constable, whom Stark may have known through Collins, seems unmistakable. A still sketchier oil of the same title, smaller and taken from lower in the valley, also in NCM and traditionally kept with this, is dated to November 1845, but this canvas may well be earlier. The naturalism of both oils provides a contrast to the classical idealism of Cotman's late view near Thorpe (cat.88), and a reminder of the divergent directions in which the Norwich artists had moved under pressure of time and distance.

DBB

102 **Dutch Fair on Yarmouth Beach** 1821

Oil on canvas 1112 × 1435
Norfolk Museums Service (Great Yarmouth Museums)

Like Stark, Vincent was a pupil of Crome, and spent much of his life in London. He first exhibited with the Norwich Society in 1811 and at the Royal Academy in 1814. He was John Berney Crome's companion on his visit to France in 1816 (see cat.32), and moved to London the following year, becoming a near-neighbour of Stark in Newman Street. Thereafter he exhibited both in London and Norwich and built up a fashionable client base like his friend's, including some of the same patrons like the Marquess of Stafford, and considerable credit with the critics in both cities. Never exclusively confined to Norfolk, his subject-matter became increasingly diverse, and the influence of Crome and other Norwich artists was greatly modified by that of Turner, Constable and others whose work he saw in London. His high professional standing was, however, marred by personal scandal or debt. He was in poor health by 1821 and tended to steer clear of Norwich, though he returned for Crome's funeral in April that year. A marriage the following year was said to be made for money, but his expectations were unfounded and further debts brought him to the Fleet prison in 1824. He was released in 1827 and lived only five more years. This picture, the largest and most ambitious of Vincent's several Yarmouth subjects, was exhibited at the British Institution in 1821, when it was much admired by the critic Thomas Griffiths Wainwright in the *London Magazine* and, for its 'Titianesque' colouring, by Robert Hunt in the *Examiner*. Together with the later *Pevensey Bay* (cat.105), it was clearly pitched at a London audience, showing his ability to paint on a bigger scale than his Norwich colleagues, and his assimilation of the work of Turner. While evidently descended from Crome's Yarmouth beach scenes (cats.9, 10) or, more particularly, his *Fish Market at Boulogne* (cat.29) in its warm and lambent colouring and animated crowd – including a prosperous couple with a poodle – it progresses beyond all these and is closest to Turner's conceptual grandeur and suggestiveness. The Dutch fair took place on the Sunday before 21 September, when Dutch boats visited before the fishing season, and set up booths. It had been discontinued during the Napoleonic War but had since returned. Its traditional site was the quay, but Vincent has moved it to a position outside the town near the Nelson monument, completed in 1819; its prominence here suggests that Cotman's later *Dutch Boats off Yarmouth* (cat.70), shown at the British Institution in 1824 was a direct response to Vincent's picture. Bathing machines and the rebuilt jetty are also visible (see Hemingway 1992, pp.209–10). Together with the post-war resumption of trade across the North Sea exemplified by the Dutch visitors, they turn the work into a grand celebration of peace. Vincent's exhibition of a picture of the opening of Waterloo Bridge at the Institution the previous year had shown a similar interest in events loaded with a national and celebratory significance, and in 1824 he was to plan large pictures of the battles of the Nile and Trafalgar.

DBB

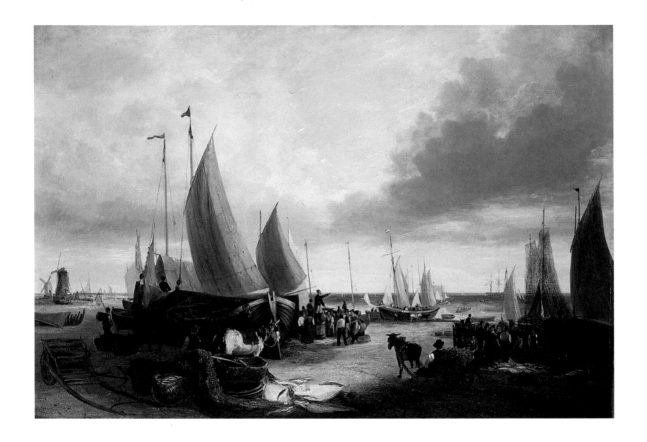

103 **Fish Auction, Yarmouth Beach** 1828

Oil on canvas 640 × 920
Signed with monogram 'GV' and dated
1828 on a boat at lower centre
NCM 1940.118.4. Sir Henry Holmes
Bequest 1940

Vincent was in financial straits in the later
1820s following his release from the Fleet
prison, and this and another, similarly
sized picture of the same subject dated
1827 in NCM may, as Hemingway suggests
(1992, p.208), have been produced for London picture dealers. The Picturesque motif
of the fish auction remained a popular one
with strong pictorial roots in Dutch painting, and local or specifically contemporary
features of Yarmouth are not so evident
here.

DBB

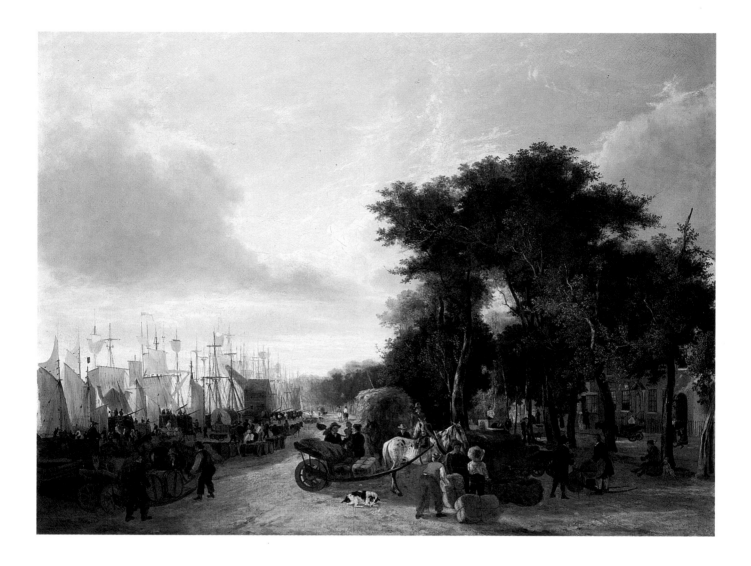

104 **Yarmouth Quay** ?1823

Oil on canvas 772 × 1030
Signed and dated at lower left on a
cartwheel 'G Vincent 1823'
NCM 1951.235.1359. Russell James
Colman Bequest 1946

This picture was probably the 'View of
Yarmouth Quay' exhibited by Vincent at
the Royal Academy in 1823; Constable
showed his own *Yarmouth Jetty* (private
collection) at the British Institution that
year. Vincent's *Quay* was not nearly so well
reviewed as his *Dutch Fair* (cat.102),
perhaps because landscape received more
attention in the Institution than in the
Academy (Hemingway 1992, p.211). The
picture is darker in tone and somewhat
drier in its touch than the preceding beach
scene, but just as rich in descriptive detail
of the busy commercial activities of the
quay and of the merchants' houses set
back from it behind a screen of trees. Hem-
ingway (ibid., p.213) notes the presence of
two beggars on the right – an ironic touch
in view of claims in contemporary guide-
books that they were nowhere to be seen in
the town. It is probably no accident that for
this and the following oil Vincent adopted
a format and size close to Turner's
favourite 3-by-4-foot canvas for English
marine and coastal subjects such as *St
Mawes at the Pilchard Season* (Tate Gallery),
which had been shown first in 1810 but
which he could have seen more recently in
Turner's Gallery.

DBB

105 A distant View of Pevensey Bay, the Landing Place of King William the Conqueror
1824

Oil on canvas 1460 × 2337
NCM 1945.17. Purchased 1945

This picture was exhibited at the British Institution in 1824. It shows Vincent reverting to a more ambitious scale, perhaps under the influence of Constable's 6-foot canvases, and to a historicised vision of the English landscape analogous to Turner's through his reference to the Norman conquest – interpreted here as a source of national prosperity; Hemingway (1992, p.297) speculates that the red-coated squire and shepherd in the foreground may represent respectively the descendants of the Norman knights and the indigenous Saxons. The picture offers a mellow and harmonious view of the English landscape and coast, which W.H. Pyne, in the *Somerset House Gazette*, equated to a vision of a 'golden age'. Beachy Head appears in the far distance across the Bay, its shoreline gleaming in the sun, while shifting light plays over the rolling fields in the middle distance. The composition is essentially classical, but divided by the group of trees off-centre in a very Turnerian manner; the paint is fluid and creamy, the palette clear and bright. An oil sketch of fishermen on the beach at Pevensey Bay, signed and dated 1824, was sent by Vincent as a gift to his Norwich friend William Davey and is now in NCM; another Pevensey scene, apparently taken from Fairlight near Hastings, was shown at Manchester in 1829. Though highly praised in the London press, and showing Vincent's talents at their highest pitch, his 1824 canvas coincided with the downturn in his personal fortunes; he was imprisoned in the Fleet in December that year.

DBB

106 **View on the River Yare, near Norwich** *c.*1822

Oil on canvas 1125 × 2020
Southampton City Art Gallery

As observed by Hemingway, this picture may be identifiable with either the 'View near Whitlingham, Norwich' shown at the Royal Academy in 1822 or the 'River Scene' in the Society of British Artists in 1829; of the two dates he prefers the earlier on stylistic grounds (1992, p.273). Once again, Vincent has used a broad, shallow canvas associated with classical composition, and constructed an idealised version of the Norfolk landscape for his London audience, in which topographical specifics are mainly conveyed by the river and the distant spire – presumably a glimpse of Norwich cathedral as Hemingway suggests – and outweighed by the very Picturesque woodland and paths on the left. While a productive and working landscape, with haywagon, sheep and cattle testifying to the agriculture of the land, and the hay and timber wherries on the river to export trade, the figures themselves are seen at a moment of rest. Hemingway (ibid., pp.175–6) remarks the absence of the more distinctively progressive aspects of Norfolk agriculture in favour of a conventional pastoral; and the unrest and hardship actually being felt in the county, as elsewhere in rural England, at a time of post-war depression on the land are comprehensively ignored.

DBB

107 **Trowse Meadows, near Norwich** ?1828

Oil on canvas 729 × 1094
NCM 1899.4.13. Jeremiah James Colman
Bequest 1898

Vincent was compared with Constable by the Redgraves in their *Century of British Painters* (1866), because he 'painted subjects seen under the sun, as Constable did'; but, they added, 'his treatment was wholly different, broad masses of greyish shadow were tipped and fringed with the solar rays'. This ambivalent relationship is evident in this picture, which is presumed to be one of two Trowse subjects exhibited at the Norwich Society in 1828 – most probably the work entitled 'Norfolk Scenery' of which the *Norfolk Chronicle* wrote on 16 August: 'we recognise the fine verdant range of Thorpe Meadows, and the sweetly picturesque heights near Crown Point and Trowse. The figures of horses, cows and men which animate, without disturbing the repose of this agreeable composition are judiciously introduced.' This description would conform to the viewpoint across the meadows towards Whitlingham and Crown Point, with Thorpe Wood in the distance. A smaller canvas (NCM) may be a preliminary oil sketch, but is also closely related to another version on panel, dated 1830 (on the London art market in 1968). With its laden cart crossing water, the composition, as observed by Hemingway (1979, p.66, and 1992, p.275), echoes Constable's *Haywain* (National Gallery) exhibited in 1821, and the impressively variegated sky, lit from behind clouds, also recalls his work. But Hemingway (1992, p.275) notes that Vincent's 'narrative of harvest' is at once more effective, in its progression from cutting and stacking in the distant meadow to the progress of the wagon bringing its load towards us across the river, and less spontaneous and immediate than Constable's. Also evident are Vincent's preferences for a more classical construction and a higher finish; instead of Constable's broken brushwork, the foreground and trees are painted with an almost Biedermeier precision. The *Chronicle*'s further comment that the picture was 'ably executed' reflects the Norwich preference for high finish that was currently operating to the disadvantage of Cotman's much more loosely handled oils (see cat.71).

DBB

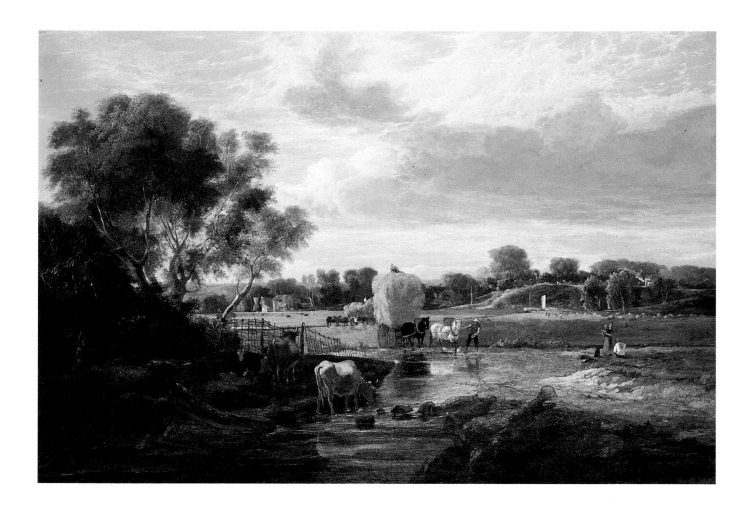

JOSEPH STANNARD 1797–1830

108 **The River at Thorpe** ?early 1820s

Oil on canvas 977 × 1116
NCM 1951.235.1263. Russell James
Colman Bequest 1946

The short-lived Stannard was the most gifted pupil of John Berney Ladbrooke. In his lifetime his relationship with his Norwich colleagues was ambiguous, since while he spent almost all his time in the city he nevertheless was never a member of the Norwich Society, having followed Ladbrooke in the 1816 secession, and often preferred to exhibit in London. His posthumous reputation also suffered as a result, as he was neither a full player in the art life of the capital nor completely a member of the Norwich 'School'. He is, in fact, a perfect illustration of how the formulation of the 'School' has hindered a proper understanding of certain artists. Though his subjects were mainly of Norfolk and conformed to the Norwich repertoire of rural and coast scenery, his style soon moved away from local prototypes and was based on original study of Old Masters – undertaken on a tour of Dutch collections in

1821 – and of contemporaries in London, of whom he must have known much more than would appear from his apparent confinement to Norwich. In these respects he is a later equivalent of John Crome, whom he clearly admired and a group of whose pictures he owned. Like his contemporary Vincent, he favoured a high finish, and, as a result of poor health, was not prolific. His compositions are also highly wrought, and his colouring notably bright, making him even more effective as an interpreter of atmospheric effect. The date of this picture is not known. With its prominent hay or reed wherry on the left and nearby location at Thorpe it is tempting to see it as in some way complementary to Vincent's *Trowse Meadows* (see cat.107), though there is no knowing which might have come first. It is likely to be a relatively early work, since it still has echoes of the earlier Crome's treatment of the Picturesque and lacks the tautness and smooth, crisp finish that seems to have developed as a result of Stannard's Dutch trip and is so evident in the later *Boats on the Yare, Bramerton* (cat.110).

DBB

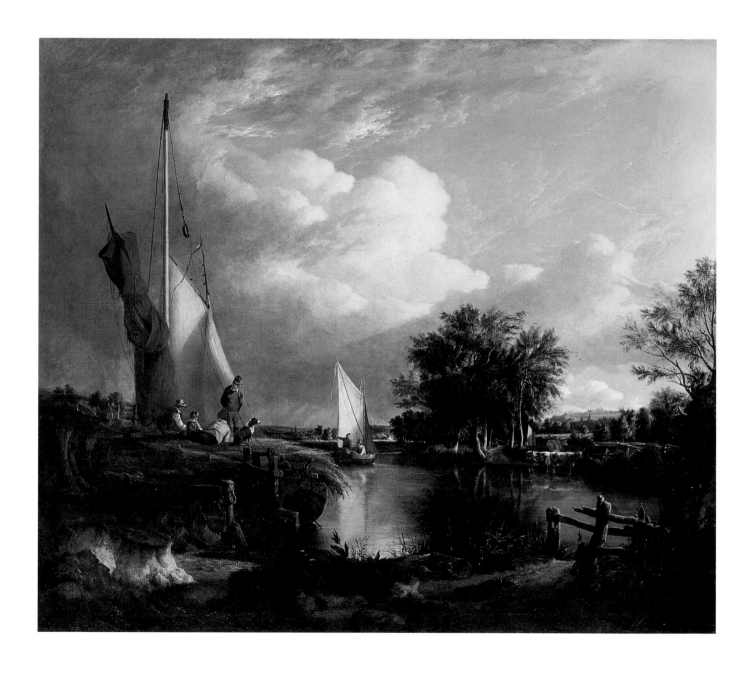

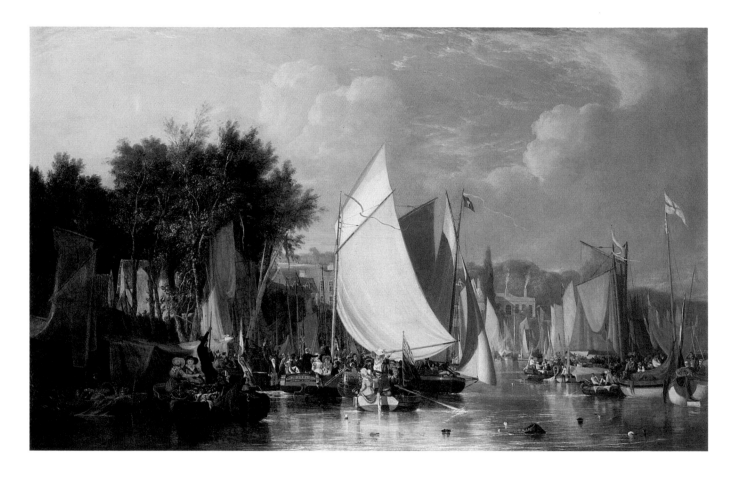

109 **Thorpe Water Frolic – Afternoon** 1824–5

Oil on canvas 1098 × 1758
NCM 1894.35. Jeremiah James Colman
Gift 1894

Stannard's skills as designer and colourist are evident in this large picture, which carries on the tradition of tranquil marines initiated in Norwich by the Cromes' *Yarmouth Water Frolic* (cat.30) and since developed by Vincent, and now represented in London by A.W. Callcott. The picture was begun in 1824 and shown at the Norwich Society the following year. Prepared from an initial oil sketch (private collection), Stannard's subject is the regatta organised since 1821 by the leading manufacturer Colonel John Harvey on the Yare alongside Thorpe village. The stretch of water depicted is now cut off from the sailing channel by rail bridges. In 1824 nearly 20,000 people watched the events including barge races and rowing matches. The artist, a skilled oarsman, competed, and has included himself, standing in a red coat and shading his eyes from the glare of the sun, on the extreme right. Ordinary folk customarily watched from the right bank, the gentry from the grounds of Harvey's house, Thorpe Hall, on the left, and Harvey appears among the latter, in his gentleman's outfit of blue coat and buff waistcoat, standing by his gondola as master of ceremonies. Together with the evening light depicted by Stannard, the group of men raising their hats nearby suggests that the moment might be that at 8pm when Harvey presented silver cups to the winning crews. Viewers of the picture, whose social position it was not for the artist to judge, survey the scene from midstream. For a contemporary audience, Stannard's respect for social distinction would have seemed as delicate as his pictorial flattery of a familiar beauty spot. Praising the picture highly, the *Norwich Mercury* observed: 'we believe there are very few artists now alive who could have produced a design where truth and fiction are so nicely blended'. Hemingway (1992, pp.284 ff.) gives a stimulating account of the picture, comparing it to newspaper reportage of the event and noting its likely role as an image of social cohesion and paternalism. It is difficult to resist the conclusion that it was intended for Harvey himself.

DBB

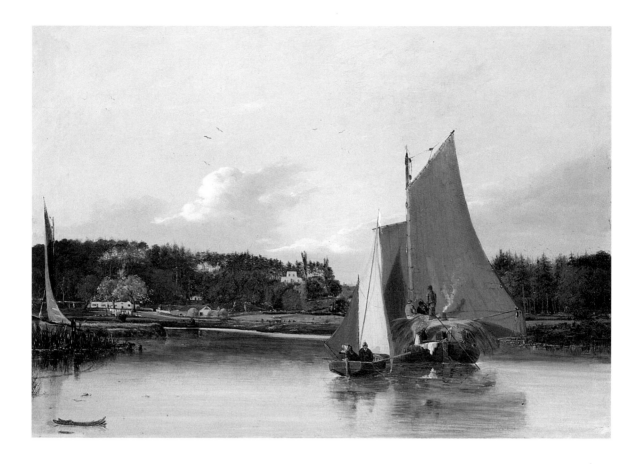

110 **Boats on the Yare, Bramerton** 1828

Oil on wood panel 572 × 772
Syndics of the Fitzwilliam Museum,
Cambridge

Stannard's full maturity can be seen here in the simplicity of the composition, in which planes of water and sky, harmonised by reflection, are broken by the band of the river bank with its dark clusters of trees, and interrupted by the vertical thrust of the sails of the laden wherry and its smaller attendant boat. The warm colouring is likewise subtly judged, moving through a range of complementary browns, yellows and greens involving both the man-made sails and the natural trees and sky. The warm, pink-edged clouds striating a blue horizon locate the source of the colouring – and the air of almost transcendant calm – to Cuyp, but there are also strong affinities with the contemporary work of Callcott, and of Linnell whom Stannard could have known through his pupil E.T. Daniell. Linnell's early naturalism may account for his close observation of the conifers in the middle distance – trees which were then considered unpicturesque and rarely painted. As first suggested by Hemingway (1979, p.70), Stannard may have begun the picture outdoors, and his use of a wood support might confirm this. In elaborating the composition with the group of boats, however, he may have turned to a drawing made for his earlier etching, *Boats on Breydon*, since an almost identical group of wherry and smaller boat appear there facing in the reverse direction (see cat.113).

DBB

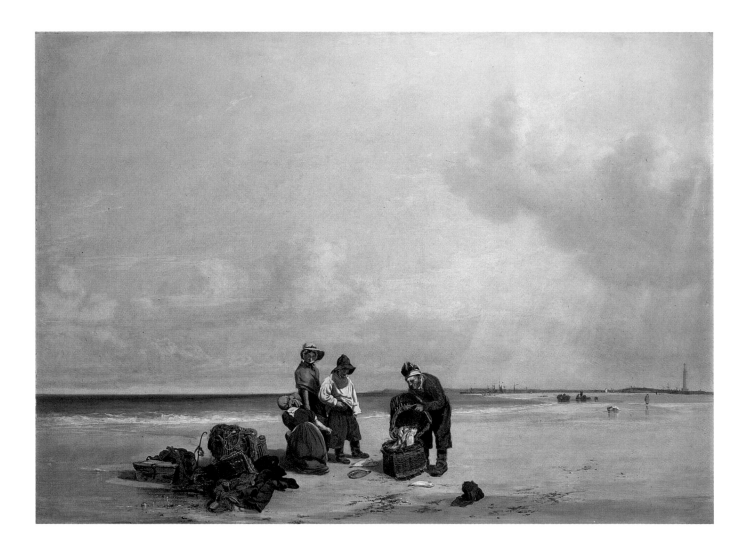

111 **Yarmouth Sands** 1829

Oil on mahogany panel 752 × 1029
NCM 1935.87. Alderman Sir Henry
Holmes Gift 1935

This picture may have been exhibited at
the Norwich Society in 1829, together with
another oil on panel dated the previous
year, *Yarmouth Beach and Jetty* (NCM).
Stannard had not exhibited in 1828 during
a long illness, and had recuperated at
Yarmouth, during which time he had
made a number of studies of beach scenes
which served for both pictures. The figure
of the fisherman emptying his catch
appears in each, while a study for the boy
in this one is among a number of related
drawings in the British Museum, and a
watercolour of the fishergirl is in the
Cotman collection. Stannard's marines
shown in Norwich in 1829 were well
received by the *Norwich Mercury*, which
commented that these 'elaborate' works
had 'all the delicate touch and high finish
of Vandervelde, whilst at the same time
they are perfectly original in their compos-
ition' (25 July). The preference of the city's
critics for high finish, currently operating
against Cotman, is again in evidence, and
fully justified by Stannard's refined execu-
tion and colouring. His conception of
beach scenery is, however, close to Callcott
and William Collins, whose Cromer scenes
he may well have had in mind. There are
also strong affinities with Bonington's
beach scenes of which examples had been
shown in London by this date.

DBB

112 **Whitlingham** 1824

Etching 105 × 148; on paper 110 × 152
Lettered within image at r. upper corner
'J.S. Feby 1824'
NCM 1925.61.14

Stannard was a skilled etcher who cut some superb plates, demonstrating his mastery of the figure and of beach scenes. They are usually small and have the quality of miniatures. He also taught the medium to E.T. Daniell, the patron of Linnell, Turner and William Blake. Stannard's sophisticated eye and wide historical knowledge are evident in the proximity of the landscape and tower motif here to etchings by Claude.

DBB

113 **Boats on Breydon** 1825

Etching 138 × 212; on paper 253 × 320
Lettered within image at r. lower corner
'J. Stannard 1825'
NCM 1971.543. Purchased 1971

One of Stannard's largest plates, this outstanding marine composition, as already noted, is centred on a pair of boats almost identical to that seen in reverse in the later oil *Boats on the Yare, Bramerton* (cat.110). Stannard may have recycled a drawing made for the print.

DBB

114 **Coast Scene** *c.*1825

Etching with drypoint 61 × 102; on paper
187 × 238
Lettered within image at r. lower corner
with monogram 'JS'
NCM 1975.424.7. Purchased with the aid
of the Friends of the Norwich Museums
1975

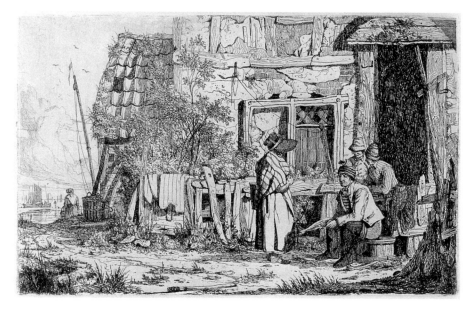

115 **A Cottage with Figures** *c.*1828

Etching 135 × 214; on paper 145 × 223
NCM 1925.61.12. Purchased 1925

This elaborate composition shows
Stannard's mastery of the figure and of
Picturesque cottage architecture – the
latter rather in the spirit of Cotman.

DBB

Anthony Hochstetter, *Plan of the City of Norwich* 1789, engraving (Norfolk Museums Service)

GUIDEBOOKS AND COMPARATIVE MATERIAL

Plan of the City of Norwich by Anthony Hochstetter, 1789 (reproduced p.153). NCM

Richard Beatniffe, *The Norfolk Tour: or, Traveller's Pocket Companion ...*, Norwich, 4th ed., 1786 (not reproduced). Open at title-page. An early example of a tourists' guide to Norfolk, designed for 'travellers, intending to make the tour of Norfolk from the Metropolis for pleasure'. NCM

John Chambers, *A General History of the County of Norfolk, intending to convey all the Information of a Norfolk Tour ...*, Norwich and London, 1829 (not reproduced). Vol.1 of 2, open at title-page with county map. NCM

John Preston, *The Picture of Yarmouth*, Yarmouth, 1819 (not reproduced). Open at p.9 with a view of Yarmouth Jetty, engraved by I. Clarke after the author's drawing. NCM. This guidebook was written by Yarmouth's Comptroller of Customs.

Anon., *Excursion in the County of Norfolk...*, London, 1820 (not reproduced). Vol.1 of 2, open at p.117 with a view of Nelson's Monument on the Denes, Yarmouth. NCM

J. Cory and John Sell Cotman, *A Narrative of the Grand Festival at Great Yarmouth, on Tuesday, the 19th of April, 1814*, Yarmouth, 1814 (not reproduced). Open at title-page and frontispiece by Cotman, showing the bonfire on which Napoleon's effigy was burnt and accompanying festivities (see cat.66). NCM

James Stark and J.W. Robberds, *Scenery of the Rivers of Norfolk from Pictures by James Stark*, London and Norwich, 1834 (not reproduced). Open at a view of the Yare near Thorpe, engraved by George Cooke after Stark. NCM

Mrs Charles Stothard, *Letters written during a Tour through Normandy Brittany and other Parts of France in 1818*, London, 1820 (not reproduced). Open at title-page with frontispiece, of women of Caen, after Charles Stothard. NCM

Dawson Turner, *Letters from Normandy*, London, 1820 (not reproduced). NCM

Dawson Turner, *Outlines in Lithography from a small Collection of Pictures*, Yarmouth, 1840 (not reproduced). Open at 'Scene on the River at Norwich' engraved by M.A. Turner after John Crome, and letterpress citing Crome's and the author's admiration for J.M.W. Turner. NCM

Mrs Dawson Turner, *One Hundred Etchings*, unpublished and privately printed (not reproduced). J.M.W. Turner's own copy, with flyleaf dedication from Dawson Turner. Open at portrait of Cotman, etched by Mrs Turner after J.S. Davis. Private collection

Dawson Turner, Letter to J.M.W. Turner, 25 August 1837, enclosing copy of the above (not reproduced): 'I am most happy to place them [the book of etchings] in yours. I should be insensitive indeed did I not feel how much honor the name I bear derives from my bearing it in common with you; and I should have a very low estimate of my own feeling for art, were I not morally certain that the time must come, will soon come, when your works will be ranked above those of any other painter in your kind, who has ever yet appeared upon the face of the earth ...' Private collection

BIBLIOGRAPHY

Exhibition venue and place of publication is London unless otherwise stated.

Allthorpe-Guyton 1977: Marjorie Allthorpe-Guyton, *John Thirtle 1777–1839: Drawings in Norwich Castle Museum*, Norwich, Norfolk Museums Service, 1977

Binyon 1931: Laurence Binyon, *Landscape in English Art and Poetry*, 1931

Bower 1990: Peter Bower, *Turner's Papers: A Study of the Manufacture, Selection and Use of his Drawing Papers 1787–1820*, exh. cat., Tate Gallery, 1990

Brown 1991: David Blayney Brown, *Oil Sketches from Nature: Turner and his Contemporaries*, exh. cat., Tate Gallery, 1991

Clifford 1968: Derek and Timothy Clifford, *John Crome*, 1968

Conner 1984: Patrick Conner, *Michael Angelo Rooker 1746–1801*, 1984

Fawcett 1982: Trevor Fawcett, 'John Crome and the Idea of Mousehold', *Norfolk Archaeology*, vol.38, part 2, 1982, pp.168–81

Goldberg 1978: Norman L. Goldberg, *John Crome the Elder*, 2 vols, Oxford 1978

Hardie 1967: Martin Hardie, *Watercolour Painting in Britain*, vol.II, *The Romantic Period*, 1967

Hawcroft 1968: Francis Hawcroft, *John Crome 1768–1821*, exh. cat., Tate Gallery, 1968

Hemingway 1979: Andrew Hemingway, *The Norwich School of Painters 1803–1833*, Oxford 1979

Hemingway 1984: Andrew Hemingway, 'Meaning in Cotman's Norfolk Subjects', *Art History*, vol.7, no.1, March 1984, pp.56–77

Hemingway 1992: Andrew Hemingway, *Landscape Imagery and Urban Culture in Early Nineteenth-Century Britain*, Cambridge 1992

Hemingway 1997: Andrew Hemingway, 'The Constituents of Romantic Genius: John Sell Cotman's Greta Drawings', in M. Rosenthal, C. Payne and S. Wilcox (eds), *Recent Essays in British Landscape 1750–1880*, pp.183–203

Holcomb 1978: Adele M. Holcomb, *John Sell Cotman*, 1978

Holcomb 1980: Adele M. Holcomb (with M.Y. Ashcroft), 'John Sell Cotman in The Cholmeley Archive', *North Yorkshire Record Office Publications*, vol.22, 1980

Hyde 1988: Ralph Hyde, *Panoramania!*, exh. cat., Barbican Art Gallery, 1988

Kennedy Scott 1998: Peter Kennedy Scott, *A Romantic Look at Norwich School Landscapes*, Ipswich 1998

Kitson 1937: Sydney D. Kitson, *The Life of John Sell Cotman*, 1937

Miller 1992: Corinne Miller (with David Boswell), *Cotmania and Mr Kitson*, exh. cat., Leeds City Art Galleries, 1992

Moore 1982: Andrew W. Moore, *John Sell Cotman 1782–1842*, exh. cat., Castle Museum, Norwich 1982

Moore 1985: Andrew W. Moore, *The Norwich School of Artists*, Norwich 1985

Oppé, 1923: A.P. Oppé, 'The Watercolour Drawings of John Sell Cotman', *The Studio*, special number, ed. Geoffrey Holmes, 1923

Oppé 1939: A.P. Oppé, 'The Thirtle Centenary Exhibition at Norwich', *Country Life*, 5 August 1939, pp.114–15

Oppé 1945: A.P. Oppé, 'The Colman Exhibition of Cotman at Norwich', *Burlington Magazine*, August 1945, pp.196–200

Payne 1993–4: Christiana Payne, *Toil and Plenty: Images of the Agricultural Landscape in England, 1780–1890*, exh. cat., Nottingham University Art Gallery and Yale Center for British Art, New Haven, Conn., 1993–4

Pidgley 1972: Michael Pidgley, 'Cornelius Varley, Cotman, and the Graphic Telescope', *Burlington Magazine*, November, 1972, pp.781–6.

Rajnai and Allthorpe-Guyton, 1975: Miklos Rajnai and Marjorie Allthorpe-Guyton, *John Sell Cotman. Drawings of Normandy in Norwich Castle Museum*, 1975

Rajnai and Allthorpe-Guyton 1979: Miklos Rajnai and Marjorie Allthorpe-Guyton, *John Sell Cotman 1782–1842: Early Drawings (1798–1812) in Norwich Castle Museum*, 1979

Rajnai *et al.* 1982: Miklos Rajnai (ed.) (with David Thompson, Michael Pidgley, Andrew Hemingway and Marjorie Allthorpe-Guyton), *John Sell Cotman*, exh. cat., Victoria and Albert Museum, Whitworth Art Gallery, Manchester, and Bristol Museum and Art Gallery, 1982–3

Shanes 1981: Eric Shanes, *Turner's Rivers, Harbours and Coasts*, 1981

Stainton 1985: Lindsay Stainton, *British Landscape Watercolours 1600–1860*, exh. cat., British Museum, 1985

Turner 1840: Dawson Turner, *Outlines in Lithography*, Yarmouth 1840

Warrell 1992: Ian Warrell (with Hiroya Sugimura), *Sun, Wind and Rain: The Awakening of British Landscape Painting*, exh. cat., Tochigi Prefectural Museum of Fine Arts, Japan 1992–3

Warrell 1997: Ian Warrell, *Turner on the Loire*, exh. cat., Tate Gallery, 1997

Warrell 1999: Ian Warrell, *Turner on the Seine*, exh. cat., Tate Gallery, 1999

PHOTOGRAPHIC CREDITS

The Trustees of the Bowood Collection (fig.9)

The Bridgeman Art Library (cat. 106)

English Heritage Photographic Library (cat.30)

GGS Photo Graphics, Norwich (colour photography of works loaned by the Norwich Castle Museum)

Leeds City Art Gallery (fig.4)

National Galleries of Scotland (fig.1)

Board of Trustees of the National Museums and Galleries on Merseyside (Lady Lever Art Gallery, Port Sunlight) (fig.3)

Norfolk Museums Service, Castle Museum, Norwich (fig.6; Map of Norwich, p.153)

Photographic Survey, Courtauld Institute of Art (fig.2)

Geoffrey Shakerley (fig.9)

Tabley House, Knutsford, Victoria University of Manchester (fig.2)

Tate Gallery Photographic Department (fig.8)

Yale Center for British Art, Paul Mellon Collection (figs.5, 7)

INDEX